Sport and the Countryside

PHAIDON · OXFORD

Sport and the Countryside

IN ENGLISH PAINTINGS WATERCOLOURS AND PRINTS

DAVID COOMBS

Phaidon Press Limited, Littlegate House, St Ebbe's Street, Oxford

Published in the United States of America by
E. P. Dutton and Co. Inc.,
2 Park Avenue, New York. NY 10016

First published 1978
All rights reserved
© 1978 by Phaidon Press Limited
Text © David Coombs
ISBN 0 7148 1823 2
Library of Congress Catalog Card Number:

Printed and bound in Great Britain by
W. S. Cowell Ltd, Ipswich

(*preceding pages*)
JAMES SEYMOUR: *Stag-Hunting* (see also page 39)

Explanation and Acknowledgements

The author and publishers are grateful to all those who have given permission for works of art in their possession to be reproduced. Particular thanks are due to the Arts Council of Great Britain and to Christie's, Sotheby's, The Parker Gallery and others who have so generously lent photographs.

One way or another this book has been more than twenty years in the musing if not directly in the making. Old sailing ships and London's history were my boyhood passions; blessed with a sensitive and enterprising mother, pictures and exhibitions have always formed a natural part of my life. The need to make a living led me first to work amongst the splendid illustrated volumes at the antiquarian booksellers, Henry Sotheran and Son. My curiosity about what was eventually to become the subject of this book was increased as for five years, from 1958, I came into close contact with the vast range of English paintings, watercolours and prints at the Parker Gallery, London. There seemed to be no literature relating to the pictures of countryside and sport equivalent to that on marine, military and metropolitan matters. Three books, and my translation to the editorial offices of *The Connoisseur* in 1962, eventually persuaded me that my ideas might be worth actively pursuing. The books were *The England of Nimrod and Surtees* by E. W. Bovill (1959), *Art and Illusion* by E. H. Gombrich (1960) and *Art and the Industrial Revolution* by Francis D. Klingender (1968).

The direct impetus for my own book came from the exhibition 'British Sporting Painting 1650–1850' organized in 1974 for the Arts Council of Great Britain by the Marquess of Dufferin and Ava, who generously suggested that I might be offered this unexpected commission.

Over the years before and since, many others, wittingly and unwittingly, have helped and encouraged me in my labours. They include Howard Blackmore, Sally Budgett, Martin Butlin, John Calmann, Nigel Coates, Penny Egan, Judy Egerton, Ian Farquhar, David Fuller, Mrs M. A. Greenall, Lisa van Gruisen, R. Hawkins, John Hayes, R. G. Hollies-Smith, Janet Holt, Peter Johnson, Michael Levey, Sir Oliver Millar, Roy Miles, Edward Morris, Bertram Newbury, Mr and Mrs Donald North, David Posnett, Keith Roberts, Michael Rosenthal, Jane Roundell, John Sabin, Timothy Stevens, Marina Vaizey and Nicholas Usherwood.

The managing director of the National Magazine Company, Marcus Morris, and Roger Barrett of the Ebury Press have, in various ways, made this book possible. My friends at the *Antique Collector* have suffered it all long enough. To everyone, I offer my grateful thanks.

DAVID COOMBS, GODALMING, 1978

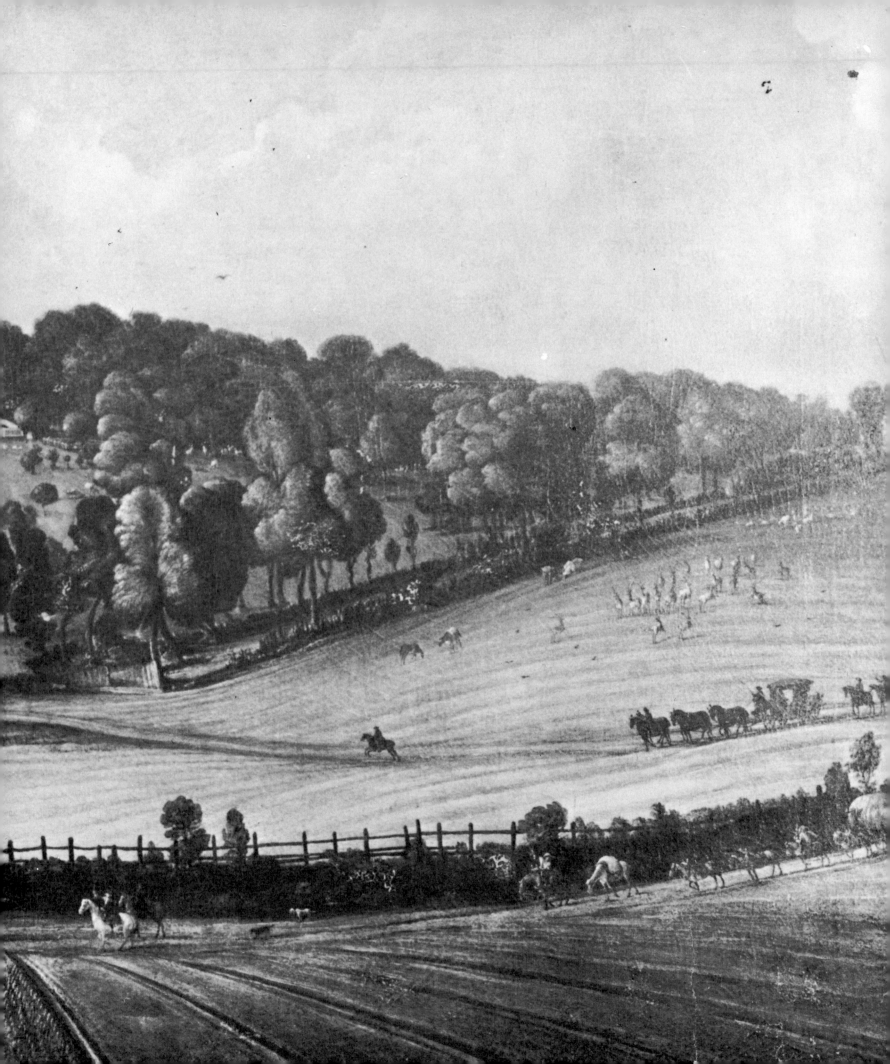

Sport and the Countryside

The background. Many of us are attracted by the paintings of old England. They remind us of a time when, we imagine, the countryside was unspoilt, the air unpolluted and all of life dominated by the slow and steady rhythm of the seasons. The pictures often show stately and elegant people, glorious animals, prosperous farms and broad landscapes with fine houses; occasionally, though more often than we realize, the pictures have a sporting content that, when particularly obtrusive, some find distasteful.

In general, sporting art has suffered as much from the over-enthusiasm of its supporters as it has from the misunderstanding of its critics. In the context of British art it has been largely relegated to a by-way; within Western art it has been virtually ignored except when it impinges upon what is now dignified as animal art.

The whole problem arises from the way we look at these pictures. Inevitably we are restricted in our understanding of the past by the limits of our own experience. Animals no longer play a major part in everyday life; they are preserved in game parks, protected in the wild, ridden in horse shows or just taken for a walk, whereas they have a natural place and presence in the paintings from the past.

In much the same way we now think of the countryside as somewhere special, to go to or to relax in, or a place that is in danger of being ruined in the interests of efficiency or profit. But all these rigid distinctions, whether between town and country, or between animal, landscape and sporting painting, are essentially modern distinctions, the result of our own preconceptions, rather than the circumstances of past times.

Country life. In the seventeenth century and, indeed, right up until the middle of the nineteenth century, most of the people in England lived and worked in the country. At the beginning of our period the total population was so small that much of the country was unworked in any form – there was no need for it, and what was not waste remained forest or woodland. But that is not to say that all of this land was unproductive: at the very least it was the source of new wealth for anyone enterprising enough to clear it for agricultural use. Both woodland and forest were a source of fuel as well as of timber for all kinds of furniture and implements for household or farm use. Fish swam freely in rivers and streams, and were there for the catching. Rabbits were plentiful, good to eat and easily netted. Trees, hedges and bushes were bountiful sources of fruit.

UNKNOWN ENGLISH ARTIST: *Averham Park from the East*. Detail from plate on page 35

In one way or another, therefore, most people were compelled to find their own food, and this at a time when most of the livestock would have to be slaughtered in winter, and their carcasses drawn, hung and stored, for there were insufficient means to keep them alive. In these circumstances many things were kept to be eaten that to our eyes might seem extraordinary: peacocks were decorative but their flesh also appealed to a delicate palate; likewise pigeons, which were fertile and gregarious and a source of fresh meat all the year round – hence the many huge and ancient dovecotes still found near large old houses or farmyards throughout the land.

Most of the people would nowadays be described as 'peasants': convenient enough as far as it goes, but their standard of living and their expectations were as different from our usual demands as their way of life was fundamentally divorced from ours. Even those who we

JAN SIBERECHTS (1627–about 1703): *Landscape with Rainbow, Henley-on-Thames.* About 1690. Canvas, 82 × 103 cm. London, Tate Gallery

Siberechts came to England from Antwerp about 1672 and painted views of many great houses for their owners. Here on the hill can be seen vast, recently enclosed fields which dominate the town and still show signs of being ploughed in individual lands (strips) – a relic of the ancient form of ownership. The spindly horses in the foreground were just that, for few had yet been bred to possess the strength of muscle of an ox: it is no accident therefore that the barge on the river is being towed by a line of straining men.

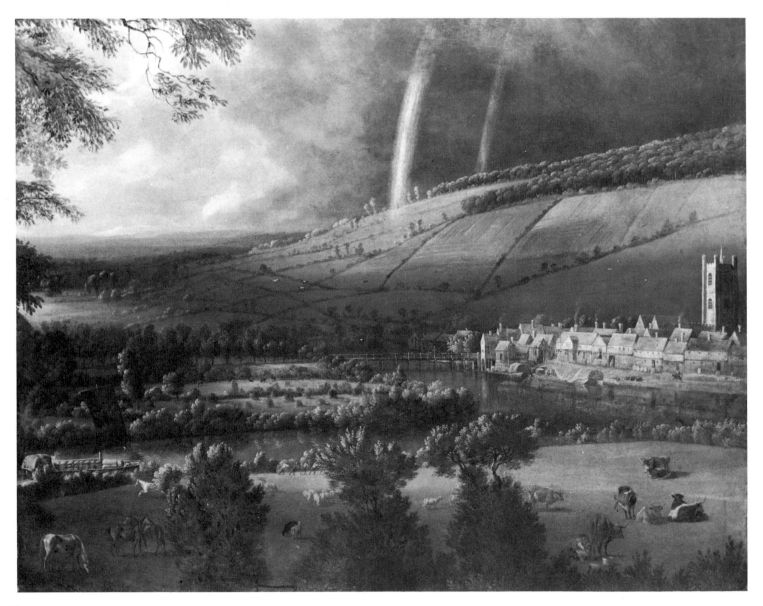

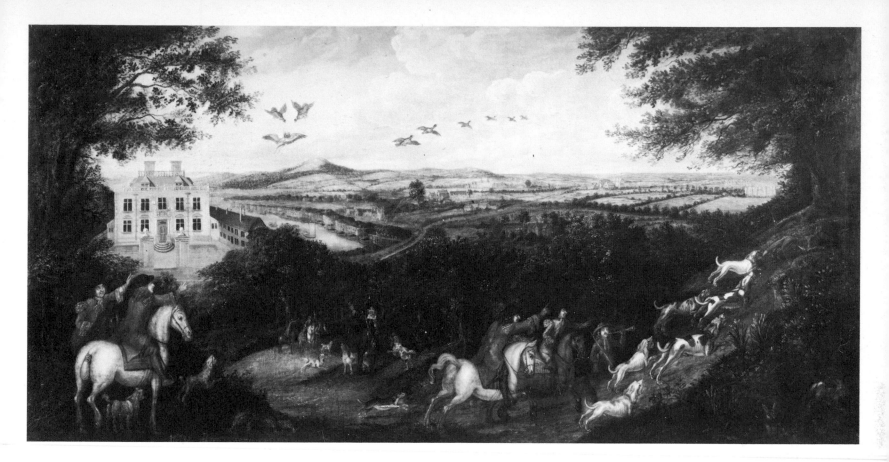

UNKNOWN ARTIST. *Harraton Hall.* 1687. Canvas, 122 × 244 cm. Private Collection

Here is a scene of considerable cheerfulness – uncommon in art at any time – with smiles all round and sporting enjoyment (of hawking and fox-hunting) as the theme. The newly built house on the left is another cause for celebration, the prosperity deriving from the coal being loaded into barges on the River Wear below, to the right of the house. This is County Durham in the late seventeenth century and one of the earliest of English industrial paintings, with the view still firmly dominated by the countryside, which for another hundred years remained, in general, free of access and use to all.

would now think of as country gentlemen would carry a hawk on their wrist when riding about their business, for there was always the chance of flushing a bird or hare for the pot.

For those sufficiently energetic or lucky enough to find themselves in better than average material circumstances, the basic country ways would have still dominated their lives. A successful harvest was as important to them as a satisfactory international balance of payments for us today; a better horse may have been a source of pride but it was also the principal means of personal transport as well as the main source of motive power, other than a man's arms and legs. For all, life was often hard but, in modern terms, it was natural; death was accepted as naturally and inevitably a part of life as birth. Urban society, our society, hides both away. None of this is intended to justify what may have happened in the past, to condone or even to condemn it, but to seek to explain part of the background that nurtured the patrons and painters of the time.

Illustration and inspiration. It will need a considerable change of thought to try and understand why England's artists in the past painted what they did in the manner that they chose. It is important, in the first place, to realize just what the pictures are not. For instance, it is always tempting to think of the artists of the past as real craftsmen, for they appear to have painted what they saw in a way that we can quickly understand; and we thus assume that they must be totally accurate. Yet all of this is to forget a basic idea underlying much art: there is a distinction between illustration and inspiration. To put it

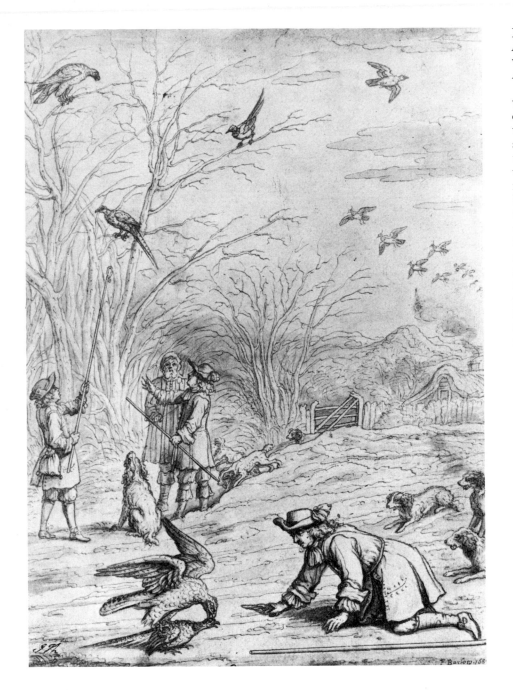

FRANCIS BARLOW (about 1626–1704):
Hawking for Pheasants. 1684. Bistre, pen and
wash drawing, 14·9 × 21·5 cm. Oxford,
Ashmolean Museum

Before guns became cheap enough to be
widely used, hawks were a principal method
of gathering fresh meat. Pheasants were
very desirable but a problem in that, once
sprung from cover by the dogs, they were
wont to seek safety in the trees where they
were used to roosting. Sticks would be
needed to dislodge them. Hawks also could
be a problem, for once they too settled in
the branches (top left in the drawing) they
were not easy to call back, quite apart from
the more common difficulty of luring them
away from their kill, as shown in the fore-
ground. Plovers likewise provided a tasty
morsel, and a flight of them is seen ap-
proaching from the right, over the cottage;
here was yet another challenge, for they
might divert the attention of the hawk away
from its intended prey.

THOMAS GAINSBOROUGH (1727–88): *Study of
a Cow*. Black and white chalks on brown
paper, 14 × 18 cm. Photograph by courtesy
of Sotheby's

This beautiful drawing expresses very
simply why livestock of several kinds is so
often found in Gainsborough's landscape
paintings. They were obvious subjects be-
cause animals dominated the countryside
then in much the same way as the rural
population dominated the towns. In par-
ticular, cattle were the source of much food
– milk, butter, cheese and, at a later period,
meat. Their hides also provided the raw
material for the many industries dependent
on various leathers to make everything from
ladies' gloves to workmen's aprons or
horses' harness.

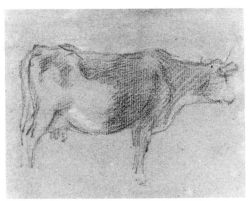

another way: to make a picture of a cart, with every detail shown and
every function understood, is not the same as to make a picture which
is dominated by a cart. None the less the important point is that the
cart inspired the picture, and not the other way round.

There is a further point: more often than we might realize we are
unconsciously influenced, in how we look at things, by the way in
which the same objects have been seen by artists of the past. Some
paintings and the work of a few great artists have become so familiar
that they have come to determine what we expect from an attractive
landscape view. Yet, more often than not, the artists were using
methods of pictorial design that demanded they select those aspects

of a view which, when placed together, most nearly met *their* ideal. At the furthest extreme these pictorial ideas were imposed on whole landscapes, through the work of major architect-gardeners.

Whilst there is a danger therefore in seeking a literal truth in the paintings from the past, there is an equal danger in looking at them solely as works of art, to be graded in some kind of hierarchy. Nobody would wish to dispute the suggestion that some artists are better than others; that some, for instance, are capable of making pictures of such a profound quality of thought as to super-illuminate simple ideas of landscape or animal beauty. But this can obscure the point that the best and the so-called lesser artists may have something else to say to us as well.

The Englishman's art. In much the same way as the environment has always been there, though only recently recognized, so in old English painting there is much to discover about our past. Whilst, as has already been suggested, there is a distinction between inspiration and illustration, both – depending on the circumstances of the making of a picture and of its basic intention – are often found together in varying proportion. Essentially ours was a countryman's art. For the countryman, as has already been said, life and death, pleasure and sadness, are as natural as the seasons. Each experience is accepted and understood as part of the inevitable pattern of change: for in the country there is no such thing as a vacuum; even stillness is a herald, and grass a crop.

Art history, as we now know it, is a modern discipline barely, perhaps, a century old, developed at a time when towns had displaced the country as the most important centres of population and economic activity. Ironically, as it happens, it took root just when we had all begun to look back with some kind of nostalgia to a golden and gentle past, however falsely based this idea may have been in reality. None the less, this romantic idea, combined with a new demand for neat divisions to help towards understanding and analysis, led inevitably, so it seems, to the creation of the myth of sporting art. It was a myth not so much because the sport it so often seemed to celebrate was an anachronism (in the eyes of non-participants) as because these sporting scenes or views were only one part of a vastly more interesting and, as can now be seen, more important body of native English art. It is this that I have chosen to call the Englishman's art.

Origins. Like so much in our island, the origins of the Englishman's art lie abroad. The Channel moat and contrary religious convictions did not encourage much in the way of influence upon English art from Renaissance Italy. Compared to Continental art – especially Italian – British achievements in the Tudor and Elizabethan periods were modest, with the exception of the great miniaturists, Hilliard and Oliver, who continued the tradition of fine work by the manuscript illuminators. There were other exceptions, portrait painters all, like Hans Holbein sent from Basle by the great European humanist scholar Erasmus to his friend Sir Thomas More; our own George Gower,

Serjeant Painter to Queen Elizabeth; and Hans Eworth, who came from his native Antwerp to work in England for more than twenty-five years.

In all of these paintings the human figure dominated the picture. The manner and matter of the dress, the addition and position of accoutrements, were all designed to establish beyond doubt the status and interests of the sitter. Accuracy of drawing was expected and the finest details included: to these things the overall design was subordinate. Each picture was expected to present the maximum amount of information in as clear a manner as possible; to this end, light and shade, perspective even, were firmly controlled and often minimized.

At the same time there were, however, close trade connections between England and the Low Countries. For many years our own Caxton lived in Bruges, an important European trading centre, where he was one of many merchants dealing in wool and cloth; it was during this period that he acquired a knowledge of printing, which he eventually brought back home. These continuing trade links were bound to be reflected in the arts. By the time of James I, the earlier Flemish passion for landscape backgrounds in both religious and secular painting had had its effect. Into English portraits there crept something akin to a stage-set with the background a kind of support for the

ROBERT PEAKE (*fl.* 1575–1623): *Henry, Prince of Wales, in the Hunting Field.* Canvas, 190·5 × 165·1 cm. Royal Collection. Reproduced by gracious permission of Her Majesty The Queen

Henry, Prince of Wales (1594–1612), never lived to inherit the throne from his father, James I, but he did inherit from him a passionate interest in hunting. Costume and detail all indicate royalty: it was for the person of the highest rank present to deliver the final wound to a stag, its antlers firmly held here by young Robert Devereux, 3rd Earl of Essex. The great horse is harnessed in a way that would have had the approval of the Prince's tutor, the Duke of Newcastle. In the middle distance can be seen the palings marking the boundary of the deer park.

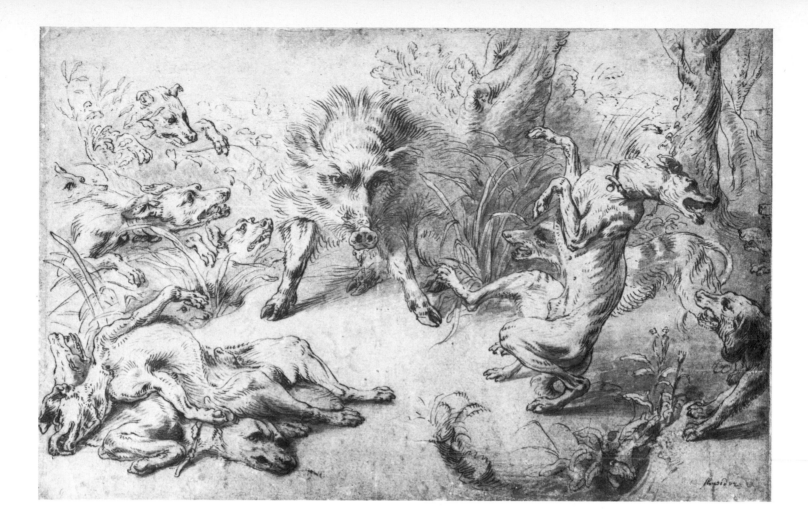

FRANS SNYDERS (1579-1657): *Wild Boar Hunt*. Pen, ink and wash, 29·8 × 45 cm. Norfolk, Holkham Hall

Snyders was a seventeenth-century Flemish artist who often worked with Rubens, notably on a series of large hunting scenes. This is a tremendous drawing of hounds held at bay by a boar, the most ferocious of all game and the one most admired by sportsmen. The considerable Flemish influence on English art took several forms, directly on a number of artists and indirectly through collectors such as the 1st Earl of Leicester, who bought this drawing following his Grand Tour in the early part of the eighteenth century.

figure, extending and harmonizing the character of the pictorial presentation.

Seventeenth-century prosperity. In the early seventeenth century England was prosperous; her merchants, aristocratic or middle class, were able to build houses of a size and comfort not commonly seen before. Sheep, cattle and corn were the basis of this wealth – on land freed from the wasteful (however idyllic in romantic retrospect) system of open-field, strip farming, and consolidated into secure holdings of a size to make individual experiment and enterprise capable of reward. It became fashionable to have a garden, in which as well as flowers, luxuries like potatoes and turnips were grown. It was not enough to build the new country houses of stone pillaged from ruined and discredited monasteries or from their attendant quarries. Brick-making skills had progressed, and the flexibility of brick as a material was recognized in so far as there were as many varieties as there were clays. And thus came to be built those glorious houses that grace our countryside (and older towns) to this day.

England became a country attractive to the enterprising or the persecuted of other lands, with sufficient people confident and wealthy enough to build themselves new and comfortable houses, and to consider commissioning a competent artist to record their success. Many of these artists were Dutch and Flemish – they had the extra glamour

of being foreigners – whose influence was to prove to be as lasting as it was profound.

To portraiture these overseas artists brought a more relaxed, more realistic, style, introducing as well subsidiary scenes of landscape, though with specific meaning in terms of property owned or pursuit enjoyed. Where an artist was employed to paint a view of a house and its park he would, more often than not, enliven it with details of an agricultural or sporting significance. These elements are barely noticed today because we are looking for the important, but not supremely important, quality of aesthetic grace: yet this would not have come into being without the more mundane stimulus of a specific commission.

Slowly, steadily, the country house began to assume a new importance, in the eyes of artists as well as owners, and two strands appeared in English art (aside from portraiture, which continued on its way, more and more influenced by the experiments and discoveries of painters and patrons in love with the thought of art).

The first of the new ideas was to bring the architectural or landscape setting into greater, sometimes almost equal, prominence with the human subject of the picture. How else indeed was the patron to display in a suitable manner the importance of his new house, and the intimate connection it had with his own position, be it real or claimed?

The second idea was for the new house, its garden and adjacent park or farms to be the principal subject of the painting, so as to become a kind of portrait in its own right. Not only did this display the manner and extent of prosperity, it was also a vehicle for the skilful application (sometimes in several neatly dovetailing but otherwise incompatible planes) of the newly appreciated science of perspective.

In both kinds of picture, the patron was able to record and display his enterprise and success, whilst the artist could indulge in another kind of display – that of his own great technical skill.

Animals. There was another uniform factor in these paintings – the animals. They share equal place with the people, whether it be prince with stag, or groom with horse; in the perspectives, hounds and horses have as important a role as ploughmen or harvesters. So it is clear from the evidence of history, seen through art, that for our forebears in the seventeenth century, sport and agriculture, prosperity and enjoyment, were inextricably entwined.

One characteristic, however, was still missing – the idea of an animal as something fine, noble, tragic, heroic, graceful or vigorous: in short, a fit source of inspiration for art. These Renaissance ideas were transmitted across the Alps to a more energetic and darker clime than Italy, where they were supremely rendered by Peter Paul Rubens (1577–1640) and transmitted to England by him and particularly by his pupil, Sir Anthony van Dyck (1599–1641). Both these artists from the Low Countries were attracted to the glamorous and prestigious court of Charles I (reigned 1625–49), one of the greatest of our royal collectors and a sensitive and appreciative patron of contemporary art. Whilst the influence of these two great artists was profound and

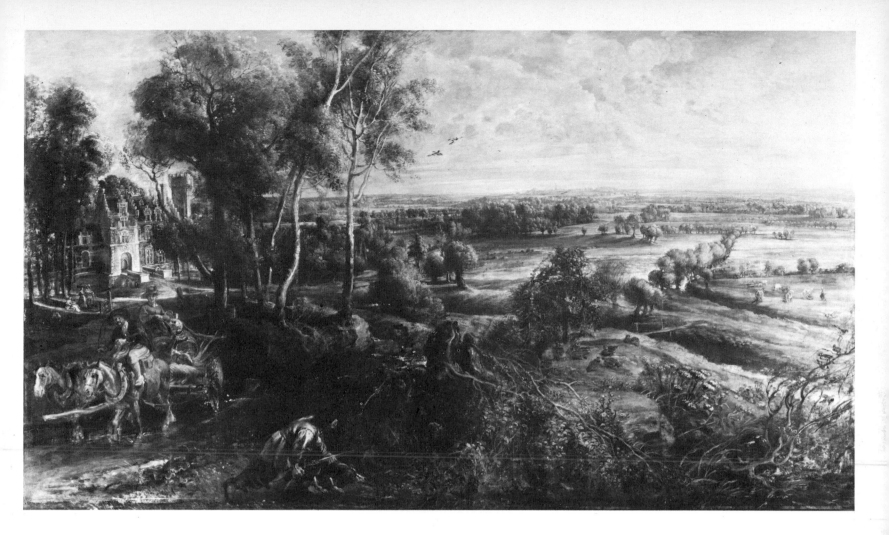

SIR PETER PAUL RUBENS (1577–1640):
Landscape with the Château of Steen. 1636.
Panel, 131·2 × 229·2 cm. London, National
Gallery

In 1635 Rubens bought the château (be-
tween Brussels and Malines) where he lived
with his young second wife. After a life-
time's intense activity as artist and diplo-
mat, his delight in the countryside is su-
premely summarized in this gorgeous paint-
ing in which it is tempting to see Rubens
himself in the role of sportsman – stalking
a covey of partridge with a well-trained
setter and an expensive modern snaphaunce
gun. This picture had a profound influence
on John Constable (it belonged to his
patron, Sir George Beaumont), who said of
Rubens in a lecture, 'In no other branch of
art is [he] greater than in landscape.'

did much to raise the level of English painting from its island pro-
vincialism to a worthy place in the mainstream of European art,
neither really has a considerable place in the story of what was to be-
come for a time a unique and native form of English art.

In the wake, effectively if not always exactly temporally, of these
two commanding Flemish painters, there came to England from
Belgium and the Netherlands a series of other artists, who laid the
foundations from which was to spring eventually the Englishman's art.

Three Flemish artists. Three are particularly important. Abra-
ham van Diepenbeeck (1596–1675) was a pupil of Rubens, though
little else is known about him. His patron was the Duke of Newcastle,
whom Charles I had appointed Tutor in Horsemanship to his sons,
including the future Charles II. The Duke was also notable for his use
of Arab or Barb stallions with English mares to improve the strain,
and for his introduction into England of the art (or science) of horse-
manship – of the manège. In essence this involved the training and
harmonizing of horse with rider by way of a series of precise move-
ments or studied exercises; the idea survives today as dressage. Diepen-
beeck painted views of Welbeck, where the Duke kept his stud in
stables designed on principles advanced even by today's standards,
and of Bolsover, where the Duke had his riding school. He also en-
graved in Antwerp the illustrations for an important and influential

15

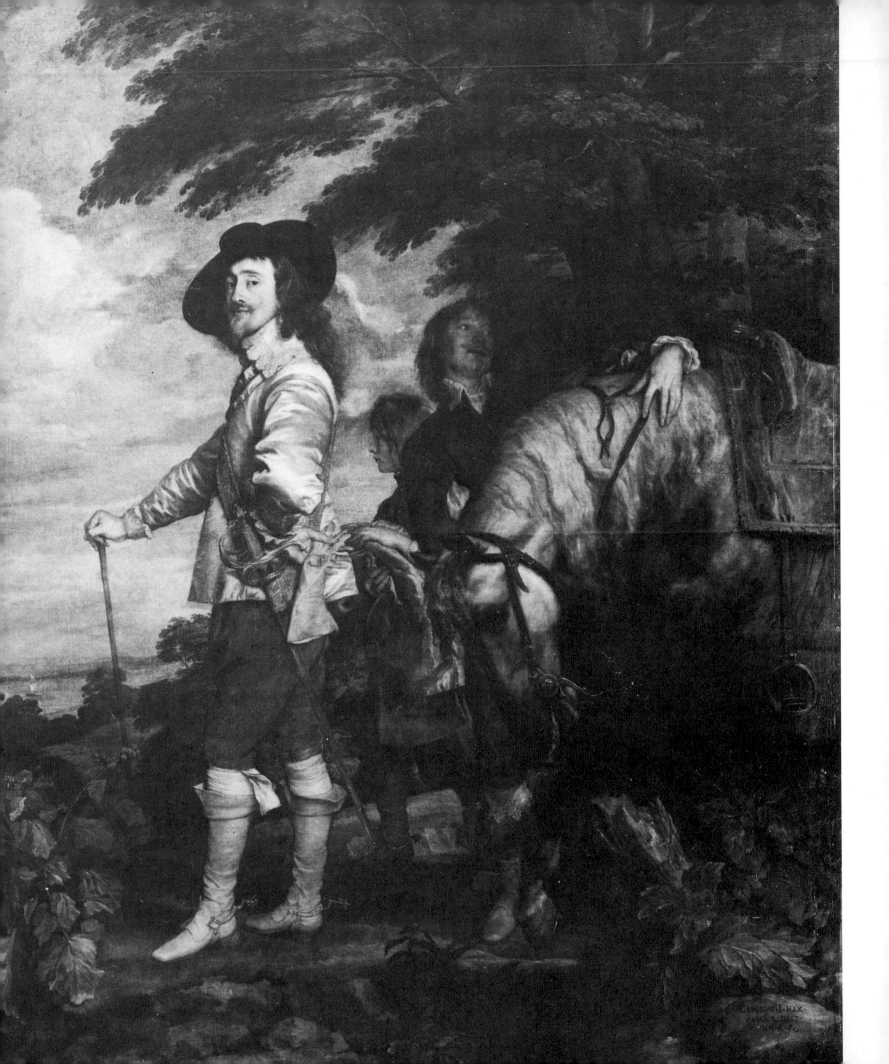

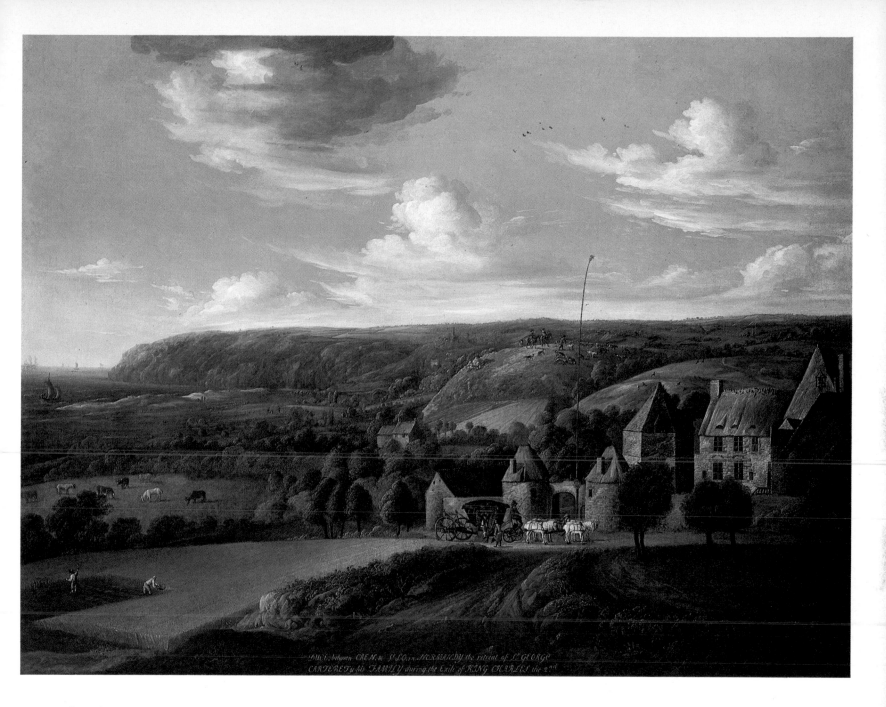

SIR ANTHONY VAN DYCK (1599–1641):
Charles I. Canvas, 272·1 × 212·1 cm. Paris,
Louvre

As much courtier (symbolized by his
knighthood) as he was painter, Van Dyck
brought, with his master, Rubens, a new
sophistication and naturalism to English
painting that it had previously lacked.
Charles I, intellectual and remote from his
people though he may have been, assembled
one of the greatest art collections anywhere,
and at the same time, like his father and
elder brother Henry, pursued an active in-
terest in sport. Here in this lyrically beauti-
ful masterpiece he is painted in hunting
costume: who could doubt that this is a
monarch?

JOHN GRIFFIER (1645–1718): *Duce between
Caen and St Lo in Normandy, the Retreat of Sir
George Carteret & his Family during the Exile
of King Charles the 2nd*. Canvas, 96·5 × 124·5
cm. Photograph by courtesy of Roy Miles
Fine Paintings

Sir George Carteret was the Royalist
governor of Jersey during the Civil War
and his French haven shows much that is
interesting. Relatively little land is being
cultivated: in one field corn is being cut and
in another cattle graze whilst a hunting
party waits on the hill behind the house.
Maybe it is the king himself who descends
from the huge coach, spectacular yet un-
comfortable, with the body suspended from
leather straps that give little protection from

the rutted road, over which it would sway
and jerk; but in the middle of the seven-
teenth century such vehicles indicated high
position and wealth. The bush is an ancient
symbol of hospitality, which, when sur-
mounting the incredibly tall spliced pole,
as here, becomes a gesture of defiance – to-
wards the Cromwellians across the Chan-
nel, no doubt. The importance of pigeons
as a constant source of fresh meat can be
gauged from the vast octagonal dovecote,
which is almost as big and certainly as high
as the house. Born in Amsterdam, Griffier
settled in England shortly after the restora-
tion of the monarchy.

book (1658) written by the Duke when in exile during the Commonwealth, and in which he described the ideas of the manège.

In 1704 there arrived, also from Antwerp, Pieter Tillemans (1684–1734). Unlike Diepenbeeck he settled in England, where he steadily built for himself a reputation as a landscape and topographical artist. He painted views of the houses of the nobility and gentry, enlivening these scenes with some kind of sporting interest, generally horses and hounds.

Finally there was Jan Wyck (1652–1700), who came to England towards the end of the century. He was in the line of artists like Philip Wouwerman (1619–68), who painted siege and battle scenes during the troubled times of the unification of the Netherlands. Wyck painted similar scenes for his patrons in England following the Glorious Revolution and the sharing of the English crown between William of Orange, and James II's daughter, Mary. But, more importantly from our point of view, he painted hunting scenes and had as a pupil John Wootton, who is generally counted among the first and most influential of our native sporting artists.

Francis Barlow. But there was one who came before him: Francis Barlow (about 1626–1704), who is mainly known by his drawings and etchings, all of which show him to have had a profound knowledge of animals, to the extent that he would now most probably be termed a natural-history artist. But as has already been suggested, such divisions are in the main and were in the past arbitrary; and in Barlow's work can be found all the basic elements of the Englishman's art: landscape, agriculture, sport and natural history. Throughout his work there is also a sturdy independence of design that is endearing and may itself

ABRAHAM VAN DIEPENBEECK (1596–1675): *Balottades par le Droite*. Line engraving by P. Clouvet, 1658. Private Collection

The most famous exponent in seventeenth-century England of the art of horsemanship was the Duke of Newcastle, seen here in front of his Riding House at Bolsover Castle. The Great Horse he rides and Great Saddle in which he sits all relate to the careful and delicate methods of direction and control that he taught; the basic ideas are much the same as the modern form of dressage. The Duke was Charles II's tutor when Prince of Wales and, as a Royalist, went into exile in Antwerp, where he wrote a book on his favoured art, from which this engraving is taken.

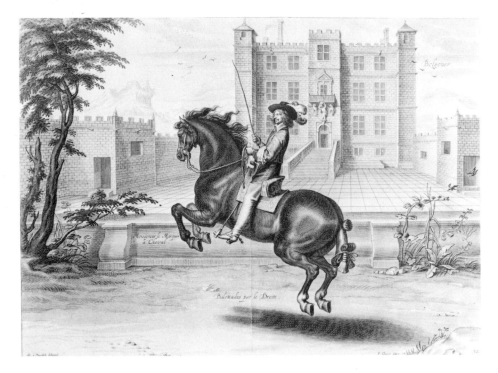

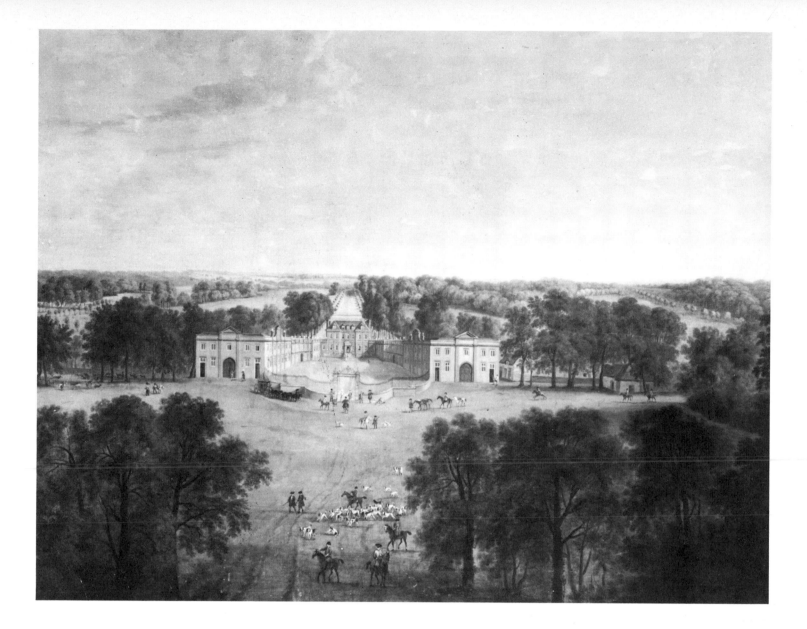

(*opposite*)

JAN WYCK (1652–1700): *Rabbit-Catching.*
Pen and ink with brown and grey washes,
29·8 × 22·3 cm. London, British Museum

Rabbits were a prime and important
source of fresh meat and here is a kind of
domestic warren near a large house, with a
dovecote in the middle distance. The rab-
bits were driven out of their burrows by a
ferret into the nets, where they would be
caught by hand; those that escaped would
be pursued by dogs in the time-honoured
way. Good artist though he was, Wyck can-
not really compare as a naturalist with
Francis Barlow.

PIETER TILLEMANS (1684–1734): *View of
Great Livermere Park, near Bury St Edmunds,
Suffolk.* Canvas, 104 × 128·3 cm. Photo-
graph by courtesy of Oscar and Peter John-
son Ltd

In the years following the Civil War
many estates changed hands and many new
ones were created. This splendid house and
freshly landscaped park is represented by
means of that excellent combination – used
in the late seventeenth and early eighteenth
centuries – of three perspectives taken from
three different eye levels which in expert
hands can work to great effect, as here. The
hunting party in the foreground is doubt-
less setting out in pursuit of deer: a group
is quietly grazing to the left of the house and
the quarry may even be a domesticated
animal that was not hunted to the kill.

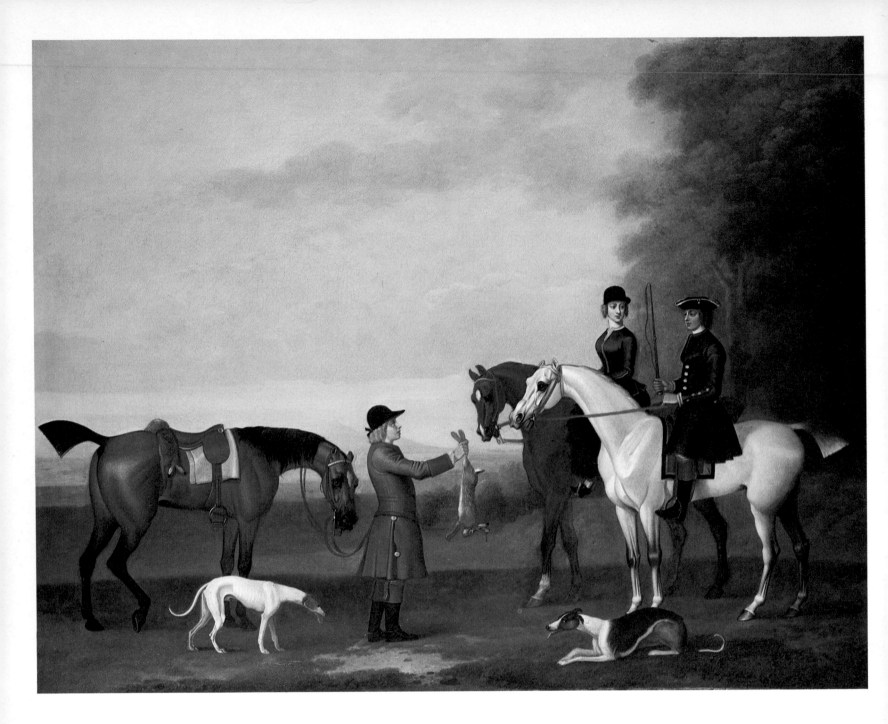

JAMES SEYMOUR (1702–52): *A Coursing Scene.* 97·7 × 124·5 cm. Photograph by courtesy of Richard Green Galleries

This is not a painting for feminists or social levellers, for there is no doubt who is the master, as much from the nature of his expression as the gaze of his lady and stance of his huntsman. The grey he rides has, in the fashion of the time, been given added elegance with ears and tail docked. His companion is probably riding side-saddle, and uses a double bridle to control her horse rather than the simpler snaffle-bit that he uses. Even the hounds enter into the spirit of the thing by appearing suitably exhausted. A splendid picture for all that.

(opposite)
FRANCIS BARLOW (about 1626–1704): *Taking Birds with a Low-Bell and Batt Fowling.* Etching, 33·6 × 20 cm, from Richard Blome's *Gentleman's Recreation,* 1686. London, British Museum

There were many ways of catching birds for the larder. Two methods of netting them at night are shown here: with the aid of a lantern if they roost on the ground, and a flare if they prefer the trees. Either way it was evidently a sport that both for success and enjoyment depended on that special sense of well-being consequent upon a well-lubricated evening meal.

have contributed to his relative neglect; on the other hand, his use of painting, as well as drawing and etching, places him firmly in the tradition of later sporting artists.

John Wootton. None the less the influence of John Wootton (about 1682–1764) was the greater, undoubtedly because he painted at a time when the thoroughbred was being developed and the horses he portrayed were therefore of especial interest. In his earliest paintings Wootton is virtually indistinguishable from Wyck: not so unexpected in any pupil/master relationship but a source of continual irritation and challenge to us today, particularly as both had and used the same initials. In Wootton, as his confidence developed, we find a new kind of equality of proportion between landscape setting and the figures inhabiting it; we now have the situation in which a balance has been obtained between artist, patron, subject and professional skill.

James Seymour. In that perverse English way there is another strand to the formation of our native art that continued down to its end – that of the gentleman amateur. The first was James Seymour (1702–52). The son of a banker, he represents that seemingly never-ending band of free-spending, constantly gambling, men whose attraction to the turf seems as inevitable as their eventual ruin. Seymour was luckier than most in that he had a natural facility with brush and paint, which, when combined with a wide experience of sport and no doubt skilful use of his social connections, has left us with an outstanding series of pictures distinguished by their meticulous attention to

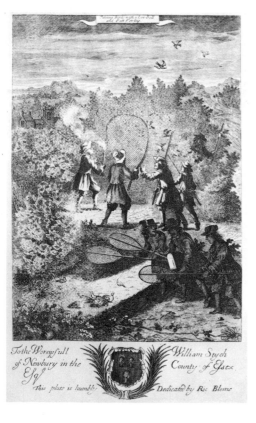

FRANCIS BARLOW (about 1626–1704): *Deer in a Park*. Signed and dated 1684. Pen and brown ink, grey wash, 15·9 × 12·1 cm. Photograph by courtesy of Christie's

This charming little drawing has more than usual interest, for it came from the collection of the diarist, John Evelyn, who knew and admired the artist. By this time deer were being preserved in special parks as much for decoration as for their meat; in this way they were also constrained from wreaking havoc on the many new and improved farms. The split-timber fence would have been expensive even then, but efficient and convenient in a wooded country. The unusual six-barred gate is often found in drawings by Barlow.

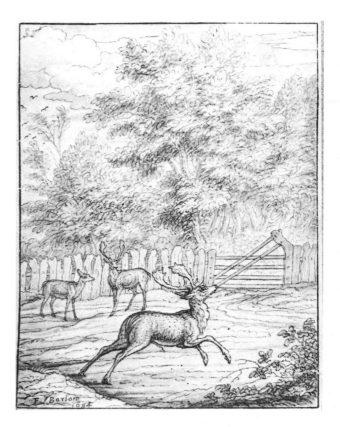

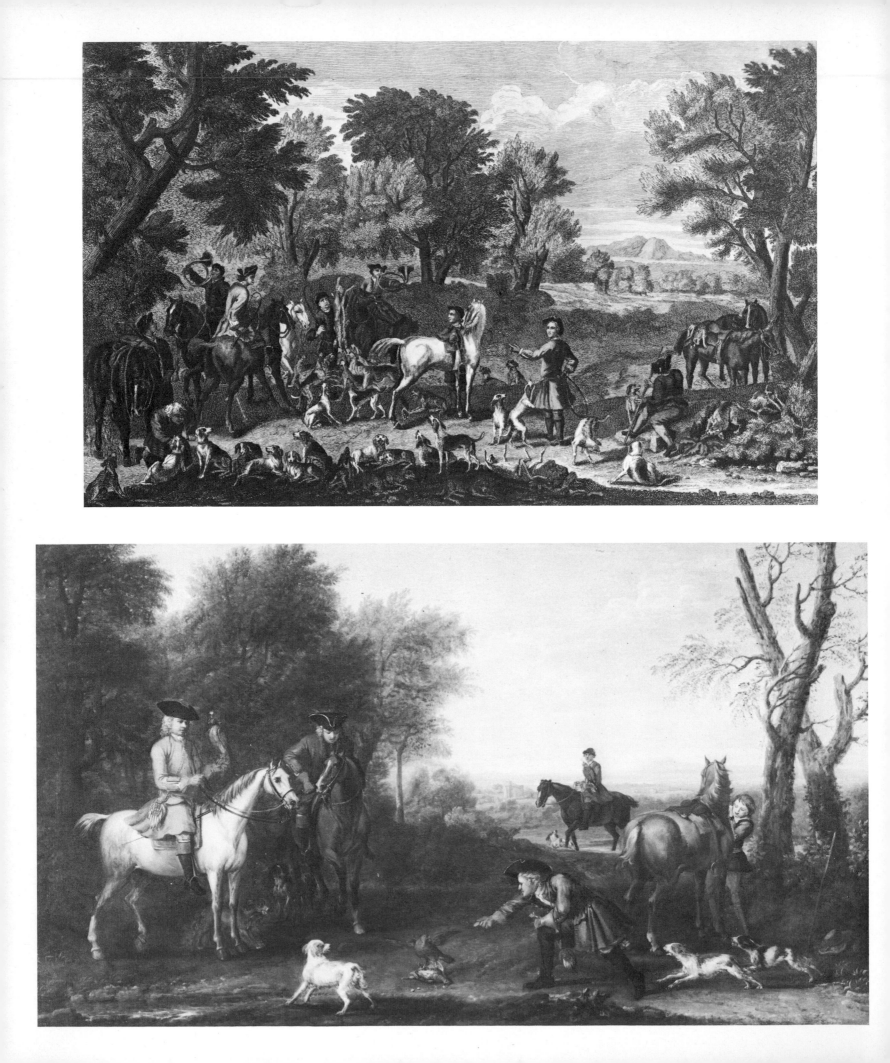

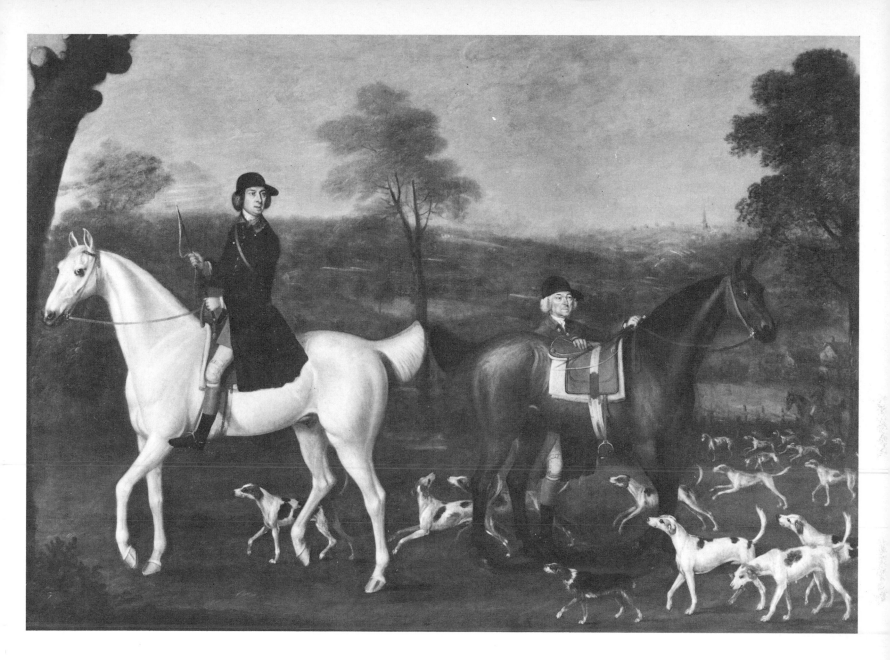

JOHN WOOTTON (about 1682-1764): *The Death of the Hare.* Engraving. Photograph by courtesy of the Parker Gallery

With a title in both French and English the print is equally ambiguous in its subject. The landscape background is as contrived as any by an artist trained in the then much admired late Renaissance Italianate style. The formality of the hunt suggests that it might be French but it could be English, as we were still sometimes imitating the sporting manners of the Continent, until our casual island ways, better horses and superior hounds became dominant. Either way the print would sell in both countries and that was no doubt the point.

JOHN WOOTTON (about 1682-1764): *Hawking.* Signed, about 1740. Canvas, 74 × 122 cm. Collection of Lady Thompson

After successfully flying a hawk against the chosen prey, there still remained the problem of retrieving it and at the same time preventing it from devouring the kill primarily intended for the pot. The training of a hawk was a not inconsiderable art and was the subject of much personal pride and almost limitless patience, for no animal would respond in such circumstances to hurt or fear. In this picture a hawk is proudly and fiercely protecting the dead partridge from a retriever which waits at a respectful distance, whilst the owner quietly stoops to lure the bird back to his wrist.

JOHN WOOTTON (about 1682-1764): *Benjamin Hoare and Groom.* 1732. Canvas, 123 × 166 cm. Messrs Hoare's Bank

Then as now, commercial or financial success was soon followed by the purchase of a country estate. Here a notable banker is leading hounds out for a day's hunting. The saddle on the groom's horse is painted with such detail as to suggest that the picture was in some way deliberately designed to advertise it. It looks uncomfortable by modern or even late eighteenth-century standards, but there was continuing experiment in the design of saddles and many paintings illustrate their variety of design and purpose.

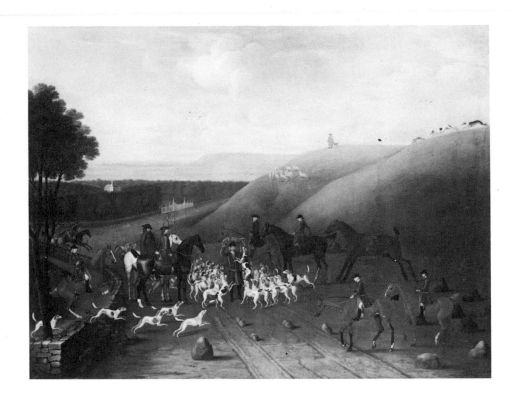

JAMES SEYMOUR (1702–52): *A Kill at Ashdown Park*. 1743. 180·3 × 238·8 cm. London, Tate Gallery

This is the kind of meticulously detailed painting in which sportsmen have always delighted, though in this instance there is more than just an especially fine hunting scene. The picture is full of symbols: a shepherd, his dog and sheep on the downs, greyhounds coursing a hare, elegant new park gates, an expensive stone wall – all signs of prosperity. The wall is being jumped standing by one of the horsemen, for the idea of flying across only became common after its later invention in the relatively safe circumstances of the Shires: no walls and only small fences and low hedges. What looks like a cart-track is a road; the boulders were a common hazard for the eighteenth-century traveller on hoof, wheels or foot.

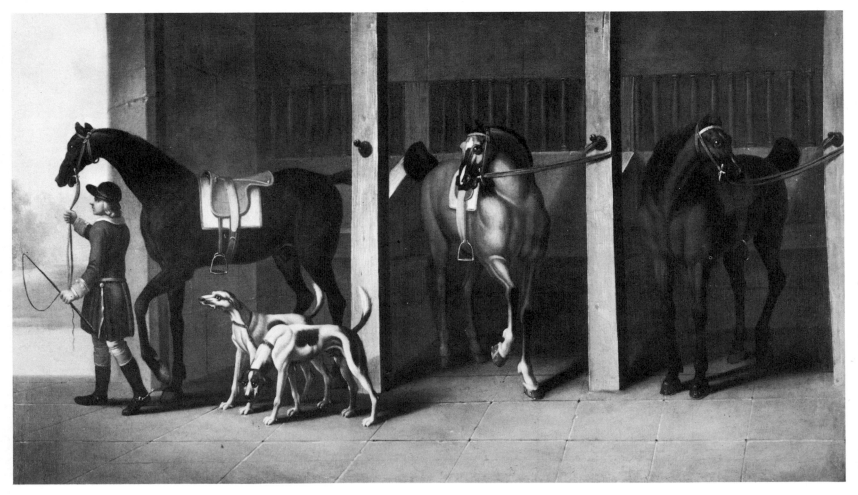

detail. Seymour is also the first of that school of so-called primitive artists that we find so appealing today but who in their time were widely patronized because they painted what their patrons wanted to see and in minute detail: they would have received no commissions if they were inaccurate, whether it be in the colour of a hound or the shape of a saddle.

The thoroughbred. It was the English who produced the thoroughbred horse. Again, the beginnings and the inspiration came from abroad, but the practical idea, application and amalgam came from Britain. We looked to France and Italy for horses and horsemanship, to the Low Countries for advanced agricultural ideas of breeding (and for their art): we mixed all these things together in the unpromising crock of a relatively unstructured and open society, added our own special ingredient, a passion for horseracing, and the result was the thoroughbred. The racing of horse against horse was as common as it was natural amongst a competitive-minded people, and of equal interest amongst those for whom the chances of winning a wager was the essential part of the pleasure of sport. Like hunting, racing was attractive to a wide range of people for whom the common interest, passion even, was of greater importance than accident of birth. The earliest racecourses – Chester, the first, then Doncaster and Lincoln, for instance – were invariably municipal creations, and at Doncaster there was already a grandstand in James I's time. At first, and inevitably, the horses raced for a prize that combined a practical origin with fair grandeur – a silver bell. (A bell distinguished the lead animal of a

JAMES SEYMOUR (1702–52): *Famous Hunters of the Duke of York*. Canvas, 81·2 × 142·2 cm. Reproduced by gracious permission of Her Majesty Queen Elizabeth, The Queen Mother

Here are three fine horses, alert and eager for a day's hunting: hare-coursing, perhaps, judging by the couple of leggy greyhounds. The impeccably clean stalls and splendid grooming are indications of a strict attention to diet and training following a summer fattening out at grass. Care is as important as kindness for any success with animals and these paved stables are obviously the last word in design. The way the reins are hitched round the stall posts is an interesting detail typical of the artist.

GEORGE STUBBS (1724–1806): *Sweet William*. Aquatint by George Townley Stubbs, 1789, 30·2 × 35·6 cm. Private Collection

The noble racehorse Sweet William was bred by Lord Grosvenor, a mogul amongst sportsmen and so devoted to the turf that when first raised to the peerage he did not know to what degree as, instead of attending the appropriate ceremony, he was watching a horse trial at Newmarket. For collectors this print has an added interest in that the details of Sweet William's racing career and breeding have been engraved by a different hand on a separate plate.

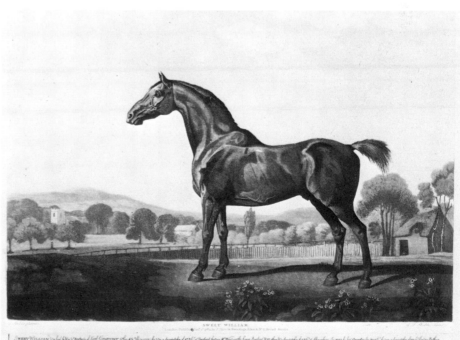

herd or flock.) But by the beginning of the seventeenth century, the bell was beginning to give way to the silver cup that remains the principal visible prize to this day. A combination of betting and the chance of prize-money already exercised a stimulating as well as possibly a baleful influence. The rules were minimal and essentially local. The other point to remember is that races were over a long course, four miles and more, and were thus more a test of stamina than of speed.

Horses then were in need of improvement. In Italy in the sixteenth century, universal prosperity and the stimulus of the *palio* races (those within the confines of a town, with a decorated banner as a prize) gave its horses an immense reputation. Henry VIII imported horses from Italy in an effort to improve the effects of the devastation wrought on

JAMES SEYMOUR (1702–52): *Flying Childers and Grooms*. Canvas, 60 × 71 cm. Private Collection

Flying Childers was bred in 1715 and raced with such success as still to be judged the first major English thoroughbred. Seymour was reckoned to be able to draw a horse better than any man and the details of this picture are worth noting. In particular the wasted appearance of the horse is a reflection of the extremely rigorous training methods current until the middle of the nineteenth century.

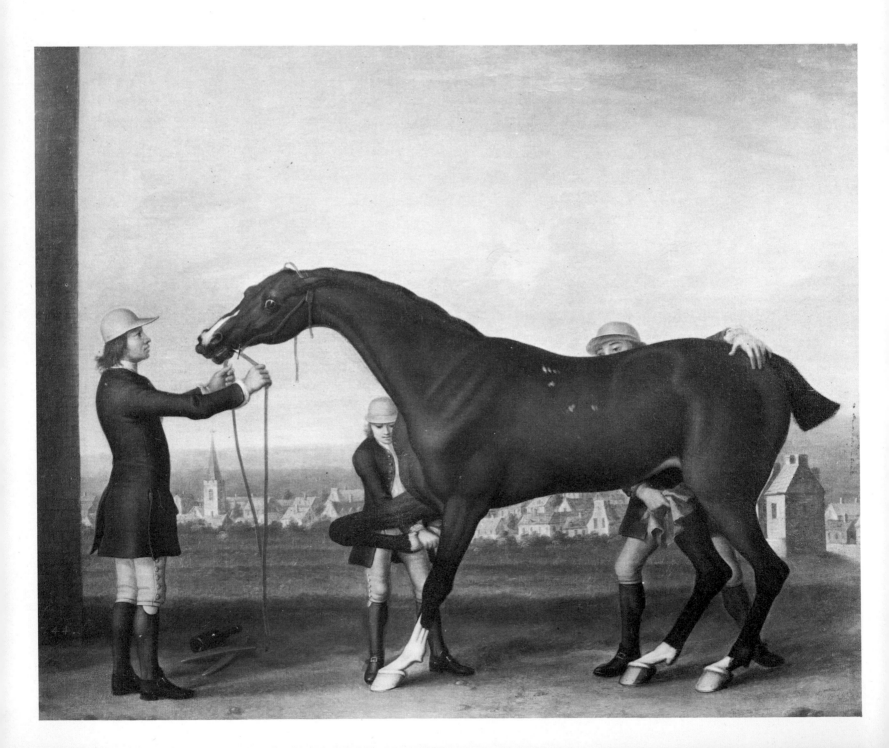

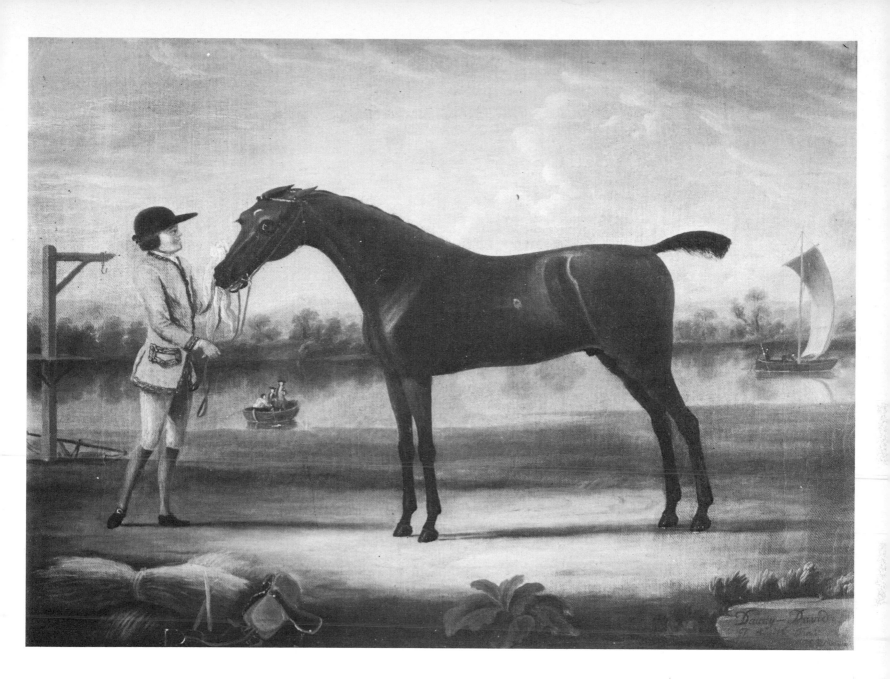

THOMAS SMITH (died 1767): *Dainty David.* Signed and dated 1758. Canvas, 44 × 58·5 cm. Private Collection

Smith of Derby was a self-taught artist principally of landscapes. Here horse and jockey are shown after a race. There is every chance that the owner was his own jockey and that sailing barges were his trade (see far right). The course would have been an informal one, locally patronized, making use in this instance of level meadows beside a river, with a loading crane doubling as the winning post. Artist, patron, horse and setting would be described now as 'primitive', but together they form a strong and long tradition of intense local pride that has never passed from English painting.

our native animals by the Wars of the Roses. This was not too difficult, as there was a large trade in wool between England and Venice.

The origins of scientific breeding, resulting in the superiority of Italian horses, came as much from Renaissance culture as from the influence of Islam – both direct and from Moorish Spain. For many centuries the Arabians of the Levant and the Berbers of North Africa had taken a careful and deliberate pride in the calibre of their horses and so, inevitably, in their genealogy. Two different lines were recognized, the Arab and the Barb, though by the time of their injection into Europe the distinction was hard if not impossible to define. We imported another science from Italy, too, that of horsemanship, which, likewise with classical antecedents, was revived and codified in Naples.

Importance of the horse. Again, it is basic and important to remember that the horse had enormous and practical importance, in war as much as in peace. It is significant, for instance, that during the

27

Commonwealth, the Council of State decreed that the horses from the royal stud at Eltham were the best in the land and should not be dispersed. Cromwell himself imported horses from Italy and the Middle East.

In the evolution of the thoroughbred horse much is owed to the personal interest of Charles II (reigned 1660–85): he excelled in everything, whether as collector, lover or sportsman. The impetus of an exiled court (with the attendant experience of Continental practices of horsemanship and horsebreeding) when returned to a nation thirsting again – after the Commonwealth – for colour, excitement and laughter, found release and focus in the personality of the King. He rode in races quite as often as he was a spectator; his position and interest in racing extended so far that he was sought as an impartial and authoritative judge in disputes. He established rules at Newmarket (founded originally by his grandfather, James I) which were based on those enforced by his old tutor in horsemanship, the Duke of Newcastle, on his private racecourse at Worksop. These had themselves been based on the first comprehensive rules invented in 1619 at Kiplingcotes, a municipal racecourse. These new royal rules embraced such things as disqualifications, the weighing before and after a race of the riders, and fouls. Thus at Newmarket the twin strands of British

THOMAS BUTLER (*fl.* 1750): *The Great Carriage Race, 1750.* Signed. 146 × 241·5 cm. Photograph by courtesy of Sotheby's

Thomas Butler was a bookseller of Pall Mall, London, who turned his hand to sporting painting. The extraordinary scene he depicts here took place on Newmarket Heath in 1750 and was just one, albeit extreme, example of the gambling mania of the day. The wager was for a thousand guineas. The conditions were complicated, involving the construction within two months of a carriage with four wheels carrying one person drawn by four horses to race nineteen miles in one hour. It was successfully run in fifty-three minutes twenty-seven seconds. The harness was made of silk and the rider of the near leader, 'who had the conducting of the rate to go at', wore a timepiece on his wrist. From such madnesses came better horses and improved carriages for everyone else.

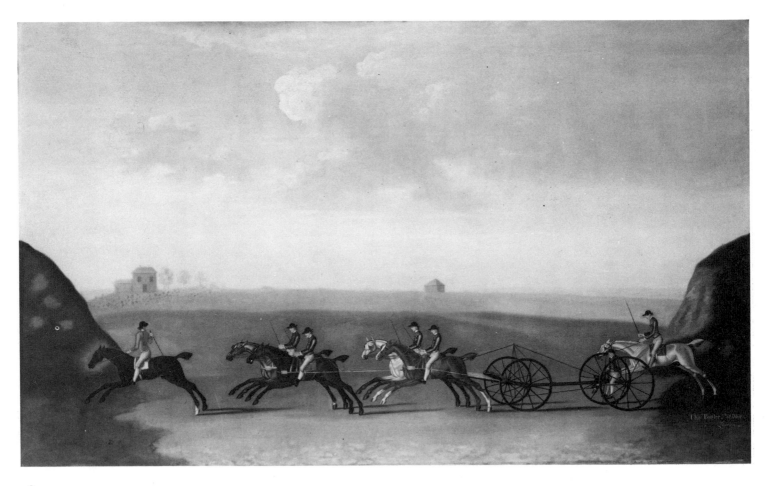

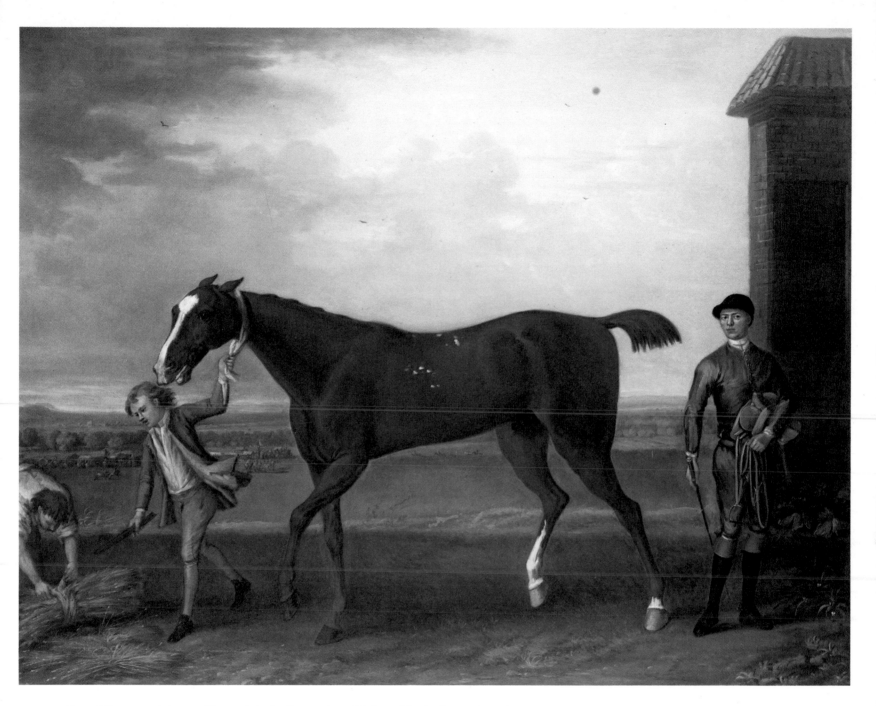

JOHN WOOTTON (about 1682–1764): *Smiling Ball*. Signed and dated 1727. Canvas, 100·3 × 124·5 cm. Photograph by courtesy of Spink and Son

In this painting Wootton reaches considerable heights in the mastery of a difficult problem of composition and portraiture. The horse, Smiling Ball, dominates the picture as intended: it is immediately after a race, the saddle and bridle have been removed (the speckles on his side are saddle sores) and he is about to be rubbed down with a wooden batten and then whisped dry with hay. The jockey is the other dominant figure, and at this period he could well be the owner himself, as his bearing surely indicates.

racing, the municipal and the aristocratic, became united through the agency of the monarchy. It is significant that the name given to the first royal plate (i.e. silver cup) was not King Charles's Plate, but the Newmarket Town Plate.

Early horseracing. As the paintings and prints witness, many races of the past were in the form of matches between two horses. The races too were longer: four miles was common, and six or seven not unusual. The races were also run in a markedly different way from today: the horses would start slowly, gradually picking up speed, until in the closing stages their riders would urge them into their fastest gallop. It was at this stage that those riders who were watching, but not competing, would join in and ride alongside the contestants urging them to the winning post. Naturally, this could be as much a hindrance as a source of encouragement, and the whole practice provided many opportunities for fouling or other kinds of chicanery if large sums of money, or prestige, were at stake. The idea of the long race was quite deliberate, for breeding was designed towards the making of useful horses rather than the more or less pure racing machines that we have become so familiar with since the nineteenth century. A big strong horse was therefore the ideal.

There was tremendous competition between owners, so much so that there was a system of heats, or eliminating races, on the same day. Hence the importance of the rubbing house, where horses would be rubbed or whisped dry with hay, and prepared for the next stage. The system of heats made rules a virtual necessity if any order or fairness, however remote the equilibrium, was to be introduced. The prizes that eventually developed as the most sought after were the plates, which were silver cups.

The many matches were the direct result not only of the strong spirit of competition but of an equally strong compulsion to gamble. This led to absurd abuses, particularly amongst the young, fashionable, and would-be fashionable, members of society, women as well as men; often the excitement of gambling was matched by the prestige attached to the wagering of ever larger sums. Not even anti-gambling legislation in the reigns of Charles II and Queen Anne succeeded in preventing the foolish from ruining themselves; from one at least we have salvaged something, for James Seymour was thereby forced to earn his living as a painter.

The compulsion in particular for match-racing, for the glory attached to the wagering of huge sums, found expression too in the various matches against time; there were other factors that might add to the excitement, involving variables like distance, weight carried, or even rules made many months before. Few seemed immune from this gambling mania. All that can be said is that for the successful owner there was much money to be made. Others would be prepared to pay dear for the progeny of a proved horse – mare or stallion – and the money thus earned would be placed towards the enormously high cost of importing fine horses from abroad.

AFTER DAVID MORIER (1705?-70): *The Godolphin Arabian*. Canvas, 63 × 76 cm. Private Collection

The importance of the Godolphin Arabian to English bloodstock is aptly summarized by part of the inscription on this picture: 'Esteem'd one of the best Foreign Horses ever brought into England. Appearing so both from the Country he came from & from the Performance of his Posterity. They being Excellent both as Racers and Stallions & Hitting with most other Pedigrees, and mending ye Imperfections of their shape.' Such stallions were worth more than gold to their owners and such pictures (all locally produced copies) served as advertisements as much for their progeny as for the horses themselves. This Arabian's favourite companion was Grimalkin, the cat, who can just be seen at the foot of the stable door.

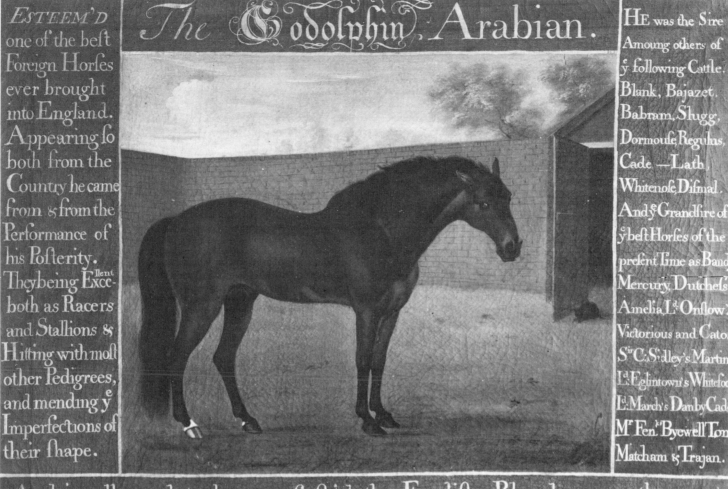

Arab ancestors. All modern thoroughbreds can trace their origin to three imported horses: the Byerley Turk, the Darley Arabian and the Godolphin Arabian. Arab horses were known, from experience, to breed true; in other words, a fine Arab stallion with particular characteristics could be relied upon to produce equivalent foals. The science or art of horsebreeding depends largely on the selection of the mares; most of these are likely to have been half-breds, as there is little evidence of Arab mares being imported on any significant scale.

The history of the trinity of the thoroughbred ancestors is interesting, and typical. First, and in parenthesis, it must be remembered that there has always been confusion about the exact definition and distinction between Barb, Turk and Arabian. The Byerley Turk was captured at the Battle of Buda in 1688 by Captain Byerley; the name

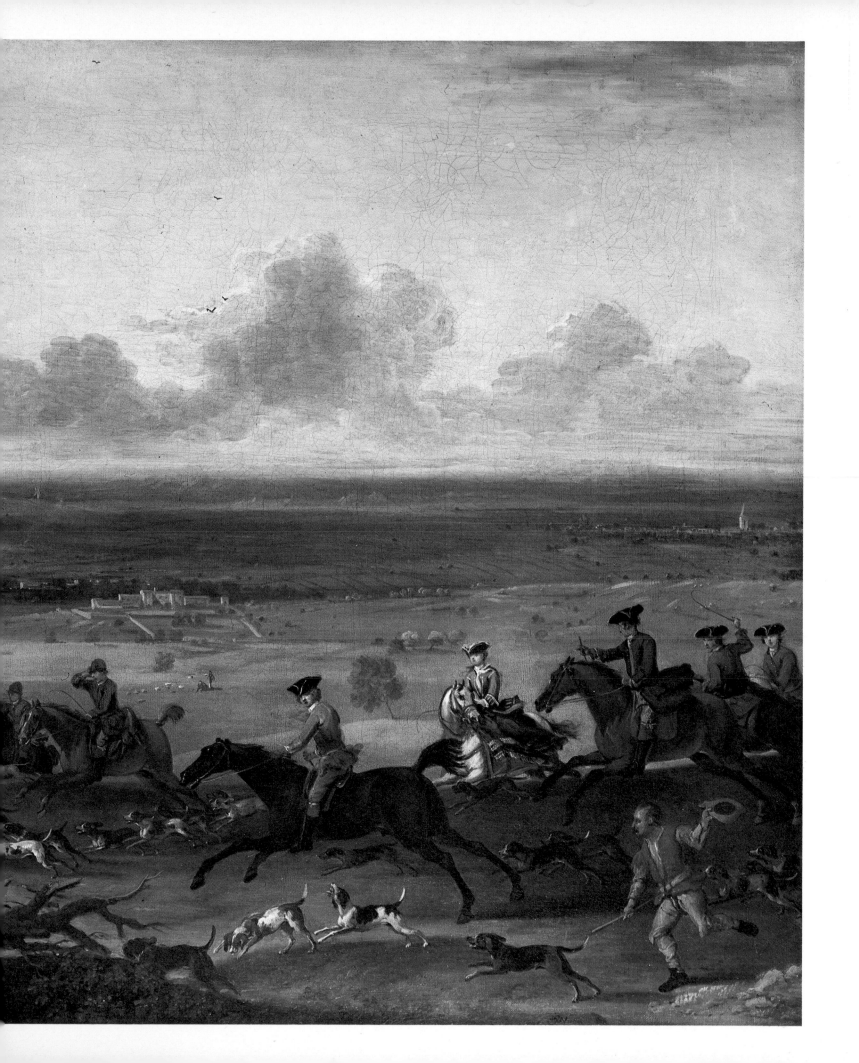

'Turk' in this instance derived from its having originally been a Turkish officer's mount, though as likely as not it was a desert-bred Arabian. The Darley Arabian was foaled in 1700 and bought in 1704 at Aleppo in Syria by Thomas Darley, an English merchant in business there, who sent the horse to his brother in Yorkshire. From this horse descended Flying Childers, 1715, the first great thoroughbred racehorse (p. 26), virtually pure-bred Eastern; and, subsequently, Eclipse, immortalized by Stubbs. The third horse, the Godolphin Arabian (p. 31), was foaled in the Yemen in 1724; he was acquired by the Bey of Tunis, who made a present of him to the King of France. Eventually this obviously exceptional horse was bought by the Earl of Godolphin for his stud near Newmarket. From these three brief histories alone, enough will have been said to show to what lengths and to what expense the English racehorse owner and breeder was prepared to go to improve the blood of the line.

The tremendous scale of the imports in the early eighteenth century – more than 150 stallions – had an effect far beyond that of the running horses. Hunters and hacks (for everyday riding) were also improved by Eastern blood. But it was not until later in the century that better general road conditions allowed the opportunity of improving carriage-horses; until then the state of the roads and primitive design of the carriages demanded the use of the heavyweight harness-horse of Dutch or Flemish origin. Over the whole field, however, the latter part of the eighteenth century saw the result of the revolution in breeding ideas: better cattle, sheep, pigs, poultry, hounds, corn, roots and grasses. But as the pictures show, the horse had no peer, whether it was for practical or sporting use: its most important qualities were courage and stamina, and its most constant ingredient was blood. Hence, and simply, bloodstock.

Early agriculture. As sport was an entirely natural adjunct to agriculture it will repay us here to look, in a little more detail, at some of its practices. In the early part of the 1600s old and thoughtless barbarities were slowly being eradicated: Acts of Parliament decreed that the annual pulling of wool from living sheep was illegal, and also the practice of drawing ploughs directly by horses' tails. New markets were found abroad for corn and meat; dairying became widespread; and the value of manuring and of draining land (in the Fens especially) was more and more discussed and rather more slowly adopted.

Just as art had benefitted from the immigration of Flemish and Dutch painters, so agriculture was profoundly changed by ideas brought to England from the Low Countries, in particular by exiles returning after the restoration of the monarchy in 1660. Sir Richard Weston was a refugee in Flanders, from which country he introduced a new rotation of crops – specifically involving clover and turnips – which, although not generally adopted for a century, paved the way for the over-wintering of stock. It is salutary to be reminded again that most of the pigs, sheep and cattle would have had to be slaughtered with the approach of winter, as there would have been insufficient

(preceding page)
JOHN WOOTTON (about 1682–1764): *Lady Henrietta Harley Hunting with Harriers*. Signed, about 1740. Collection of Lady Thompson

Lady Henrietta was the daughter of the famous horseman, the Duke of Newcastle. She was a considerable sportswoman on her own account and is seen here (to the right) wearing a blue and silver habit on a grey horse. The hare is a wily prey but obviously the harriers (specially bred hare-hounds) have the line and everything else is forgotten in the moment of pursuit. Only this could have drawn everyone's attention away from the wide and expansive view; it looks a good day for sport.

UNKNOWN ENGLISH ARTIST: *Averham Park from the East*. About 1720. 101·6 × 193 cm. Photograph by courtesy of Henry Spencer and Sons

The painting is possibly unique in English art: it shows in the foreground one of the huge open fields that dominated our system of agriculture from medieval times until the enclosures; the wide furrows are clearly seen, each one separating the individually owned and worked lands. The hill has been partially cleared of trees, a new house built and some planting done; part of the area has already been enclosed as a deer park. The most common method of enclosure was through purchase or exchange of lands. The great pond on the left was a water supply and a source of fresh meat through the snaring of wildfowl.

UNKNOWN ENGLISH ARTIST: *Averham Hall from the West*. About 1720. 152·4 × 281·9 cm. Photograph by courtesy of Henry Spencer and Sons

The fine new house with separate wings has been built in a commanding position on top of a hill sheltered by trees. Here is a new kind of elegant yet ordered country life with a formal enclosure protecting peacocks, geese, pheasants and household from invasion by wild deer. In the right foreground a proud gentleman shows the deer to a couple of the large southern-mouthed hounds.

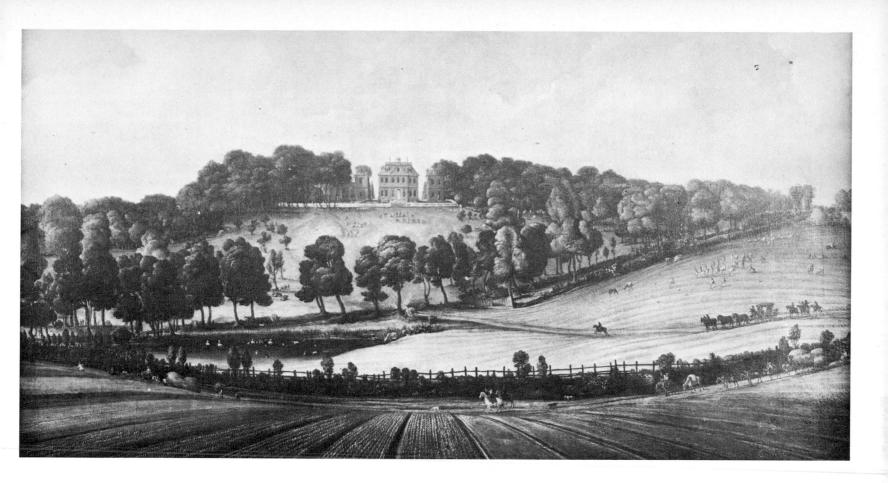

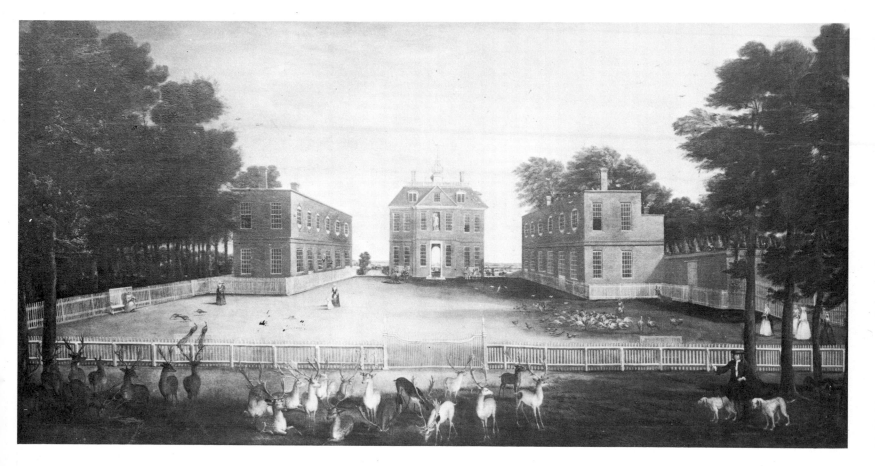

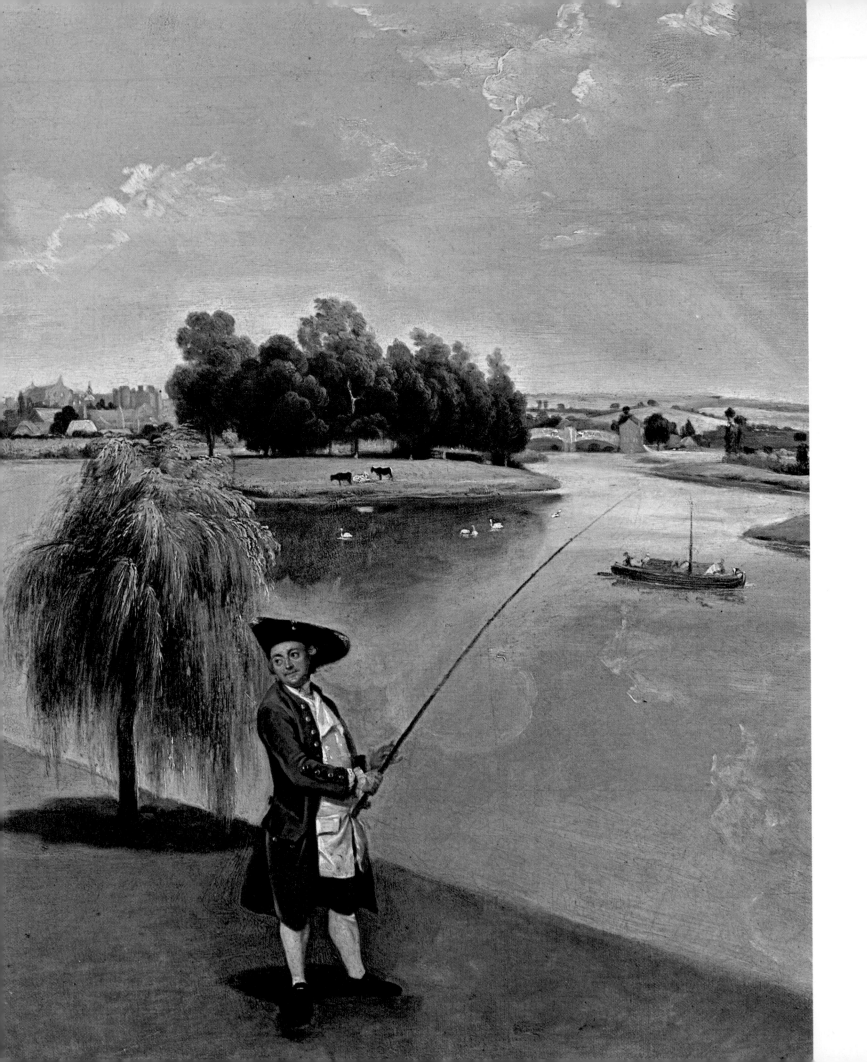

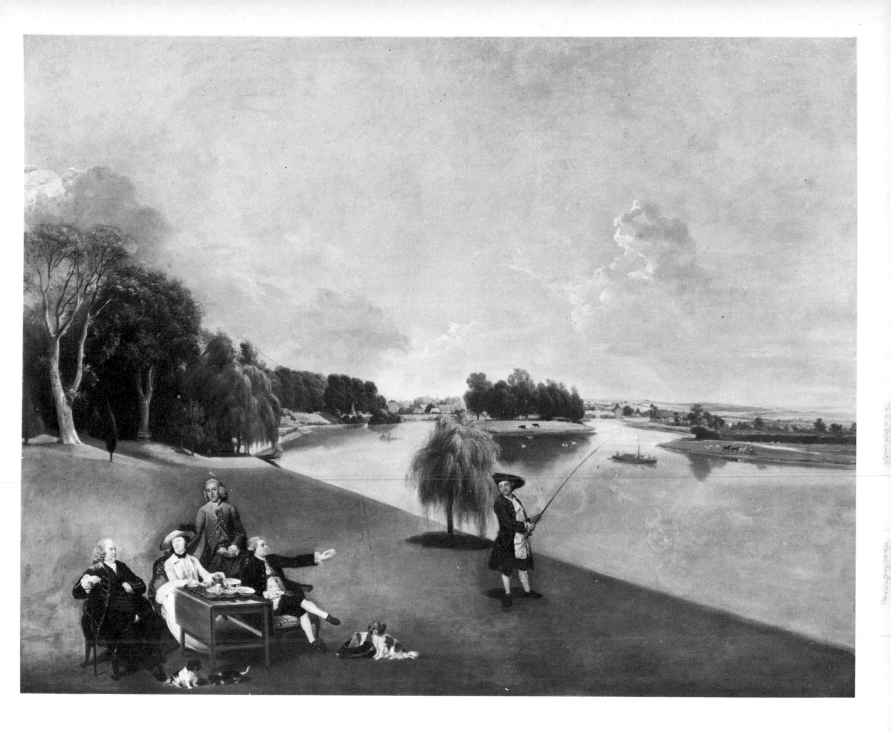

JOHANN ZOFFANY (1733–1810): *A View in Hampton Garden with Mr and Mrs David Garrick Taking Tea.* 1762. Canvas, 99·7 × 125 cm. Collection of Lord Lambton

The actor David Garrick and his wife are watching his brother George indulge in a favourite pastime of those lucky enough to live beside a river – fishing for the next meal. The Thames here is broad but, as the elegant clothes and smooth lawn suggest, this is urban living – London can be seen on the horizon.

food for them. Other ideas included improved treatment of woodlands to ensure a consistent and continuous supply of timber.

In line with the eccentric painters there were some eccentric agricultural innovators. Robert Child went so far as to suggest in 1651 that an elephant would make an ideal form of rural transport for the practical reason that with its ability to carry fifteen men on its back it would be just right to carry villagers to and from their farm strips. Child's point was at bottom a serious one, for his concern was in reality to try and persuade those of scientific persuasion away from the houri of perpetual motion, towards more thought to the improvements of cumbrous agricultural implements. It was Gabriel Plattes (of Flemish origin) who invented the seed drill, which sowed corn in regular rows

37

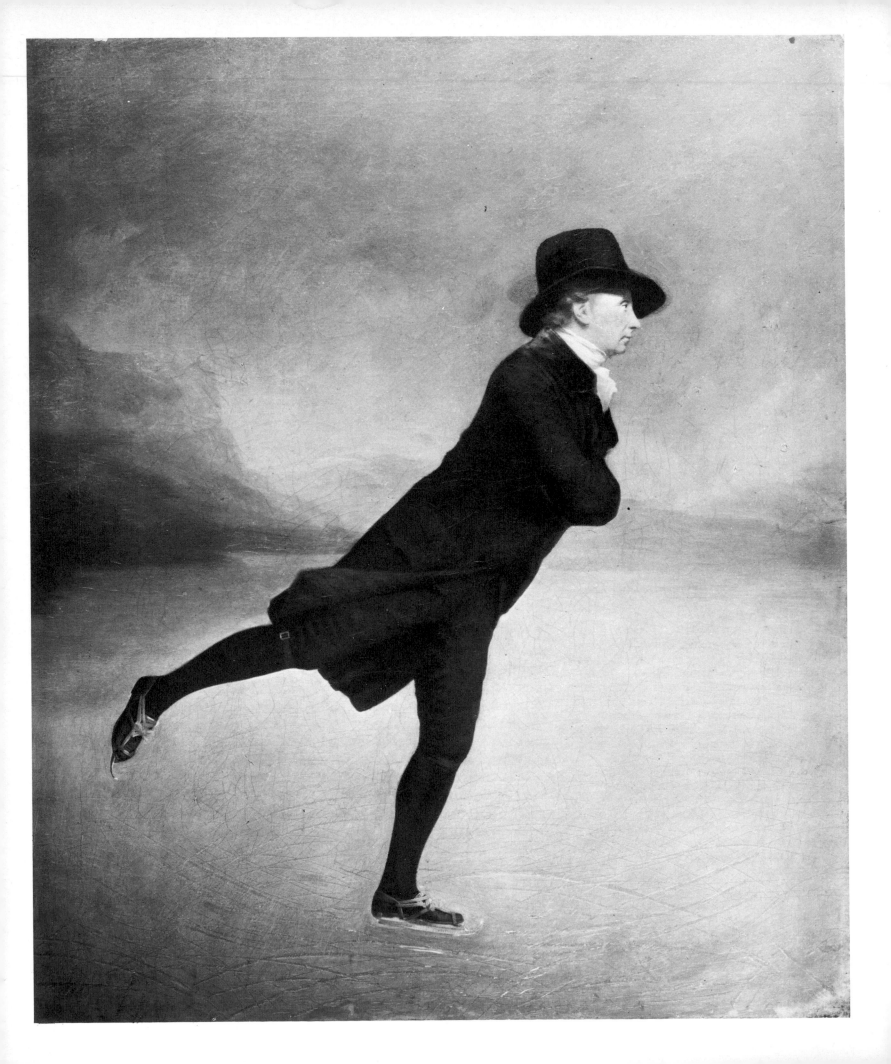

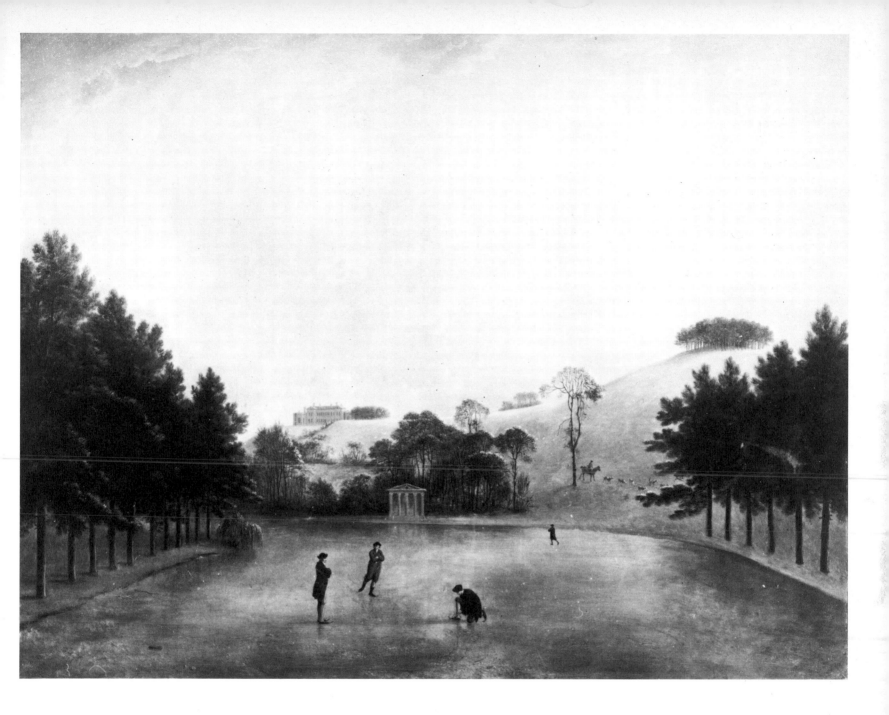

SIR HENRY RAEBURN (1756–1823): *The Reverend Robert Walker, D.D., Skating on Duddingston Loch*. 1784. Canvas, 73·6 × 61 cm. Edinburgh, National Gallery of Scotland

One of Scotland's most important portrait painters, Raeburn began as an apprentice to a silversmith and as a miniaturist. He was an almost exact contemporary of Dr Walker (1755–1808), who practised his ministry largely in Edinburgh but who learned golf, and presumably skating, in Holland. Here the mixture of movement and repose seems appropriate in a divine; Dr Walker joined the Skating Society in 1784 at a time when, like today, there was a marked increase in interest in the idea of outdoor exercise.

ANTHONY THOMAS DEVIS (1729–1816): *Upton House from the South*. 100 × 125 cm. Upton House, The National Trust (Bearsted Collection)

The neoclassical façade of the waterside pavilion lends an air of slight unreality to this scene of outdoor winter exercise – skating on the frozen lake with, in the distance, hounds going out. Nevertheless it succeeds through that kind of unstudied English compromise that should not work in theory but always seems to in practice. No doubt much the same could be said about our addiction to sport.

41

English longbow was deadly; it was cheap and very quick to load and fire. But for hunting, the crossbow was the more useful weapon: although relatively slow and laborious to load, it cast a heavier shaft further; it could also be shot from a horse's back, even a galloping horse, as well as from cover or a hide.

As for the gun, it had already developed far enough in the sixteenth century to be used in one form or another for sport. There were still problems in that the loading was a lengthy process, the matchlock firing mechanism remained unreliable (despite improvements in powder it still involved bringing a slow-burning match fixed in a serpentine that moved down on to the touch hole at the pull on the trigger) and accuracy was not always certain – at any range. But by the early seventeenth century firearms had become relatively cheap and were widely used. (Already in Henry VIII's time target shooting with a gun had become so popular that there was a specific prohibition against firing at marks on houses, churches and dovecotes.)

For the sportsman there were essentially two varieties of matchlock or, more strictly, arquebus. The musket was a heavy weapon that re-

FRANCIS BARLOW (about 1626–1704): *Partridge-Stalking.* Signed. Brush drawing in grey wash, 20 × 29·5 cm. London, British Museum

Here the sportsman is approaching his prey camouflaged by the slow-moving, old and specially trained stalking horse. Most likely the birds were to be caught by a net, common practice in the seventeenth century and later. Modern-day naturalists will notice the accuracy with which Barlow has indicated a variety of characteristic movements of partridge, and will despair in the knowledge that the museum catalogue describes the snipe (on the left) as kingfishers. The penetrating eye and distinctive crouch of the setter on the extreme right are also worth noticing.

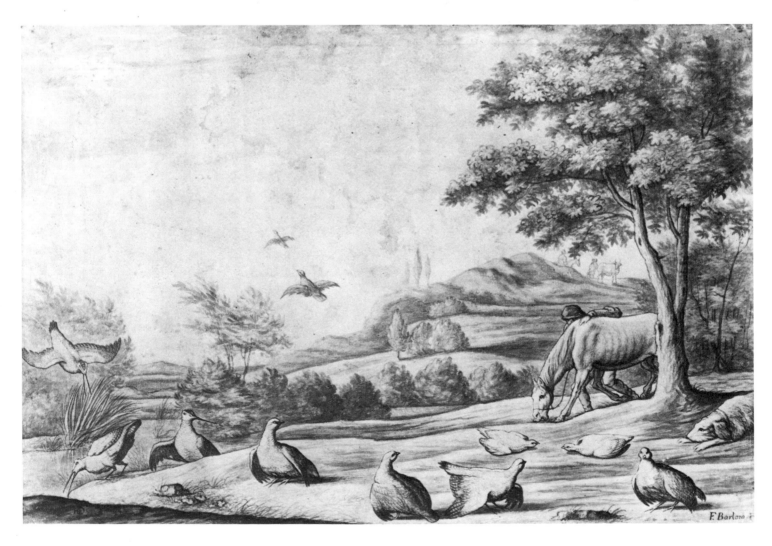

WILLIAM DOBSON (1610–46): *Endymion Porter*. About 1643–5. Canvas, 149·9 × 127 cm. London, Tate Gallery

The fine yet homely face of Endymion Porter betrays his country background as the son of a small landowner in Gloucestershire. He rose to become one of the most beloved courtiers of King Charles I and was the friend of painters like Rubens and Van Dyck and of the poets Robert Herrick and John Donne. Porter was a sensitive connoisseur and, although without the resources to build a large collection of his own, made many purchases for his royal master, who formed one of the largest and most important of the time. William Dobson was the best English painter of the seventeenth century and his portrait shows Porter in his natural guise as a country gentleman returned from hunting with retriever, hare and wheel-lock rifle (slightly old-fashioned as a weapon by now, but sportsmen are uniformly traditional and tend to be faithful to what they already know). The portrait has added interest in its allegorical references to Porter's patronage of literature and the arts.

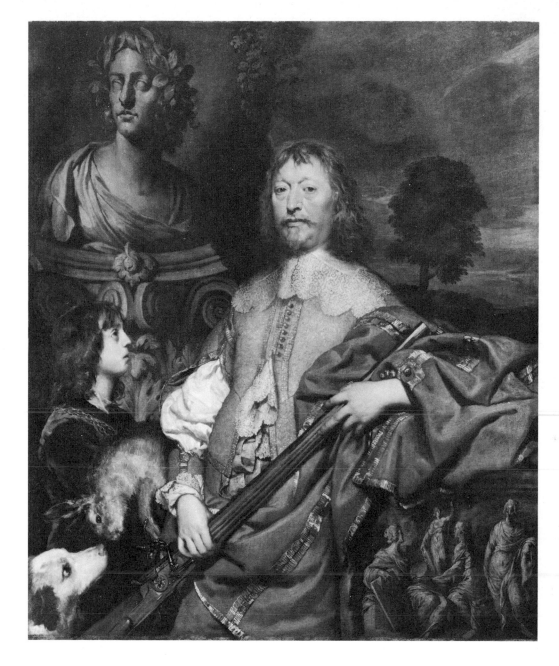

quired a forked rest but was large enough to be used against deer. The culiver was a hand weapon that could be used against bird or rabbit. Both had one thing in common: they were so slow of action that the target had to be motionless. Thus in close or wooded country the sportsman could approach his prey upwind with the utmost discretion and skill. In open conditions there was the stalking horse: a gentle-mannered animal trained to walk at little more than grazing pace, with the sportsman concealed behind until within range, when he would fire from beneath the horse's neck (p. 42). As for the invaluable dog – setters, retrievers and pointers had already been developed and trained.

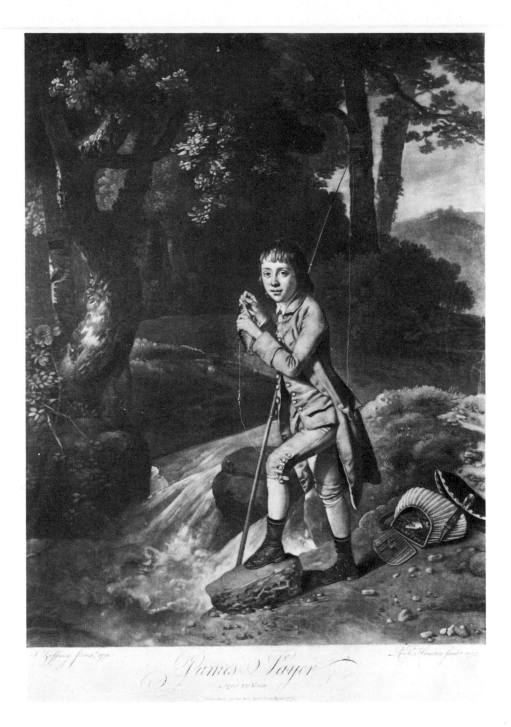

JOHANN ZOFFANY (1733–1810): *James Sayer*.
Mezzotint by Richard Houston, 1722.
49·8 × 35·5 cm. Private Collection
 The subject of this charming portrait
was the thirteen-year-old son of the print
publisher, Robert Sayer. His rod has no
reel, is made of several sections and has the
line attached simply to the tip – no room
here for back casting. Angling was growing
steadily in popularity and the banks of
favoured rivers were already being cut back
and cleared; the sport was particularly
attractive to townsmen as it was unre-
stricted by the game laws. Young James's
splendid woven willow creel by his right
foot would be widely envied today.

Hawking and fishing. Although the increasing reliability and
sophistication of the gun ultimately led to its taking preference over
other methods of killing game, for centuries the hawk was carried on
the wrist of every country gentleman whilst about his business. For the
sportsman, falconry was the highest art and a consciously guarded
mystery combining elements of chivalry and practical natural his-
tory – in the training, maintaining and, ultimately, aiming of one wild
animal in the controlled pursuit of another.

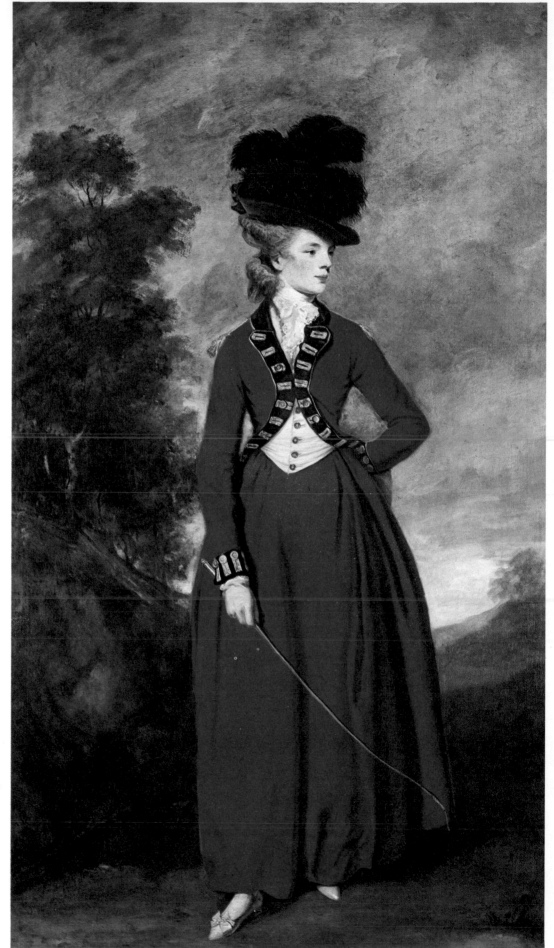

SIR JOSHUA REYNOLDS (1723–92): *Lady Worsley*. 1780. Canvas, 236 × 144 cm. Collection of the Earl of Harewood

The shoes give the game away. Sir Joshua and his sitter were both obviously in agreement that a riding habit suited her: and none would contradict the pretty effect. The effect is the point, for this is a drawing-room picture by the most sophisticated portrait painter of the day – a townsman dependent, like everyone else, on horses but who instinctively realized that a dainty foot is much more flattered by a shoe than by a riding boot.

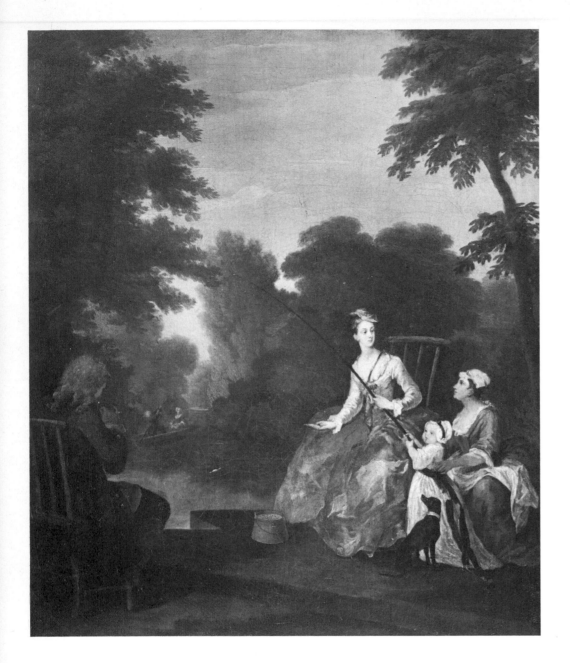

WILLIAM HOGARTH (1697–1764): *A Fishing Party*. About 1730. Canvas, 54·9 × 48 cm. The Governors of the Dulwich College Picture Gallery

Angling can be a delicate and skilful art and more often than may be supposed it is patronized and graced by women. That a mother should introduce her child to the sport is as natural as the taking of any food that is in abundance, close at hand, and fresh. It might be blackberries, or it could be fish; the idea is the same.

By contrast with the steady and accelerating decline in hawking, that other, often solitary, sport of angling – deceptively gentle and given social respectability first by monkish and then philosopher adherents – was to find more and more followers through the seventeenth century. A high point was reached in 1653 with the publication of Izaak Walton's *Compleat Angler*, a book with a profound influence continuing to the present day. The basic motive for angling, as always at the time, was food. The idea of angling as an art was encouraged and stimulated by those who, like Walton, sought to bring science into the activity. In the face of pike and marauding poachers, fish were actively preserved, and rivers stocked from breeding ponds. There

were advances in tackle and technique: rods were beginning to be made from cane, the reel came into use, and casting was invented. Following this latter development, came the idea of clearing the banks of trees and undergrowth; and in line with growing knowledge and understanding of the life of animals, the idea of a closed, or breeding, season was introduced for fish, as for other animals.

New elegances. Towards the end of the seventeenth century and into the early part of the eighteenth, advances in agriculture and science prepared the way for the explosion of art and intellect that was to characterize what has been so aptly called the Age of Elegance. The restoration of the monarchy in 1660 symbolized and at the same time stimulated the new mood of openness and optimism. The Royal Society was founded, open to all intellects and not, as now, restricted to scientists. Fine furniture and silver were made on a scale and in a variety not seen here before; porcelain was also collected and displayed. There was time to think about the design of gardens. Principles were established, and consideration given to the relationship between a formal parterre and wood, vista or bowling green (which was recommended for low or marshy ground). It became fashionable to notice the landscape: the planting of evergreen trees was encouraged for their practical, visual appeal during the winter; new flowers were introduced, notably the tulip (like so much else, brought from Holland); the first pineapple was grown, in a heated greenhouse.

Travel abroad became possible again, for, whether from exhaustion or alliance, most of the great nations of Europe had settled into a kind of peace. Aristocratic and wealthy travellers from England found their way to Italy, became enthralled by the intellectual principles of Renaissance art and architecture, and came under the spell of Claude, the Frenchman from Lorraine, whose ethereal depictions of calm and ordered landscape came to represent the essence of classical art. They collected his drawings and paintings with compulsive zeal, and a strand of Italian grandeur entered into English art.

The connection with Holland remained; for a time the two thrones were united under William and Mary. The extraordinary art of the Low Countries – ranging from the cool intimacies of Vermeer, the landscape harmonies of Ruisdael, the coarseness of Bruegel, to (most unexpected of all from such a vigorous and determinedly commercial society) the quietness of the galaxy of flower and still-life painters – was in one way or another to make its mark upon the development of English art into the middle of the nineteenth century.

An even more direct influence remained through the many visiting artists who were attracted by lucrative commissions and sensitive patronage. These included the Van de Veldes (father and son from Holland) and, half a century later, Antonio Canaletto (1697–1768) from Venice.

Hogarth, Reynolds and Gainsborough. In the midst of all this there developed the cynical yet warm-hearted and rumbustious genius of William Hogarth (1697–1764). He barely enters our story

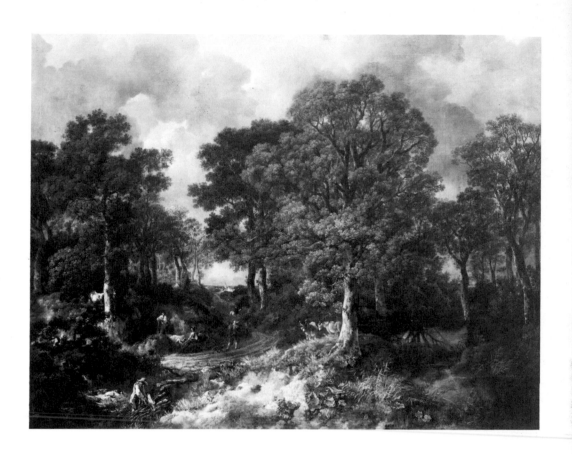

THOMAS GAINSBOROUGH (1727–88): *Gainsborough's Forest* (detail, left). 1748. Canvas, 121·9 × 154·9 cm. London, National Gallery

The profound influence of the landscape painting of the Low Countries on English art could hardly be better illustrated than in this most English of woodland scenes. Here it is not so much the feeling as the detail that is important, shown with an accuracy to which Gainsborough himself refers in a letter. Much of the country remained to be cleared of trees as economic necessity slowly decreed. In the meantime, woodland provided grazing for livestock, cover for game, and timber for fuel, implements and furniture. It is easy to forget that one reason for an artist like Gainsborough to consider painting a scene like this was that it was familiar and typical in his lifetime.

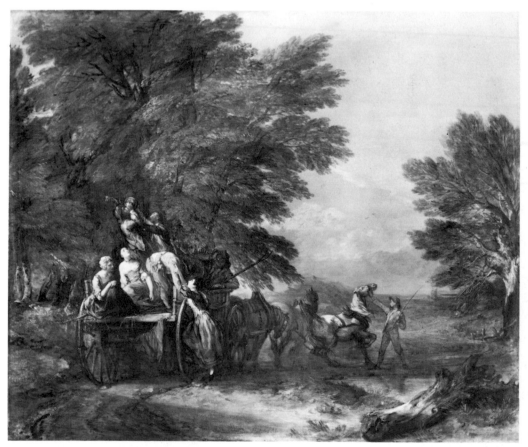

THOMAS GAINSBOROUGH (1727–88): *The Harvest Wagon*. 1767. Canvas, 120·3 × 144·5 cm. Birmingham, Barber Institute of Fine Arts

Into a landscape background derived from the Italian masterpieces of the great French painter, Claude Lorraine, Gainsborough has introduced the bucolic horseplay and euphoria that commonly erupts in England at the end of a long and hard day in the harvest fields. The large box-wagon must have been a memory of his East Anglian youth, for a quite different variety was generally in use around Bath, where he now worked. A fully loaded wagon of this kind was immensely heavy, so a team of three horses would be needed to pull it and they would not be easy to control. The lead horse was specially important, therefore; the grey in this picture is traditionally said to have belonged to his friend Walter Wiltshire, a carrier, who gave it to Gainsborough in exchange for the painting.

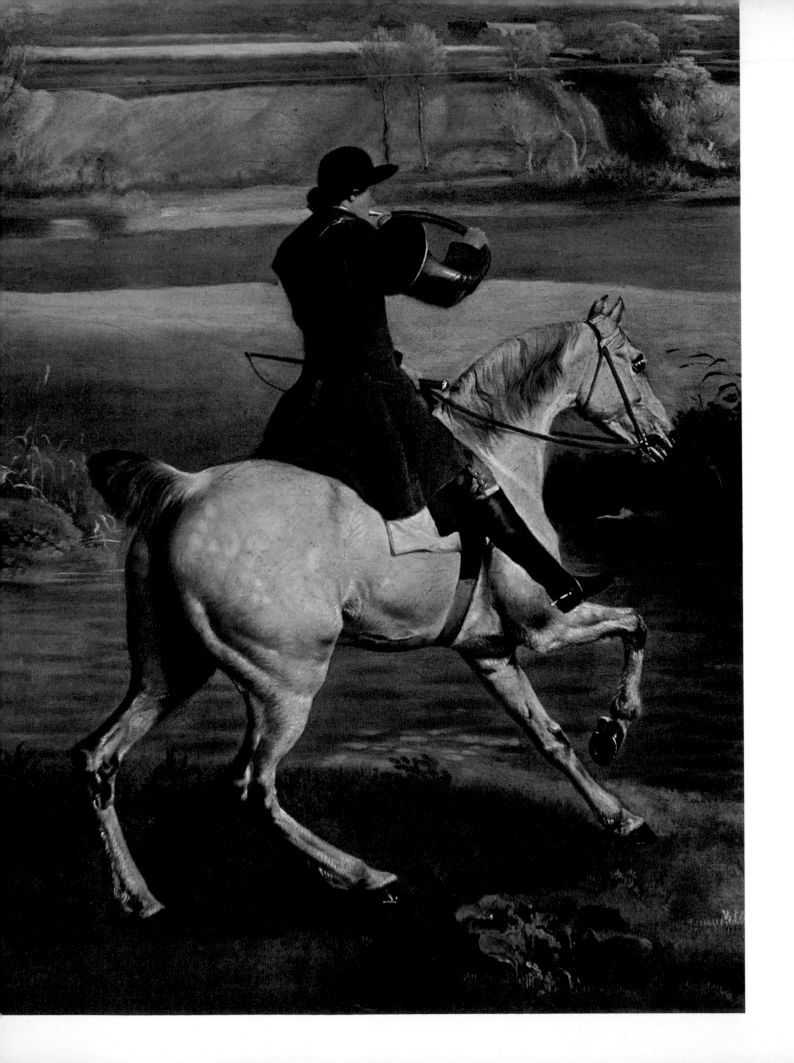

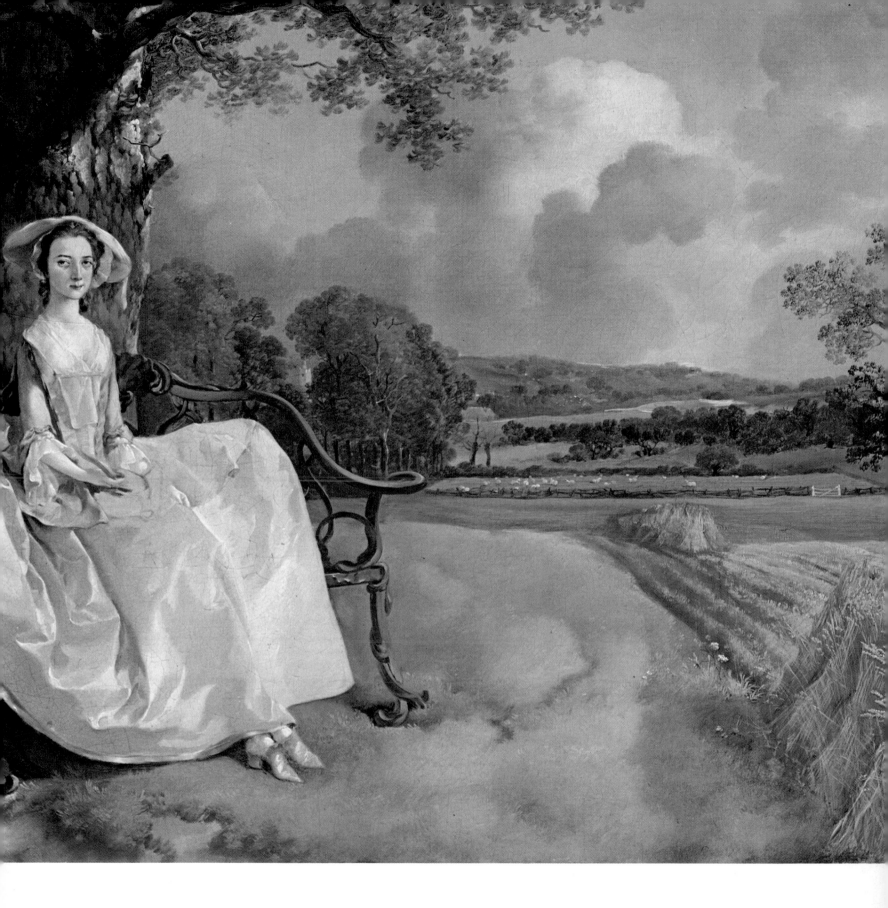

GEORGE STUBBS: *Huntsman.* Detail from *The Grosvenor Hunt*, page 52

THOMAS GAINSBOROUGH: *Mr and Mrs Andrews.* Detail from plate on page 52

51

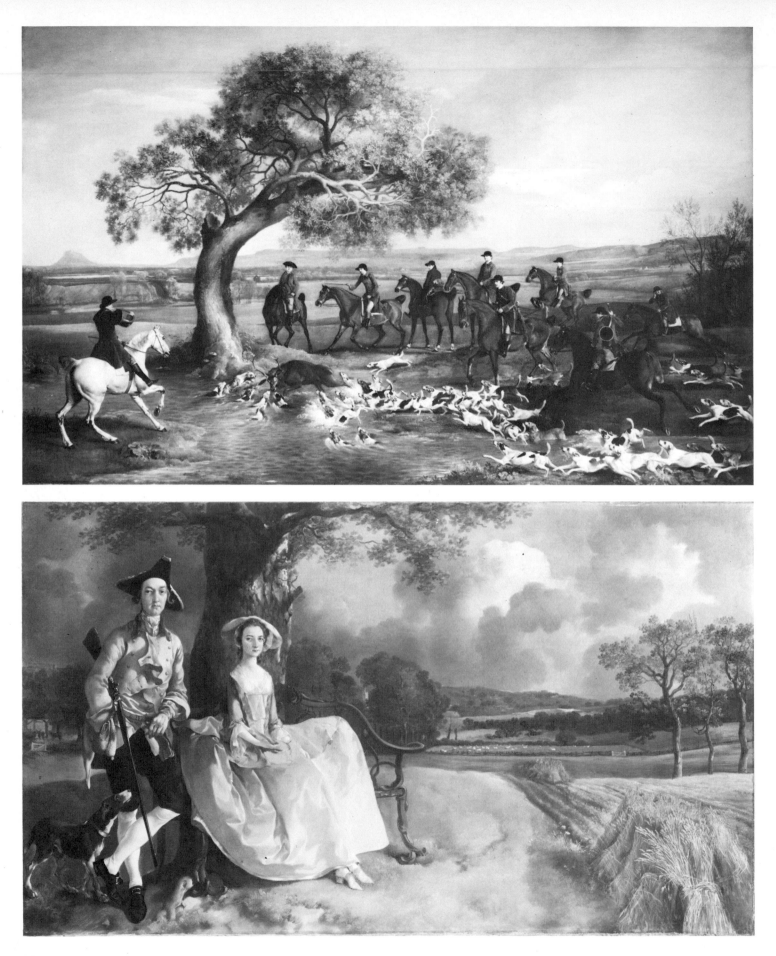

GEORGE STUBBS (1724–1806): *The Grosvenor Hunt*. Signed and dated 1762. Canvas, 150 × 242·5 cm. Trustees of Anne, Duchess of Westminster's Settled Life Fund

Arguably the greatest of all sporting pictures, this was painted for Richard, 1st Earl Grosvenor, who is seen reflected beneath the curve of the great old tree. By now deer-hunting was almost exclusively the preserve of the very wealthy. Though the hunted beast is noble and its death throes majestic, the scene in all its essentials is typical: the enthusiastic hounds painted in a stream of excited movement contrast with the contented exhaustion of men and horses.

THOMAS GAINSBOROUGH (1727–88): *Mr and Mrs Robert Andrews*. About 1848–9. Canvas, 69·8 × 119·4 cm. London, National Gallery

Where once a hawk would have marked the country gentleman, now it was a fine flintlock gun. Elegance and prosperity are indicated by a lavishly gowned wife and a wrought-iron seat in the rococo style. Modern ideas and scientific farming are shown (with major prominence) by neatly enclosed and hedged fields and by corn sown in rows rather than broadcast. The sportsman (or hunter for food) is further suggested by the dead bird held firmly in the woman's lap – ironically this detail was never finished by the artist.

WILLIAM HOGARTH (1697–1764): *Pit Ticket*. Drawn and engraved by the artist, 1759, 29·7 × 37·4 cm. Photograph by courtesy of the Parker Gallery

Here, in his most cynical and malicious mood, Hogarth expresses in a masterly way the effect that he deems cock-fighting to have on all those who follow it. Men of all social levels from royalty to thieves surround the pit – a principal feature of 'cocking' being the opportunity it gave for betting and thus inevitably for all kinds of skulduggery. It was often organized in conjunction with race meetings at which a large crowd could be guaranteed and unruly behaviour more easily accepted.

for he was firmly a townsman at a time when towns were steadily and inevitably increasing in influence and importance. That particular grandeur represented by Sir Joshua Reynolds (1723–92) is also outside of our scope, for his was a sophisticated, urban art, exemplified by the beautiful portrait of Lady Worsley in riding habit (p. 45). But Thomas Gainsborough (1727–88), a countryman born and by instinct, has his place with us. He had to make his living as a portrait painter, first in his native Suffolk, then at Bath and finally in London, and the elegant results delight and thrill us to this day; but throughout his life he continued to paint (though invent might be a more accurate description) landscapes enlivened by specific references to the many details of rural life. Occasionally a commission would give him the opportunity to combine his talent as a portrait painter with his experience as a countryman; this is supremely represented by his portrait of *Mr and Mrs Robert Andrews* (p. 52), in which sport, agriculture, elegance and even the garden are all so successfully combined.

But there is another side to Gainsborough and his place in our history: as has already been said, he was able to indulge only peripherally in his country-based ideas. His genius and his need to make a living took him firmly back into the mainline of English – and European – art through his portraits. What this represents, symbolizes even, is the beginning of that divergence of what we have now come to call sporting art away from the mainstream of the intellectual ideas that refresh and revive all life and art. These ideas undoubtedly touched sporting art, as this history tries briefly to show in the course of describing its

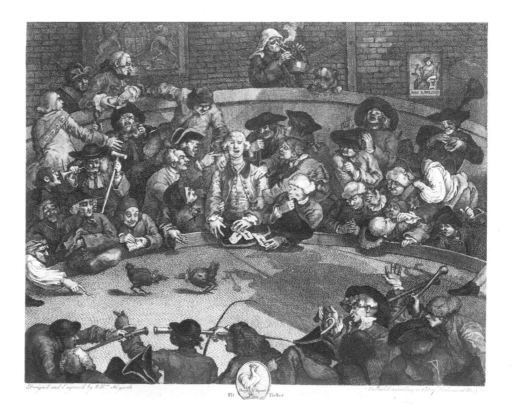

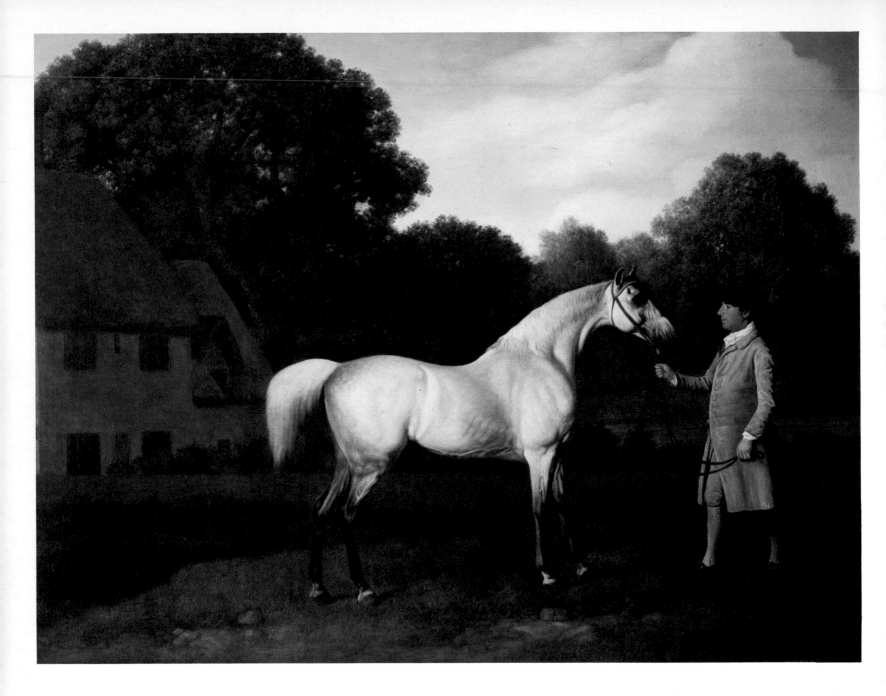

GEORGE STUBBS (1724-1806): *Gimcrack*.
1770. Canvas, 84 × 110·5 cm. Collection of
Lord Irwin

By now Gimcrack was ten years old and
had faded almost to white from his original
dark grey. The horse attracted all by his
charm, which gained him the affection of
many beyond those closely concerned with
his racing and breeding – and there is more
than a hint of this indefinable manner in
Stubbs's painting. Although old now, the
alert and bright-eyed character of the finest
kind of thoroughbred is quietly emphasized
by the natural dignity of the groom.

GEORGE STUBBS (1724-1806): *Whistlejacket*
(trimmed). 1761-2. Canvas, 325 × 259 cm.
London, Kenwood House, Iveagh Bequest
(on loan from the Earl Fitzwilliam)

This life-size portrait of a proud stallion
is impressive even when reduced for repro-
duction. Whether a background and rider
(George III, according to tradition) were
ever intended is not relevant to the idea of
a powerful and wilful horse conscious of its
looks and its dignity. Such understanding
of an animal is rare, for despite the tempta-
tion of the size and nature of the commis-
sion there is no attempt to show the horse

as an heroic figure, an idea contrived only
by human pretensions. There seems no rea-
son to doubt the story that Whistlejacket
instinctively attacked both artist and pic-
ture, for the latter certainly represented
a rival.

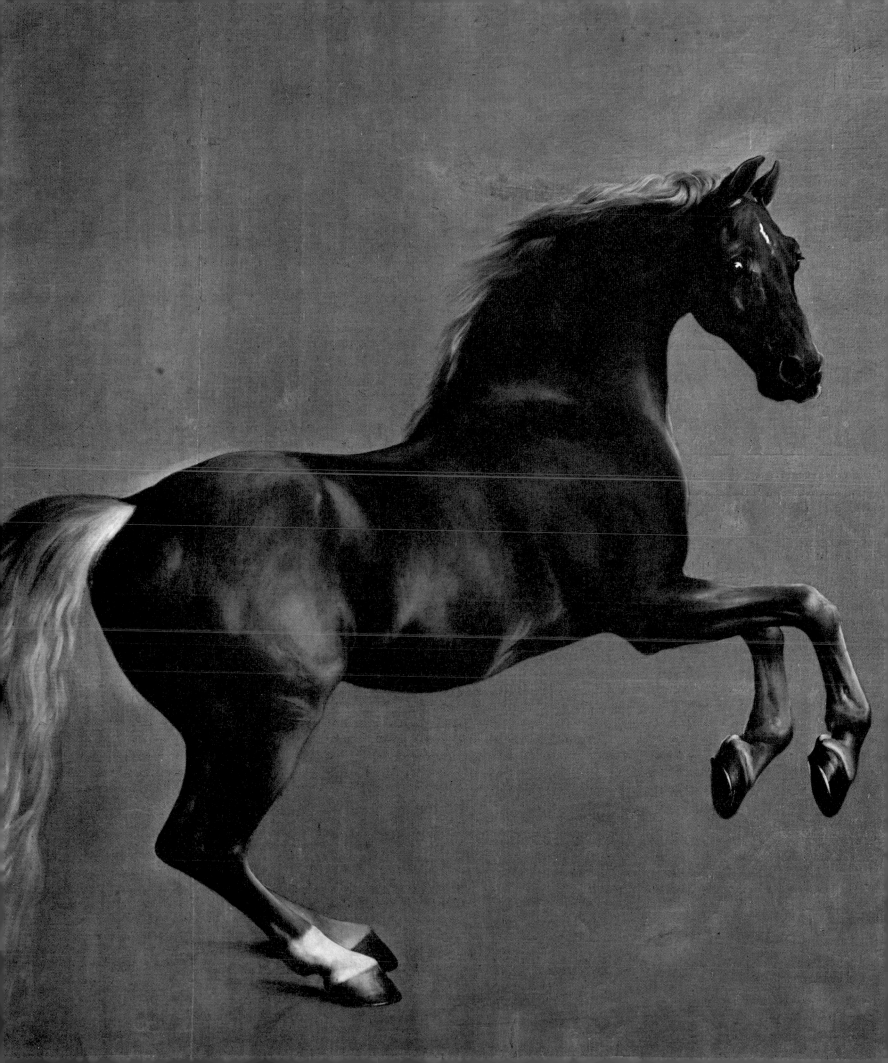

development, peak and ultimate decline – in close harmony with the transformation of a country-oriented English society to an industrially centred one.

George Stubbs. At its peak is George Stubbs (1724–1806). For all of us who have had any concern with the Englishman's art, there is no painter like Stubbs; he is the master with whom everyone else is compared. His patrons were as great as, and sometimes the same as, those who gave important commissions to Canaletto (the Duke of Richmond, for instance); yet because Stubbs painted horses he has been conveniently lumped together with sporting artists. A less dogmatic view of his pictures will show that, like theirs, his art sprang naturally from its environment, a prosperous, country-based economy in which the horse was the prime means of transport and a major source of motive power. At the other extreme the horse also provided much pleasure and entertainment in the hunting field and on the racecourse. It is no wonder, then, that horses dominate Stubbs's pictures; and quite apart from their economic importance to society at large, the

GEORGE STUBBS (1724–1806): *Laetitia, Lady Lade*. Signed and dated 1793. Canvas, 102·2 × 127·9 cm. Royal Collection. Reproduced by gracious permission of Her Majesty The Queen

The insouciant pose of the rider and the powerful, prancing horse speak as clearly as the hint of a foot of the famous Letty. She was the hard-riding, coarse-swearing wife of the equally notorious Sir John Lade, who had picked her up in a brothel. Both formed part of the Prince of Wales's particular set of sporting and gambling companions, a fact that only modern ideas of morality and behaviour find hard to reconcile with his equally active and sensitive patronage of the arts.

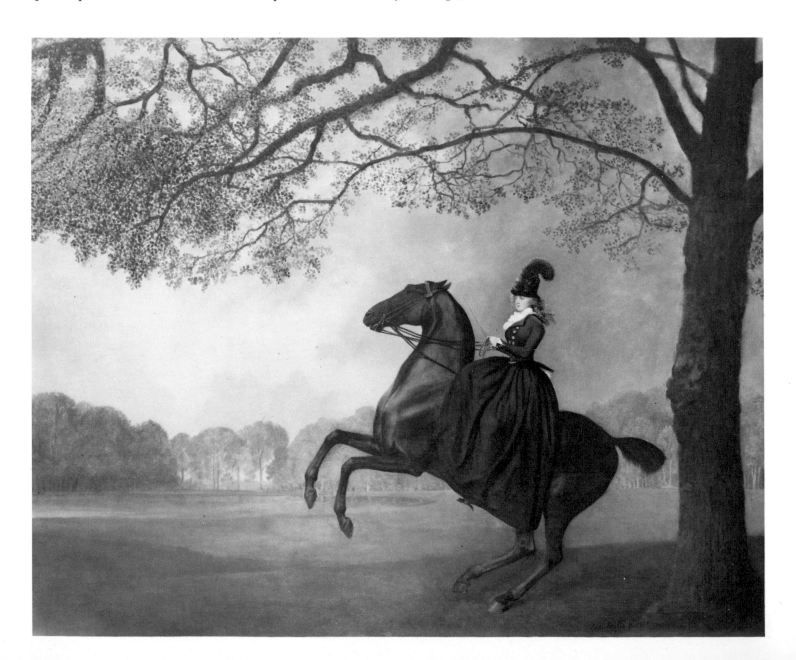

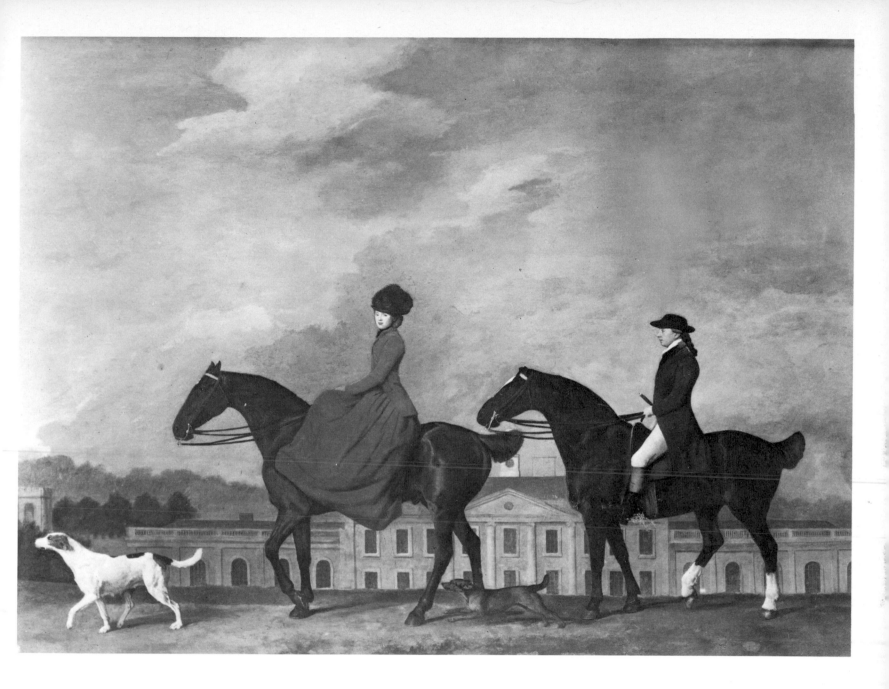

GEORGE STUBBS (1724–1806): *John and Sophia Musters out Riding at Colwick Hall.* Signed and dated 1777. Panel, 96·5 × 128 cm. Private Collection

Even for Stubbs this is a startling composition, as much for the partial view of the Hall as for the line of figures moving quietly past at a walk. John Musters founded a famous pack of hounds in south Nottinghamshire, led, no doubt, by the self-contained and dignified animal on the left. Some time after this picture was completed, both figures were painted out – perhaps because Mrs Musters had been unfaithful – and two grooms, walking, added by another artist. It was not until the 1930s that the picture was restored.

finest are so beautiful and so cared for as to be worthy of portraits in their own right. The connection between the horse and art is thus twofold, at least.

Another irony about Stubbs is the rediscovery of his art in recent years – rediscovery by the world at large that is, for to all who have enjoyed the work of England's sporting and country painters, he has always been the greatest and most important of them all. If others have failed to recognize this, it is only one more sign of the change in the basis of society from country to town, and the simultaneous rise of the need to organize everything into convenient categories. This compulsion to build an artificial barrier, and to create (only after the event) a kind of painting called sporting art, has been condoned if not encouraged by its devotees, thrown more and more on to the defensive as fewer and fewer of us understand what it means to be a countryman.

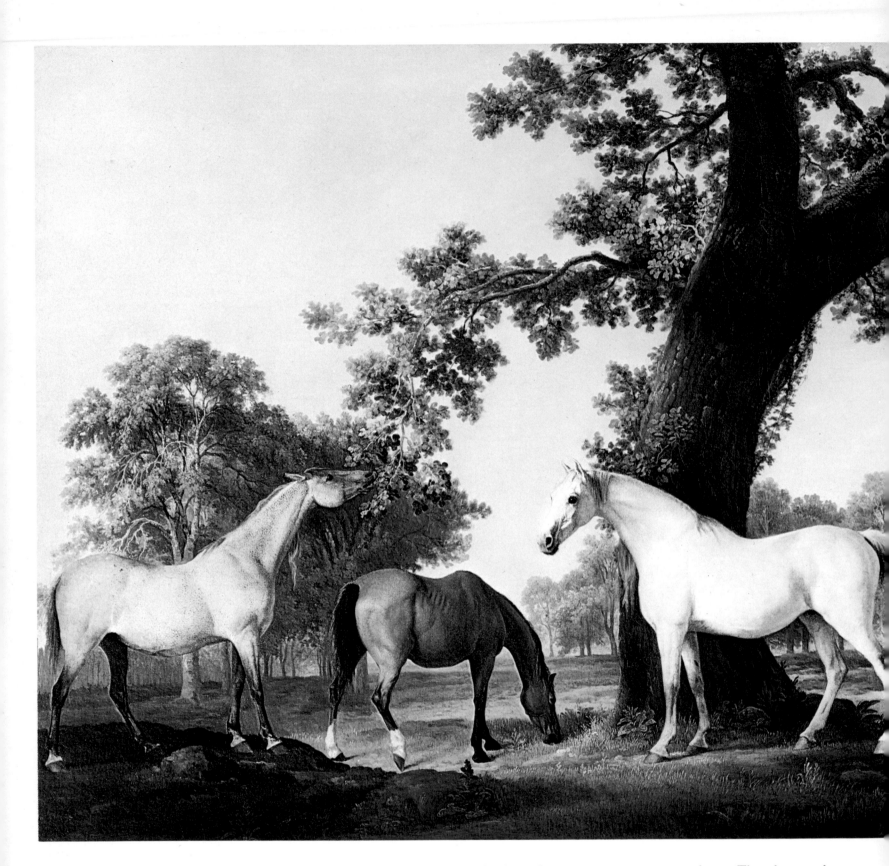

GEORGE STUBBS (1724–1806): *Mares by an Oak Tree*. 1764–5. Canvas, 99·1 × 188 cm. Ascott, Wing, The National Trust (Rothschild Collection)

Though the economic importance of mares in a society largely dependent on horses must have been the original inspiration for Stubbs's various paintings of the subject, his genius raised the idea to something akin to a series of visual meditations upon a common theme. That they can be understood and appreciated on so many levels is not the least of their many remarkable aspects.

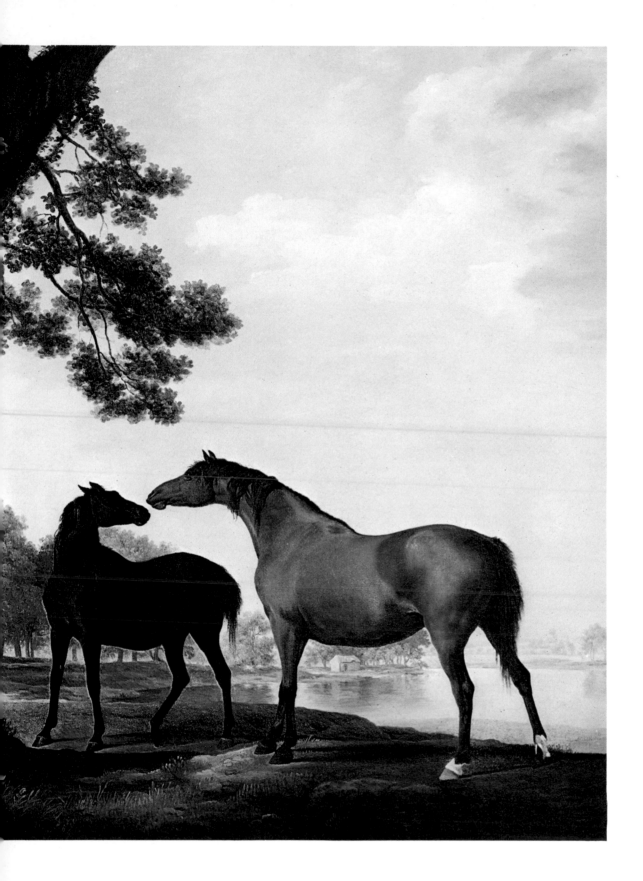

There is no need nowadays to attempt to defend or enhance the reputation of Stubbs. His paintings can speak for themselves, and the brief facts of his life can tell the rest. He was born in Liverpool in 1724 and visited Italy thirty years later (soon after Reynolds). He then embarked upon a methodical, minute study of the horse through the dissection of corpses; in this he was more or less unconsciously following the contemporary desire for knowledge. Coming to London, therefore, Stubbs quickly found himself the centre of attention among a group of aristocratic patrons, young, rich and keen to make their mark; many were members of the Jockey Club only recently founded. That he painted their horses was almost a foregone conclusion, for these were being bred to an increasingly high standard of excellence and growing international fame. (In this connection it is worth remembering that the word 'jockey' was originally applied to all of those who had a close connection with the turf and was not, as now, exclusively applied to the riders.) The venturesome and independent spirit that led Stubbs to engrave his own designs for his book, *Anatomy of the Horse*, in 1766 (he could find no one else to do it) also led him, for instance, into a partnership with Josiah Wedgwood and to a series of paintings on enamel tablets. The same impulses made him experiment with techniques and materials that have resulted in a number of his paintings falling into bad condition with the passage of time. The same close observation, evident and best known in his pictures of horses, is also found in Stubbs's sensitively portrayed human figures, as well as in his paintings of wild and agricultural animals. Outliving his success, almost inevitably in view of his toughness of spirit, Stubbs eventually died in 1806 in the midst of another revolution in the ideas of art.

The Sartorius family. Although Stubbs's talent and skill, intellect and vision, tower above all other country painters of his time, it is important to be reminded of that subsidiary but very strong tradition initiated by Seymour and now conveniently, if rather patronizingly, described as the primitive style. This is well represented by the Sartorius family: the progenitor John and in particular his son Francis (1734-1804) and grandson John Nost (1759- after 1824). What they all provided, for an exacting and knowledgeable clientele, was a simplicity of composition and a vigour of style, combined with meticulous and detailed accuracy. Their subjects were all sporting, in a landscape: in short, a countryman's art.

Agricultural changes. Let us return once again to the sporting and agricultural background of that long period from political revolution of the republican Commonwealth and subsequent restoration of the monarchy to the colossal social changes consequent upon the industrial revolution. In general the country was becoming less wild: both the wolf and the wild boar disappeared during the reign of Charles II. Animals were now beginning to be consciously preserved as much for their food value as for the sporting interest – two ideas then inextricably intertwined. This preservation and protection took a

JOHN NOST SARTORIUS (1759–after 1824): *A Landscape with Figures*. Signed and dated 1834. Canvas, 69·8 × 89·5 cm. Photograph by courtesy of Sotheby's

This picture is as much about prosperity as it is about sport. The energetic pointers make excellent working companions for a successful farmer strolling out for a quiet morning's shoot. The fences are good (there is an expensive new iron one in the middle distance), his family is well mounted and fashionably clad, and his house has recently been doubled in size by a large extension. By today's standards both artist and patron may have been relatively unsophisticated, but both understood the interconnection of country with sport.

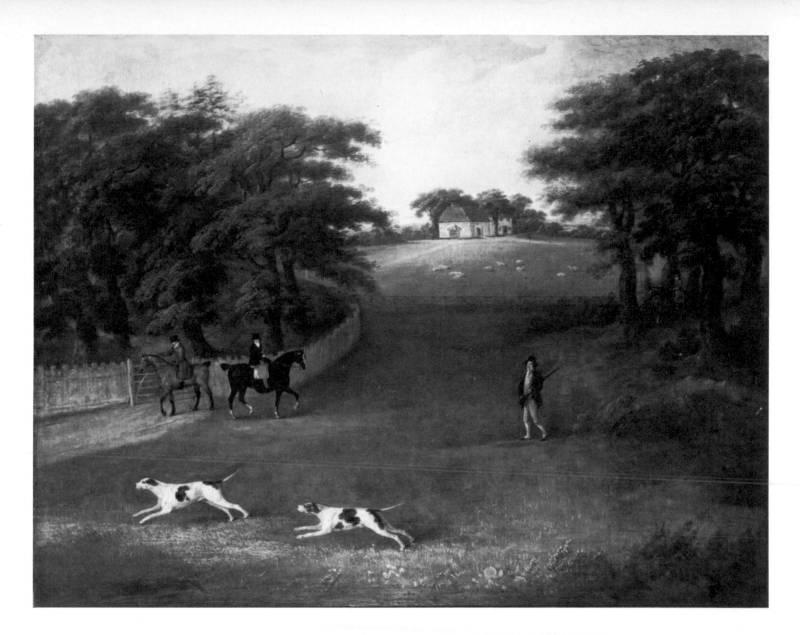

FRANCIS SARTORIUS (1734–1804): *Coach-Horses in the Possession of Sir John Lade, Bart.* Mezzotint by Edward Dayes, 1795, 32·7 × 41·9 cm. Private Collection

By this time coach-horses were no longer valued for strength and weight alone but for speed and looks through a thoroughbred ancestry. Improved harness design likewise made driving potentially more skilful and Sir John Lade was tutor to the Prince of Wales in that art, as well as being one of the boon companions of his youth. Sir John was a wild and cheerful character, whose equally hard-riding wife was painted by Stubbs for the Prince's collection (*Lady Lade*, p. 56); he eventually gambled all his money away and turned his skills to advantage by becoming a professional coachman on the London-to-Brighton run.

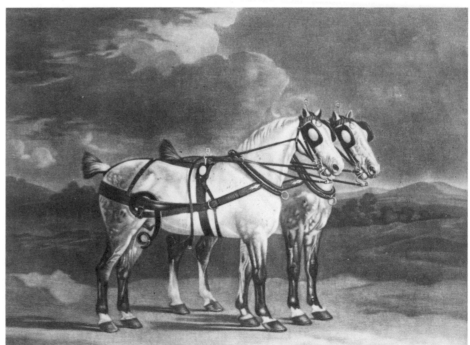

JOHN NOST SARTORIUS (1759–after 1824):
Newmarket Races. 1810. Canvas, 53·5 × 76
cm. Collection of the Earl of Jersey

Almost without exception artists seem to
have preferred to paint races in their closing
stages when the excitement was at its height.
In this instance the scene is far out on the
course well away from the throng of spec-
tators, with two horses duelling for the lead
closely challenged by a third. It is not un-
reasonable to assume that the picture was
painted for one of the jockeys, for this was
still in the period when owners would often
ride their own horses in races.

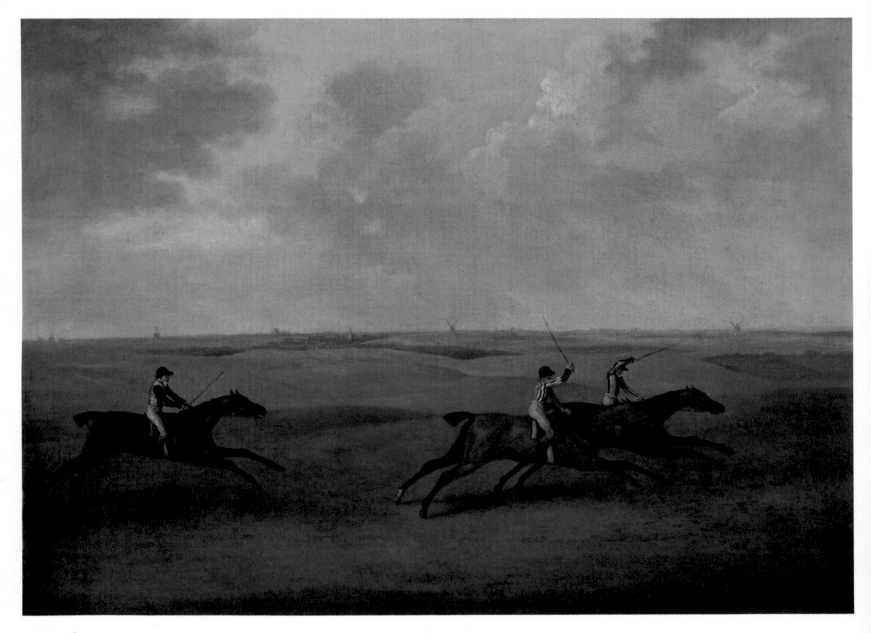

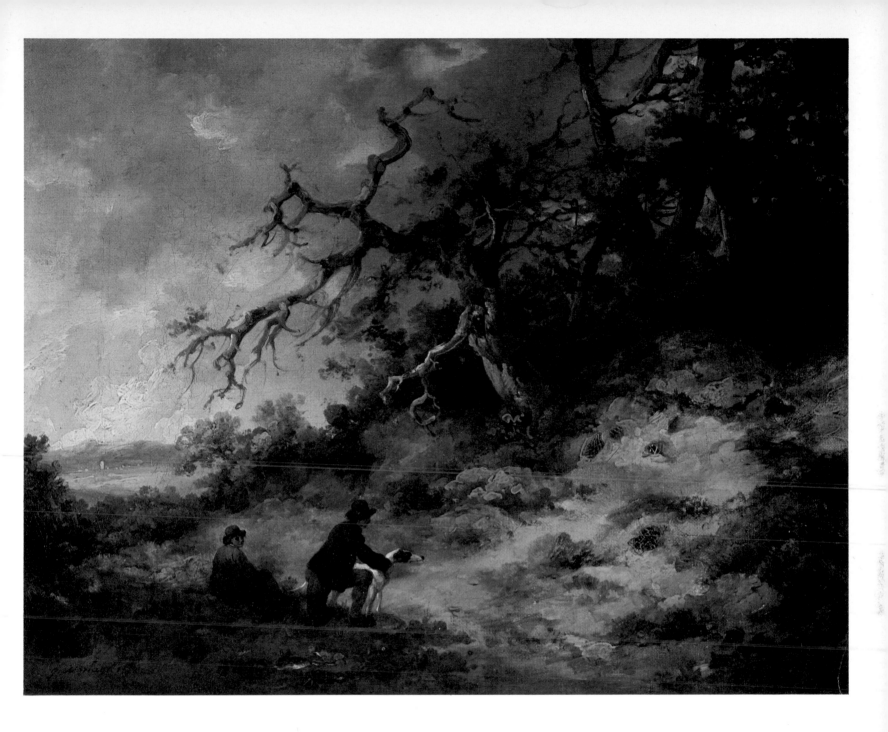

GEORGE MORLAND (1763–1804): *Ferreting*.
Signed and dated 1792. Canvas, 28·5 ×
37·5 cm. Collection of Major A. S. C.
Browne

Rabbits have always been a common
source of food for country people. In this
bank the holes of the warren have been
stopped with twigs and a ferret put down to
drive the rabbits out of the last remaining
one, which has been covered by a net. Any
rabbit that escapes will be caught by the
dog, which is already expectant and needs
to be restrained from attacking the hole and
pushing aside the net.

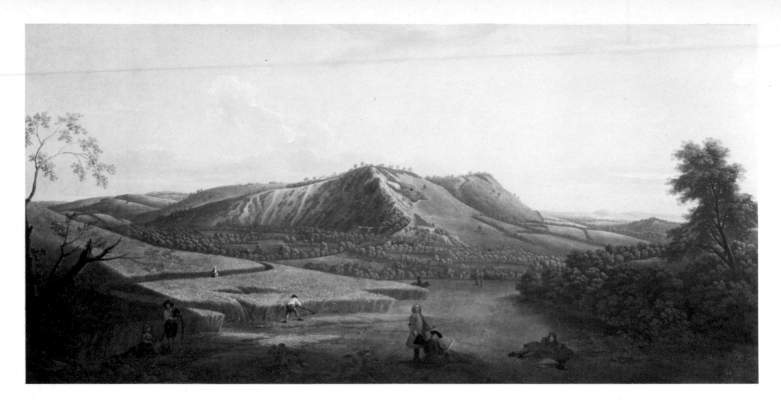

GEORGE LAMBERT (1700–65): *Hilly Landscape with a Cornfield*. Signed and dated 1733. Canvas, 90·8 × 184·2 cm. London, Tate Gallery

Any frontiersman will immediately recognize the significance of this scene in which the figures assume a symbolic rather than an actual significance. The painting celebrates the gaining of new, productive land from waste; boundaries have to be agreed and drawn, hands engaged, a bailiff appointed. Prosperity will be the result of modern agricultural practice and leisure can thereafter be taken.

EDWARD HAYTLEY (*fl.* 1740–61): *View from Sandleford Priory towards Newtown Village and the Hampshire Downs*. About 1744. 88·5 × 149·8 cm. Photograph by courtesy of The Leger Galleries

Even two centuries ago townspeople were wont to look upon the country as a place of recreation and temporary retreat. Sandleford Priory was owned by Edward Montagu, shown here sitting beside his telescope, which would bring closer the details of the 'fine prospect'. Behind him stands his wife, Elizabeth, whose evening conversation parties in London attracted the intellectual and

artistic elite and, incidentally, gave rise to the phrase 'blue stocking'. In harmony with the general idea of this picture, the haymaking is shown to have a ritual and decorative importance, far removed from the economic and agricultural facts of rural life.

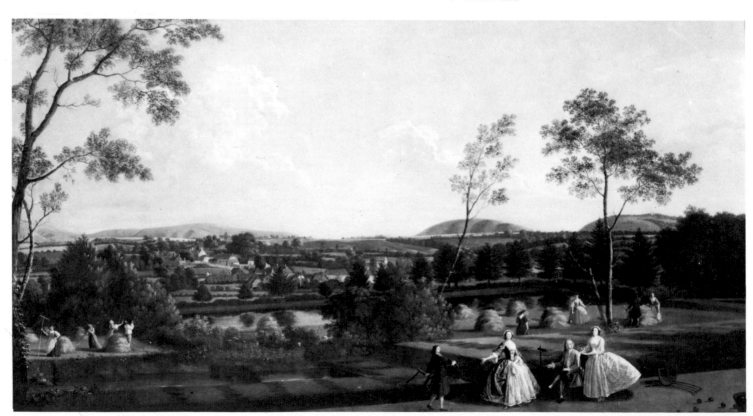

FRANCIS BARLOW (about 1626–1704): *The Decoy at Pyrford*. 404 × 279·4 cm. Clandon Park, The National Trust

The full title of the painting is expressive: 'The Decoy at Pyrford with waterfowl at sunset startled by a bird of prey.' It was common for a house of any size to have its own decoy either on a lake or dammed stream. Tamed birds, either pinioned or tethered, would call to their wild brethren flying freely overhead and so attract them down to the water, where they would be netted for fresh food. In the background is a keeper's small hut beside a sluice used for controlling the level of the water.

variety of forms: the stocking of rivers and ponds with fish (as already mentioned above); the maintenance of deer parks – though many had been irretrievably opened or destroyed during the depredations of the Civil War; and latterly the protection of the partridge – as much a target for the gun as a tasty morsel for the pot. The game laws of 1671 sprang from the old feudal idea that the pursuit of deer was the prerogative of the king. They were not necessarily a hardship in a sparsely populated and largely wilden land, and the impact of the restrictions would be lessened by time, custom and a natural country insouciance. Nevertheless the resurrection by a reformed Stuart Parliament of this outdated concept was not conducive to harmony. The Act of 1671 forbade all smaller landowners from killing game – even on their own land. (Rabbits were not game.) The point was that game wandered generally from the land of large, and thus presumably preserving, owners to that of small and usually foraging owners. The spirit of protection abounded: many landowners were new and unused to country ways, having made their fortunes in banking or other commercial enterprises. As far as agriculture was concerned there was

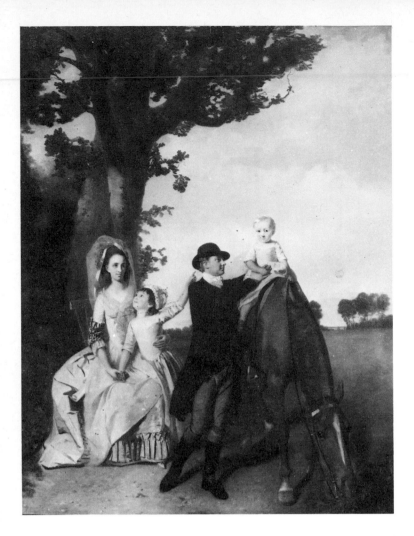

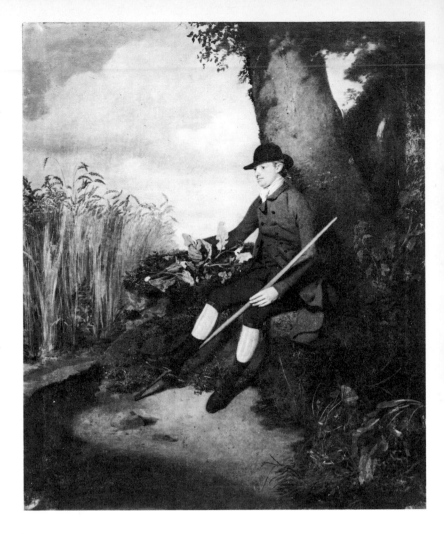

money to be made in corn and cattle: a bounty was paid on any corn exported and a heavy duty imposed on any brought in from abroad; cattle raising was encouraged and their importation prohibited.

But for the common man rabbits abounded – a quarter of the land at least was waste. Half of the rest was still being cultivated on the old open-field system and was the source of constant quarrels and litigation: landmarks could be easily and clandestinely shifted, a neighbour's land ploughed, his grass mown. From August to February there were common rights of pasture and thus no incentive for any individual to grow turnips or clover as winter feed. With strips scattered over many fields, time was wasted in travelling between each, and much land lost through innumerable footpaths and balks (wide, unploughed boundaries). In addition, all occupiers were bound to one another in respect of the seasons for sowing or reaping. Any innovation, even drainage, was therefore practically impossible. The commons were little better: cattle and sheep competed for grass in virtually uncontrolled numbers and carried diseases one from another. Yet despite all these problems, England was in the first part of the eighteenth century called the granary of Europe. Prosperity was by then more widespread, too; the peasants (for they still existed here) enjoyed fresh meat and wheaten bread. But before the industrial revolution there came the agricultural revolution, during which time upwards

HENRY WALTON (1746–1813): *The Tyrell Family* and *The Reverend Charles Tyrell*. About 1780–90. 113 × 87·6 cm. and 74·9 × 62·2 cm. Photographs by courtesy of Sotheby's

Mr Tyrell of Thurlow, Suffolk, was rector of Thurston. The gently grazing horse (shown in a startling and unusual perspective) allowed him to move quickly and easily about his parish. When not enjoying the company of his wife Elizabeth and his children, or about his parochial business, Mr Tyrell must have been something of an agricultural pioneer. Dressed in thick gloves and stockings, the rector muses upon his crop of wheat, planted in orderly rows and not sown broadcast, thus allowing it to be cleaned, whilst growing, with the hoe he carries in his hand; the weeds are tossed away behind him. He also holds the freshly cut stem of some kind of crop like kale, which, when turned into fodder, provided for the over-wintering of stock: previously most of the animals would have been slaughtered.

of four million acres were enclosed – including, it must not be forgotten, waste and common land as well as open fields. Many of the enclosures were the result of local agreement without the need for recourse to Parliamentary Acts. The incentive was naturally economic and there would have been hardship as a result. But what revolution has ever been kind, whether it be intellectual, social or economic? It is a convenient but sad doctrine that all revolutions rely on posterity to prove them right – or wrong.

The superbly named Jethro Tull (1674–1741) was the archetypal and curmudgeonly agricultural pioneer. The ideas that he inspired are often to be found inhabiting the background of the paintings that are the subject of this study. For it was Jethro Tull's inventions and experiments that made possible the growing of wheat and turnips in orderly rows. On open fields, seed sown broadcast was planted thickly and at various depths, whereas Tull discovered that thin sowing at a constant depth produced the thickest crop. The sowing in rows allowed the land to be kept clear of weeds by hoeing; this was an idea Tull conceived after a study of vine-culture in the south of France. Tull's ideas were slow of acceptance and his mechanical seed drill was soon superseded. Yet agricultural improvement became the fashion and amongst those who adopted his systems on a large scale – including his advocacy of sainfoin, an artificial grass, as fodder – was Lord Townshend. The latter urged the use of turnips on his Norfolk estates with such zeal as to be remembered still as Turnip Townshend. The principle was easy: sheep fed on turnips fertilized the soil; some of the turnip crop was kept for winter use to maintain the sheep, their manure further enriching the land. But change is slow in the country and largely accepted only by experience and successful example.

Improved livestock. Along with the introduction of the use of turnips and clover came the idea of improving cattle and sheep. There were three basic uses for sheep (apart from food) – as sources of manure, leather and, most of all, wool. There were almost as many varieties of

MRS V. H. WILMOT (*fl.* 1794): *Sheep*. Mezzotint by I. Grozer, 1794, 45·5 × 63·5 cm. Photograph by courtesy of the Parker Gallery

Mrs Wilmot must have been a very considerable amateur artist and she dedicated this rare print to the famous animal painter, Sawrey Gilpin, obviously as much out of admiration for his work as out of a desire to attract his interest and sponsorship. The unashamedly, and then highly fashionable, picturesque nature of the composition need not detract from its value as a representation of a kind of livestock that has dominated the English rural economy for many centuries, yet was rarely shown in such prominence.

In the early part of the nineteenth century, experiments directed towards a general improvement of livestock reached substantial proportions. Prints like this (typically made locally, this one in Keighley, Yorkshire) spread the fame, and increased the value, of exceptional animals; just as a flattering dedication, in this case to two local landowners, would gain interest and patronage and stimulate sales of the print. Status of another kind is suggested deliberately in the background with its mixture of wild local beauty and modern architectural elegance. In the same way the grasses so strongly growing underfoot indicate the natural and healthy grazing that produced the monstrous beast.

GEORGE STUBBS (1724–1806): *The Lincolnshire Ox*. 1790. 66 × 96·5 cm. Liverpool, Walker Art Gallery

Towards the end of the eighteenth century, in the face of the growing demands of an urban industrial population, determined efforts were made to improve cattle for their meat. The best artists of the day were commissioned to commemorate, and advertise, huge animals like this. The ox was bred at Gedney in 1782 and is shown in St James's Park, London.

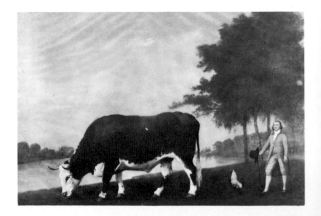

sheep as there were counties that bred them, and they were selected and bred for almost as many and arbitrary reasons. With cattle, too, there was a large variety of breed, chosen for the quantity of milk they might give, or for the strength of their shoulder when pulling a heavy plough or cart. Horses were generally worse, small and used only for personal transport or as pack animals. But the new coaches and wagons being developed in the Low Countries suggested that improvements were also necessary in working horses.

The pioneer stockbreeder was Robert Bakewell (1725–95); he wanted sheep and cattle as much for mutton and beef as for other uses. He did not cross two breeds so much as breed in from the same family exhibiting the points he wanted to secure: in particular, flesh and fatness. He put his ideas to good use in the development of a new kind of draughthorse, with an emphasis on strength rather than weight. His ideas were quickly imitated and improved upon: no doubt the contemporary success of similar ideas for the thoroughbred racehorse had much to do with the relatively speedy adoption of new stockbreeding concepts.

Roads and landscape. But what of the landscape background in the seventeenth century? So used are we to wheeled transport and to comfortable metalled roads, that the idea of a broad highway as wide as a modern motorway – upwards of fifty yards – with no discernible boundaries other than an occasional rudimentary ditch is hard to grasp. Yet how else were huge flocks of sheep, large herds of cattle and long lines of pack-horses to be accommodated as they passed from place to place across the land? In summer the dust raised could be so thick as to clog the eyes, nose and hair; in winter the pot-holes were so treacherous that the road was widened further by those seeking to avoid being soaked or even drowned. Virtually the only travellers

THOMAS ROWLANDSON (1756–1827): *Ford-ing a Rocky River*. Pencil, pen with sepia and grey ink, watercolour, 40·5 × 55 cm. Photograph by courtesy of Sotheby's

Goods that were not either driven live on the hoof or transported by water would generally be carried by pack-horse – using the special type of saddle illustrated on the leading animal here. Carts (or the four-wheeled wagons) were relatively uncommon until the roads began to be improved, and for personal transport most people either walked or rode. It is curious that no visual record seems to remain of the long lines of pack-horses, or the huge herds of cattle or sheep, that were such a feature of rural England in the past.

(*opposite*)
WILLIAM HUGGINS (1820–84): *A Bull and Sheep in a Meadow*. 59·7 × 75 cm. Photograph by courtesy of Christie's

Huggins had a great contemporary reputation as a painter of animals, wild and domestic, but has only been rediscovered in relatively recent times. By any standards this is a masterpiece of agricultural art, painted at a time when cattle were being bred for their meat and not only for their hides which, with cows' milk, had been their principal previous value. This magnificent bull is portrayed with a grandeur that he would recognize as his due.

JULIUS CAESAR IBBETSON (1759–1817): *A Phaeton in a Thunderstorm*. Signed and dated 1798. Canvas, 67·3 × 92·8 cm. Leeds City Art Gallery

The scene is in Wales during a tour made in 1792 with the Hon. Robert Greville, whose carriage is being braked on a steep incline by Ibbetson with a convenient rock. The new-found romantic glories of mountain travel are stirringly portrayed here, and only a pair of determinedly romantic young heroes would have chosen to seek adventure in an exciting but totally unsuitable vehicle like an open phaeton.

were those on business of some kind; most people walked, the better-off rode. There were a few ponderous wagons drawn by teams of oxen; Queen Elizabeth I was driven in a springless carriage (brought over from Holland) but private coaches did not become at all common (and then only in London) until the reign of her successor.

Throughout the eighteenth century the roads remained very bad: one county was notorious for not possessing a single wheeled carriage; another had lanes so rutted that balked wagons were extricated only with the help of thirty or forty horses; a third's roads were so bad in winter that wagons were taken off their wheels and dragged on their bellies. Sledges remained common, as did ruts four feet deep and boulders the size of a horse. The road surfaces were not improved by the hooves of a multitude of pack-horses, which remained the main

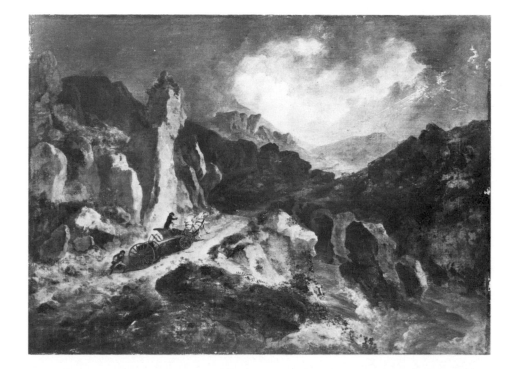

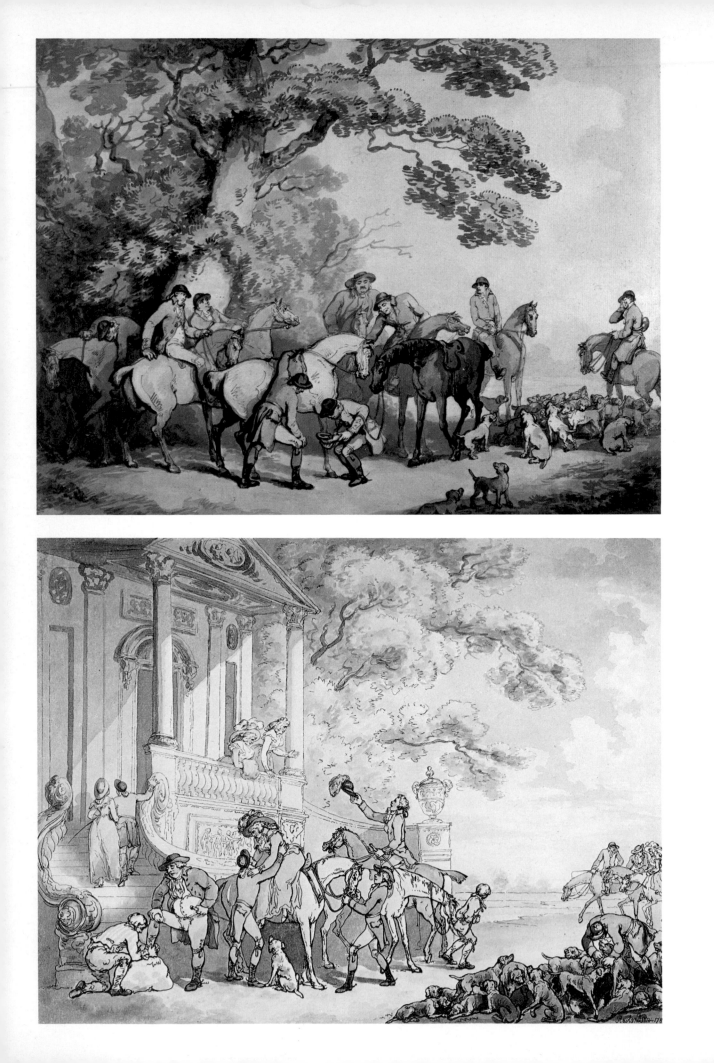

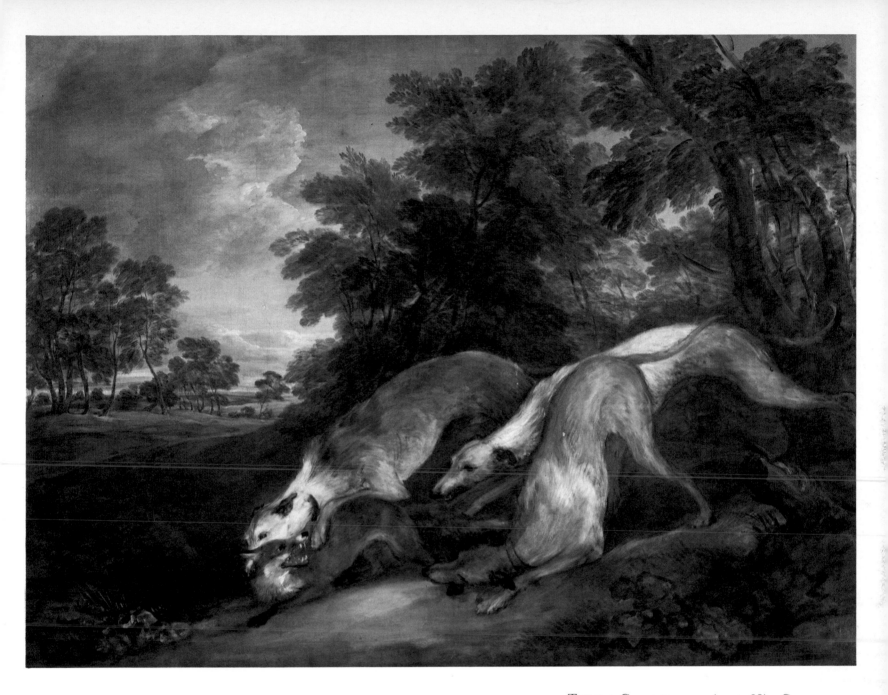

THOMAS ROWLANDSON (1756-1827): *The Kill*. 1788. Pen and watercolour over pencil, 36·8 × 49·5 cm. Birmingham, City Museum and Art Gallery

The horses are tired but excited, likewise the hounds which are being called together by the huntsman prior to moving away for another find. The grey in the foreground has shown signs of lameness during the run and so its hoof is being carefully examined for a split or stone by an experienced horseman. Deep knowledge and long observation on the part of the artist is obvious from every detail, attitude and movement in this wonderful watercolour.

THOMAS ROWLANDSON (1756-1827): *The Return*. Hand-coloured etching by the artist, 1788, 47·6 × 56·2 cm. London, British Museum

The cheerful exhaustion of the hounds is a nice detail: doubtless the ladies have ridden out in the middle of the day to meet the returning hunters, who at this period would have risen early, well before dawn, to catch the fox asleep and satiated after its own nightly hunt for food. This is a superb example of Rowlandson's genius with an etching needle and his sublime understanding and affectionate observation of people.

THOMAS GAINSBOROUGH (1727-88): *Greyhounds Coursing a Fox*. About 1784-5. Canvas, 178 × 238 cm. London, Kenwood, Iveagh Bequest

Born and bred a countryman, even the gentle Gainsborough, at the height of his fashionable success as a portrait painter, could not forget the great paradox that life and death are inevitably intertwined. He owned a sporting painting by the seventeenth-century Flemish artist, Frans Snyders, and this Gainsborough picture may be based on a Snyders' work still in the Methuen collection at Corsham, where Gainsborough painted and studied. Life-size, this huge rendering is painted with lyrical colours that belie the more vicious character of the Flemish original.

71

means of transport for goods. Sheep, cattle, geese and turkeys were driven in vast, slow-moving concourse to the towns, particularly London. Because of the inefficiency of the roads there was considerable interchange of agricultural produce by river and also round the coast by sea. And as the paintings show, enclosures brought new field patterns, which were smaller and had newly planted hedges of hawthorn. New roads with wide verges were designed by the enclosure commissioners, many of which remain to this day. Another difference in the landscape was the newly built and relatively isolated farmhouse. This was a simple and logical development of the redistribution of land into more compact blocks in single ownership. Was it not much more sensible for a farmer to live in the centre of his land rather than in a village on the edge?

Origins of hunting. The new hedges in particular and the enclosures in general were to have a profound effect on sport, especially hunting. As has been explained, the countryman's skills were widely known and practised, whether in pursuit of game for a fresh meal or of herbs and roots for medicinal remedies or palliatives. A simple snare or a net would catch most small animals, for rabbits and birds, including wildfowl, were a necessary and natural part of the diet. It

FRANCIS SARTORIUS (1734–1804): *The Fermor Brothers.* Signed and dated 1764. Canvas, 89 × 150 cm. Private Collection

Son and father of sporting painters, Francis Sartorius here shows hunting before it became the fashion and when it was still pursued only by landowners, their friends and servants. The tiny hounds are harriers (specially bred to hunt hare). Aynhoe House is on the hill in the centre and in the fields to the right can be seen signs of agricultural progress; enclosed wheat fields with a new windmill conveniently situated nearby and a farmhouse built away from a village are also indications of changes in the pattern of the ownership of land.

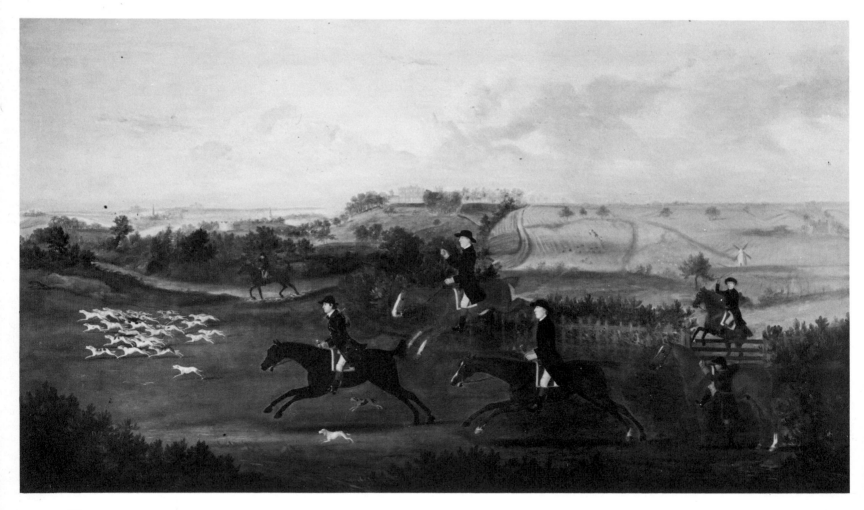

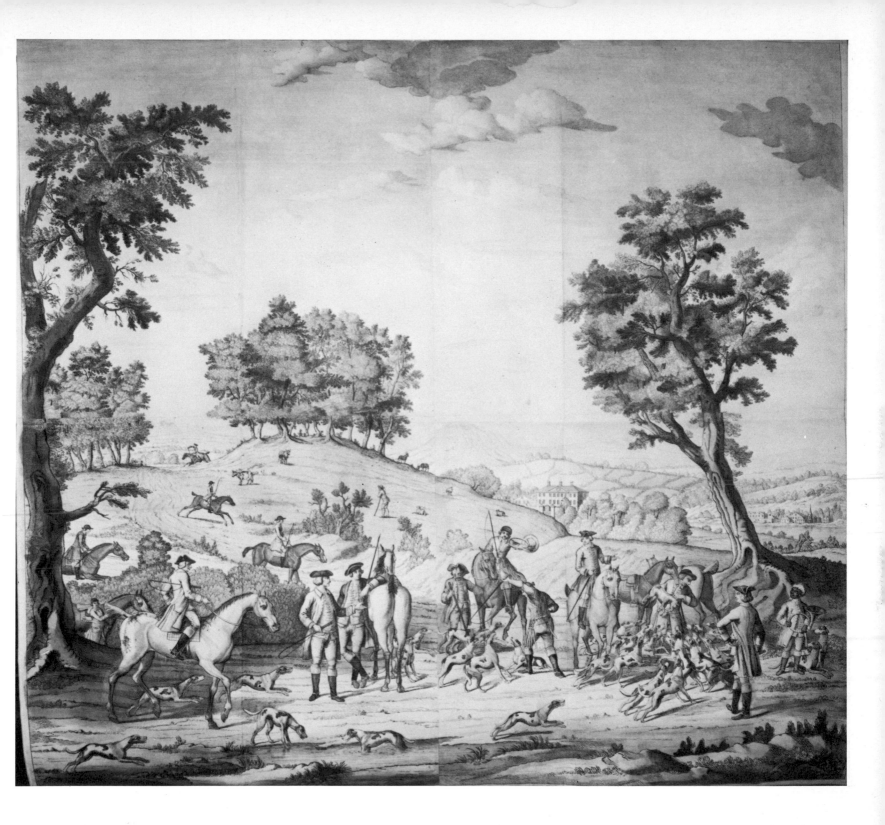

JOHN JUNE (*fl.* 1740–70): *The Death of the Fox.* Line engraving, hand-coloured with sepia, blue and grey washes, 103·5 × 112·7 cm. London, British Museum

But for the invention of the aquatint and the all-pervading attraction of the many-coloured watercolour painting, this rare print might have had many imitators. It takes its inspiration from the tonal style of wash drawing then fashionable. Because of its relatively large size it is made from four sheets of paper joined together: another century was to pass before the invention of machinery able to make paper larger than a man could hold. The composition of this print is also fascinating, for the landscape has been as artfully designed as if it were one of the newly constructed parks of Capability Brown. The elegance has been extended to the sportsmen, whose self-consciousness is as obvious from their swagger as from their small blackamoor servant – seen on the extreme right.

OTHO HOYNCK (*fl.* 1661–86): *A Greyhound.*
Signed and dated 1673. Canvas, 113 ×
145·5 cm. Private Collection
Hoynck came to England from The
Hague in 1661 as painter to (that is, under
the patronage of) the Duke of Albemarle.

GEORGE STUBBS (1724–1806): *Ringwood, a
Foxhound.* 1792. Canvas, 100 × 126 cm.
Collection of the Earl of Yarborough
It was not until the latter part of the
eighteenth century that as much careful
attention came to be given to the breeding
of foxhounds as to horses. One of the most
important of the family-owned packs was
the Brocklesby, whose master, Charles
Pelham, 1st Baron Yarborough, commis-
sioned this portrait of a great stallion hound,
ancestor of a continuing and reliable line.
The foxglove on the right is a plant which
has had powerful fairy connections from
ancient times; the fairies were said to have
given the flower heads to the fox, which,
when wearing them on its feet, was ren-
dered silent of approach or retreat.

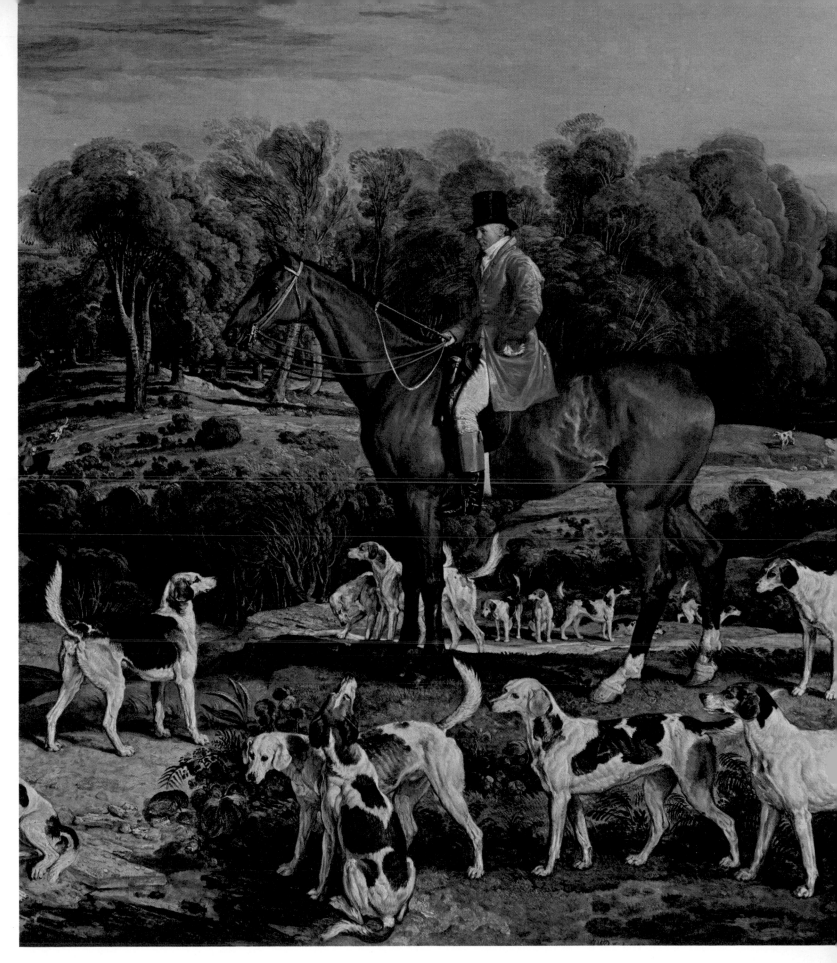

James Ward: *Ralph Lambton and his Hounds.*
Detail from plate on page 79

FRANCIS BARLOW (about 1626–1704): *Hare-Hunting*. Pen and wash drawing, 14·9 × 21·5 cm. Oxford, Ashmolean Museum

Barlow was an artist who really understood animals and who keenly watched them. These hounds, the large southern-mouthed variety, are seen to be what their reputation says they were: slow enough to be followed on foot, with good noses, equable enough to be directed by voice and gesture, yet sure and steady once they were on a line. Eventually they were to be ousted by the breeding of quicker, better working hounds in harmony with the general improvement in horses.

is no wonder, then, that brutal enclosures of large areas of waste land, or the draining of many acres of fen, were sometimes the occasion for mob violence and riot, for what had been taken away was not so much the land as the opportunity for the taking of food. When one's way of life demands that one lives from day to day, then the idea of agricultural improvement is hard to bear, for the results will only be seen several seasons away. It was this need to find and take food from the countryside that kept all hands turned against the fox, which preyed on the same animals – wild and domestic – as man. The idea of hunting the fox had been welcomed by all from the earliest times, but it was only late in the history of the English countryside that the fox began to be hunted because it provided the chance of a good day out on a splendid horse in convivial company.

Since medieval times hunting the hare had been considered the supreme test of skill for horseman and hound; it was very fast but it ran a jinking, intermittent line that gave those in pursuit as much chance of catching it as of losing it. The fox, on the other hand, could run a true, straight line, with every chance of outdistancing its followers as both horses and hounds were as yet relatively slow. Like the hare and indeed deer, the fox could be coursed by greyhounds, though these depended on sight rather than scent.

Mention has already been made of Queen Elizabeth I's interest in sport. Her successor on the throne of England, James I (reigned 1603–25), was likewise passionately fond of hunting – as had been his mother, Mary, Queen of Scots. He took the opportunity of the long journey south for his coronation in London to hunt all the way. His quarry was the hare, and the country he passed through was mainly uninhabited, untilled heath. In fact it was sport that first attracted James I to Newmarket, for the Heath gave him a variety of opportunities for hunting both with hounds and with hawks. It remained for his grandson, Charles II, to make Newmarket the centre for racing.

Early hounds. One of the curiosities, to modern eyes, of a hunting picture of the seventeenth or early eighteenth century is the size (and general physical appearance) of the hounds; it is tempting to explain this as an example of artist's licence or, in other words, as inaccuracy on the part of the painter. This is to forget the supremely important thing about the kind of art that is the subject of this book: that it was produced to the exacting requirements of a very knowledgeable patron. To be successful, technical accuracy was more important even than artistic merit (however defined); but sometimes, to our delight, the two are happily combined.

The large hounds so often shown in the early pictures were indeed like that, for these were the southern-mouthed hounds. Thought to have originated in Gascony in medieval times, they were slow, heavy, patient, steady and with a good nose for a scent. Hunting of fox and hare was a vastly different sport in earlier days: it was much slower and, with long runs uncommon, could easily be followed on foot. Generally it was a private pastime restricted to the master, his family and a few invited friends. And they would meet much earlier, before dawn, so as to find the fox above ground and with a full belly after a night's hunting on its own account. Lastly, these hounds were usually too slow to catch the fox, which would generally run to earth, be dug out and then killed. All being well, the hunt would be over by the middle of the morning, after which all could go about their usual business.

However, in line with the other revolutions, there were to be quite considerable changes in the mode of hunting – faster horses alone demanded new ways, if only to ensure good, that is long and exciting, runs. Although hounds were too slow to catch a fox, it was not uncommon for them to work the fox out of cover and then for greyhounds to course it. Another method was for one or two old and experienced hounds to find the fox in cover, after which the rest of the pack would be uncoupled for the chase. The contrast to the slow, steady southern-mouthed hound was the northern fox-beagle, fleet and tiny by comparison. It was from their union, brought about – fittingly enough – in the Midland counties, that the modern foxhound is derived.

Hunting revolution. The person most closely identified today with the changes in fox-hunting was Hugo Meynell, an immensely wealthy squire who moved to Quorndon Hall in Leicestershire in 1752. As a young man he grew dissatisfied with the old ways of hunting, in particular with hunting hare, which was undeniably skilful but not particularly exciting for the keen horseman; nor indeed was the slow, methodical hunt for fox from cover to cover in the early morning. Meynell began his hunting later in the day; by mid-morning the fox would have slept off and digested its night's meal and would be prepared to run. In line with this, Meynell paid close attention to the breeding of hounds, for pace and endurance as well as for their powers of scent. The open character of the country around him – the mature turf, the low hedges and fences, and the long, fast runs – attracted

followers with blood horses, which were superbly bred and vastly expensive even then.

Thus it was in the 1780s that a new style of hunting was evolved: riding up with the hounds and flying over the hedges and ditches. (The earlier custom had been for the horse to take a jump standing, sometimes even with its rider dismounted.) In addition, Hugo Meynell was not only rich, he was a man of fashion, conversation and manners – and these were their own attractions for a high-quality field of followers. They also contributed to his success with farmers and other landowners, for he was as considerate of their rights as he was conscious of his own duty to repair damaged fences and to see that gates were closed. Then, as now, fox-hunting was really only possible with the voluntary cooperation of many more than those who actually rode to hounds. Mr Meynell's success contributed to the rise and dominance of the Shires (Leicestershire, Northamptonshire and Rutlandshire) as well as to the idea that it was fashionable and stylish for

JAMES WARD (1769-1859): *Ralph Lambton and his Hounds*. Signed with initials. Pencil and watercolour, 16·2 × 22·2 cm. Photograph by courtesy of Christie's

This is the sketch for the finished painting on the opposite page. In size and finish it has all the marks of a hasty sketch done in the field, worked up afterwards in watercolour at home.

JAMES WARD (1769-1859): *Ralph Lambton and his Hounds*. Canvas, 137 × 213 cm. Collection of the Duke of Northumberland

Here in superb combination are the talents of a great artist and a famous master of hounds. This is the epitome of the sporting picture, set in the wonderful rolling landscape of County Durham.

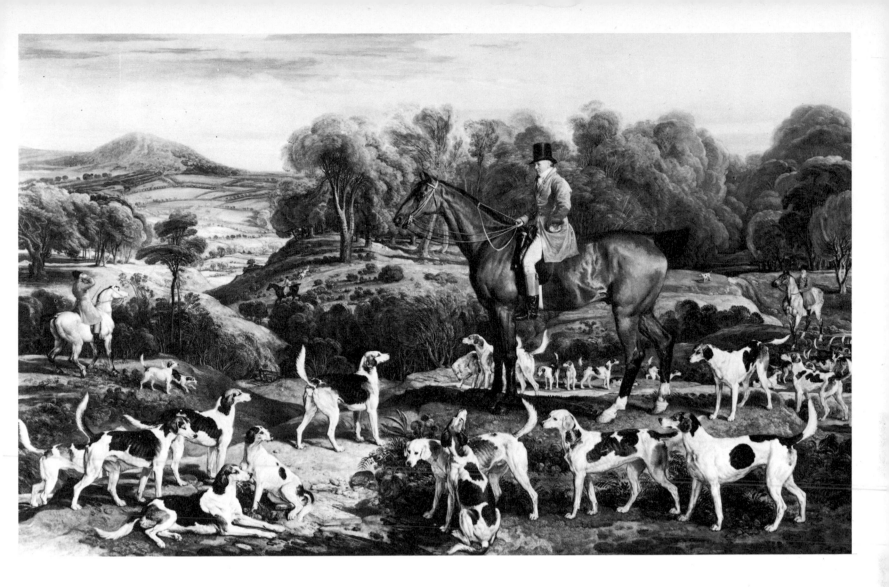

JAMES WARD (1769–1859): *A Foxhound in a Landscape*. Signed in monogram and dated 1835. Panel, 24·1 × 33·7 cm. Photograph by courtesy of Sotheby's

This painting expresses as much about the favour with which an important hound might be viewed, as it does about the slowly changing attitude of sporting painters to their art. Though the animals are portrayed as clearly and carefully as in the past, the seeds of sentimentality have already been sown in the way that the hound has been given an heroic pose emphasized by the confines of a tiny picture. The same hound appears in the large painting of Ralph Lambton with his pack (above).

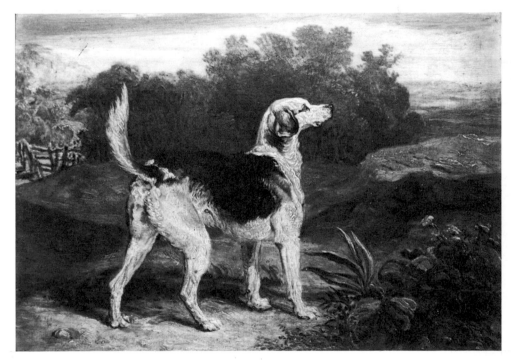

like-minded hunting men to don a uniform. The hunt supper and the hunt ball were invented, and men like John Corbet and John Warde became a kind of peripatetic master of hounds, moving on from pack to pack as inclination and invitation took them.

Coursing. At about the same time there grew up an interest in the improvement of the breeding of the coursing greyhound. Despite the decline of interest in hare-hunting with harriers, the hare remained an important source of fresh meat, as well as of sport. It was in 1776 that organized match-coursing first began with the foundation by Lord Orford of the Swaffham Coursing Society in Norfolk. With prizes in prospect and the ever-present attraction of wagers on the

SAWREY GILPIN (1733–1807): *John Park-hurst of Catesby Abbey, Northamptonshire*. 1785. Canvas, 127 × 165 cm. Private Collection

This marvellous picture explains just why so many people go hunting – the thrill of riding a good horse well, the excitement of an unpredictable chase, the fascination of watching hounds work. Here the aptly nicknamed Handsome Jack is bringing up a couple of laggard hounds to cover – the woodland on the right into which the rest of the pack and the huntsman have already disappeared in pursuit of a fox.

EDMUND BRISTOWE (1787–1876): *William Sharpe on Cocky*. Signed and dated 1816. Panel, 62·2 × 73·6 cm. Private Collection

William Sharpe was huntsman to Charles Shard of Lovel Hill, Berkshire. Charged with the day-to-day management of the hounds and requiring a deep knowledge of the surrounding countryside and its people and of the habits of its animals, especially the fox, successful huntsmen achieved fame equal to their masters. There was no condescension in a master commissioning a portrait of a servant, for their relationship was securely founded on mutual respect; the idea of servility as opposed to service is of modern urban origin. Bristowe was born in Windsor and worked mostly in the district, always in the meticulous manner that this painting exhibits.

HENRY BERNARD CHALON (1771–1849): *Unkennelling the Royal Hounds on Ascot Heath*. Signed and dated 1817. 103 × 129·5 cm. Royal Collection. Reproduced by gracious permission of Her Majesty The Queen

Painted for the Prince of Wales, who, like his father, George III, was a keen sportsman, the picture shows the frisk and general delight of hounds fanning out in a stream from their kennel gate before a day's hunting. The huntsman in the centre, wearing the distinctive gold and scarlet royal livery, is George Sharpe on his favourite horse, Flamingo.

HENRY BERNARD CHALON (1771–1849): *Raby Pack*. Mezzotint by William Ward, 1814, 52·1 × 59·6 cm. London, British Museum

The 3rd Earl of Darlington (later Duke of Cleveland) hunted a huge country in Yorkshire; he had enormous energy and concerned himself with every detail to a meticulous degree. Something of this can be gauged from Chalon's unique representation of the Earl's hounds feeding in ken- nels. His huntsman, Sayer, is in the door- way, with the dog-feeder, Leonard, in the centre of the genial affray. As well as 'correct portraits of the most celebrated hounds' (as stated in the legend under the print), Jasper the terrier is prominent in the right foreground.

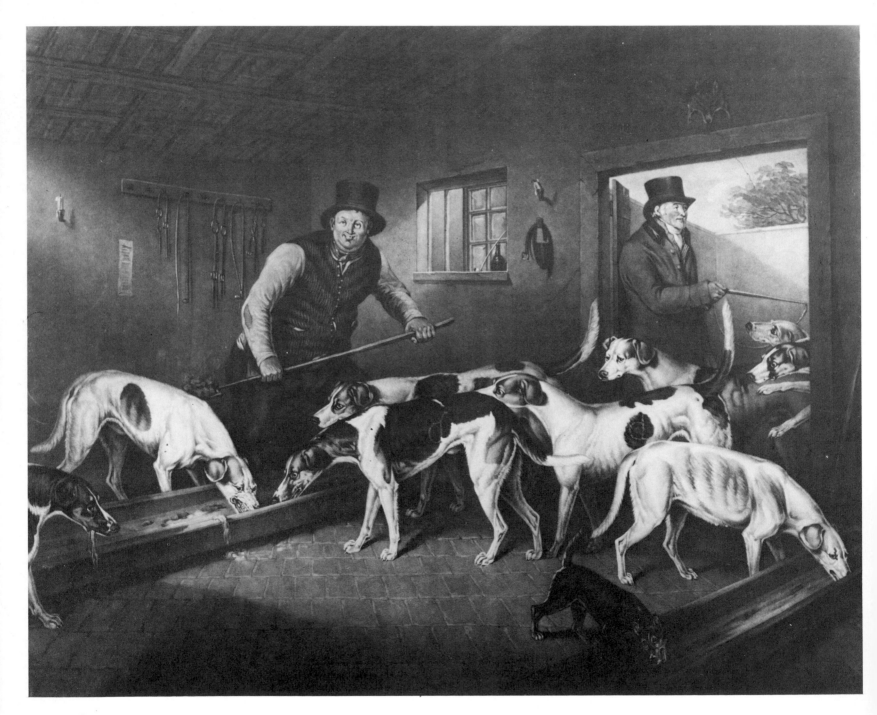

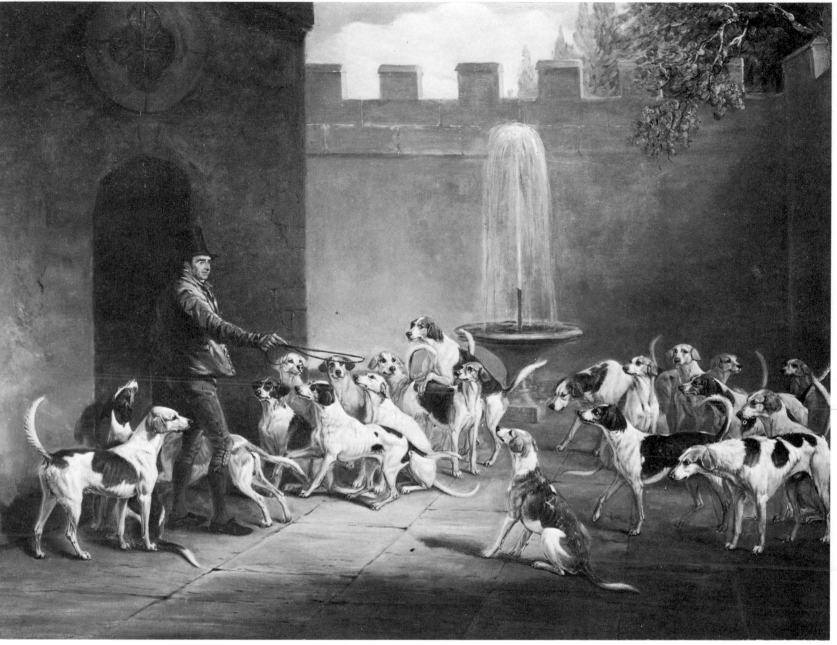

JOHN FERNELEY (1782–1860): *Ralph Lambton's Hounds Drawing for Feeding with the Huntsman, R. Fenwick*. Signed and dated 1833. Canvas, 83·8 × 113 cm. Photograph by courtesy of Arthur Ackerman and Son

Such grandeur for kennels gives some indication of why the days of the private pack were surely numbered. Few men could afford the several thousands of pounds a year necessary to maintain such a stylish and large establishment; within the next two or three decades even the most splendid magnates were soliciting hunt members by subscription. On the extreme left is the same proud hound that occupies the centre of James Ward's painting of Mr Lambton and his pack (page 79).

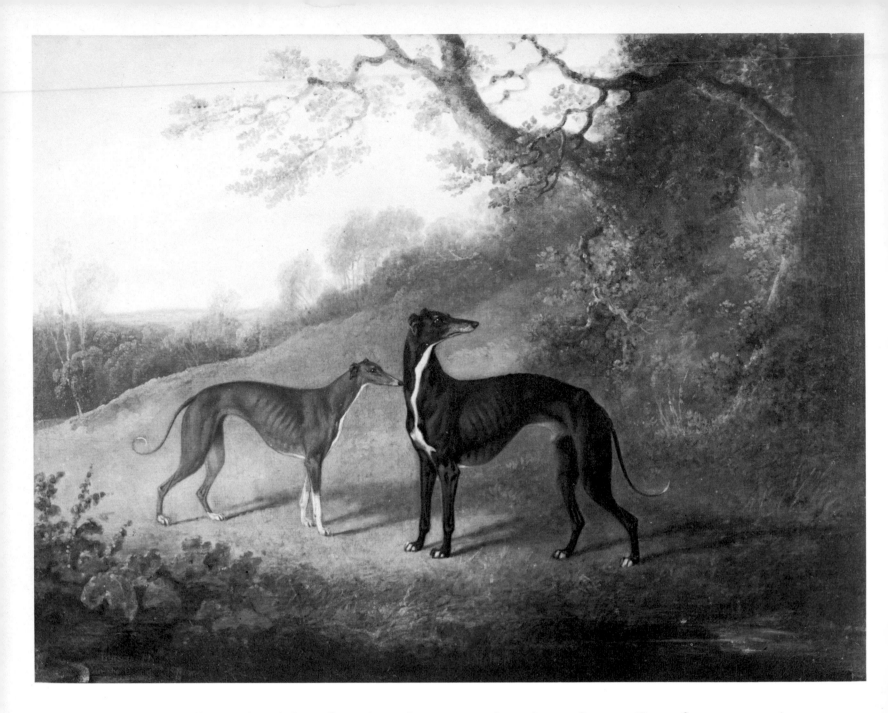

result, the breeding and training of greyhounds to course hare in competition with each other became of great importance. The new sport grew at a phenomenal rate and was to cover the whole country by the end of the century.

Cricket. It is surely no accident that the last half of the eighteenth century saw the rise and formal organization of cricket. This mysterious and rhythmical game, as gentle as it is fierce, essentially depends upon firm, undisturbed turf with some kind of obvious boundary. It grew, not surprisingly therefore, in the counties of the old (that is, Tudor and earlier) enclosures in south-eastern England: Kent, Sussex and Hampshire. The length of the pitch is not so arbitrary, either, when it is realized that the effective width of an individual's strip of land was approximately twenty-two yards – measured from ridge to

CHARLES HENRY SCHWANFELDER (1774-1837): *Botsam Fly*. Canvas, 68·5 × 88·9 cm. Trustees of the Lane Fox Settlement

Though of German descent, Schwanfelder was born in Leeds and painted largely in and around his native Yorkshire; he was animal painter to George IV. The affection of dog and bitch is seldom shown and can rarely have been painted in quite such a touching way. Greyhounds or not, fine animals always know themselves to be such and carry themselves with great natural dignity.

HENRY BERNARD CHALON (1771–1849):
Snowball. Mezzotint by William Ward,
1807, 49·5 × 58·5 cm. London, British
Museum

Chalon was a well-known animal painter
who was patronized especially by the royal
family. He married a sister of the artist
James Ward. In the tradition established by
Stubbs, Chalon was a particularly close
student of animal anatomy, well illustrated
in this very fine print.

GEORGE GARRARD (1760–1826): *Two Grey-
hounds in a Stable*. Signed and dated 1822.
91·5 × 133·3 cm. Photograph by courtesy
of Christie's

Much attention was paid to the breed-
ing, training and feeding of the greyhounds.
Here two enthusiasts discuss their chances
whilst others are bringing their blanketed
greyhounds to the door of the inn opposite.

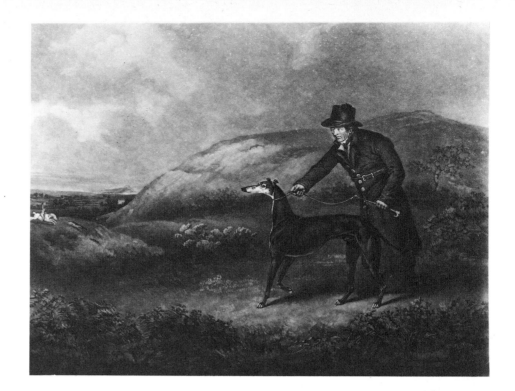

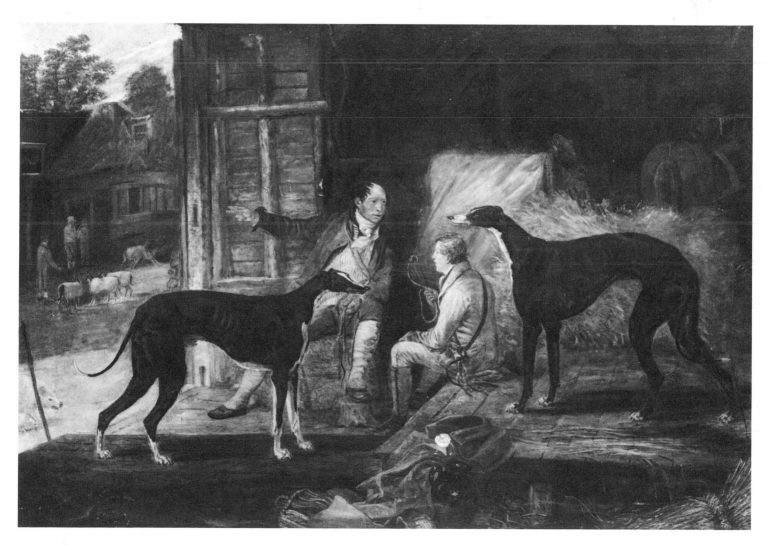

THOMAS HENWOOD (*fl.* 1842): *The Scorer – William Davies of Brighton.* 1842. Canvas, 35·5 × 30·5 cm. London, Marylebone Cricket Club

William Davies was scorer to Lewes Priory Cricket Club and he is surrounded here by the tools of his trade – a tobacco pipe to ensure equanimity, alcohol to aid concentration, bats, ball and stumps for the game, plus a tape-measure to confirm that the wicket is the right length. Cricket is a game that is also a sport; exactly why is known only to those that watch or participate.

GEORGE FREDERIC WATTS (1817–1904): *Alfred Mynn.* Lithograph by the artist, about 1847, 33 × 25·4 cm. Marylebone Cricket Club

Watts portrayed in superlative form many Victorian celebrities, none larger perhaps than Alfred Mynn (1807–61), who was more than six feet tall and weighed close on twenty stone. He was a hop merchant and he played cricket for his county, Kent, and the All-England Eleven. Mynn was immensely popular and particularly famous for his fast, accurate, round-arm bowling. His action, so powerfully drawn here, is reminiscent of the pugilists of an earlier time.

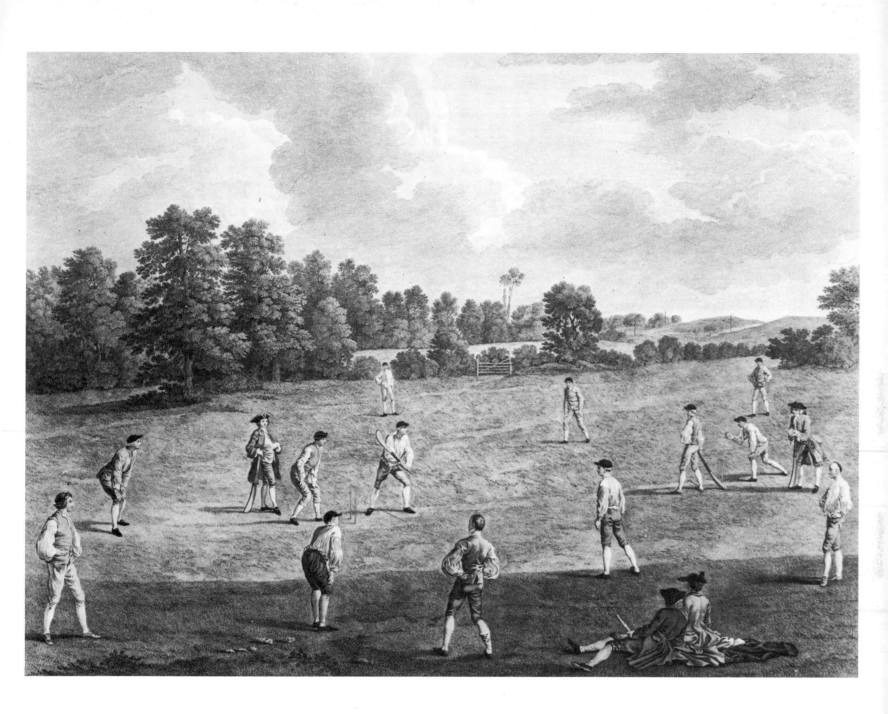

Francis Hayman (1708–76): *Cricket in Marylebone Fields*. Line engraving, 1748, 23·5 × 34·2 cm. London, Marylebone Cricket Club

In this peaceful setting at Mr Lords' cricket ground just outside (old) London, it is difficult to remember that the game could be played in a vastly different way. Under the pressures of team sponsorship and enormous bets, games might be fixed or thrown, so that as a spectacle they sometimes ranked with others equally unsavoury, like prize-fighting or bull-baiting.

ridge as worked by the plough. In earliest times it was the bowler who chose where to pitch his ball, although this was to a certain extent predetermined by the lay of the land; even the wicket must have had its origin in the stumps of wood that marked the boundaries of each strip, and in the simple skill of the hurdle-maker, whose products were used to fold the sheep. Like so much in the countryside, cricket was a classless sport; once more its competitive aspect soon attracted the attention of those who found their enjoyment in the placing of wagers and in betting – with all that this meant in attendant roguery and skulduggery.

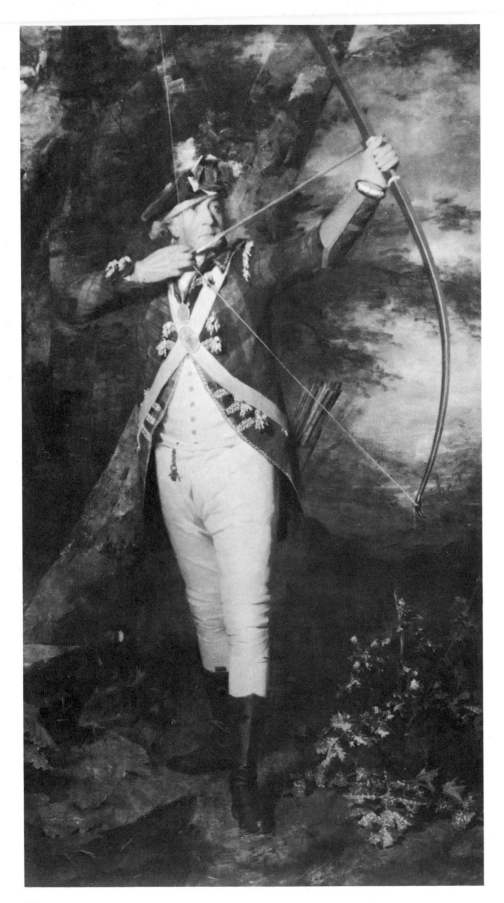

SIR HENRY RAEBURN (1756–1823): *Dr Nathaniel Spens*. 1791. 237 × 147·3 cm. Edinburgh, Royal Company of Archers

Dr Spens was president of the Royal College of Physicians of Edinburgh and later president of the Royal Company of Archers, whose uniform he is seen wearing here. It would be hard to express better the mixture of martial elegance and military eccentricity that characterized the whole romantic revival of archery during the latter part of the eighteenth century. Important portrait painter though he was, Raeburn excels himself in this picture.

ROBERT SMIRKE (1752–1845) AND JOHN EMES (*fl.* 1785–1805): *A Meeting of the Society of Royal British Archers in Gwersyllt Park, Denbighshire*. Etching and aquatint by C. Apostool, 1794, 46·3 × 58·4 cm. London, British Museum

In the late eighteenth century the idea of the Picturesque infiltrated all forms of English art and architecture. Much less familiar is the impact that it had socially, most notably in the revival of archery, and this at a time when the gun had become much improved and was more generally available. Archery societies sprang up all over the country, several under the patronage of the Prince of Wales. Some, like this one, insisted that women shot on equal terms with men. With its appropriately picturesque composition, this beautiful print shows that there were two other important aspects to archery much emphasized at the time: relaxed sociability and the wearing of specially designed uniforms.

The figures are by Smirke and the landscape by Emes.

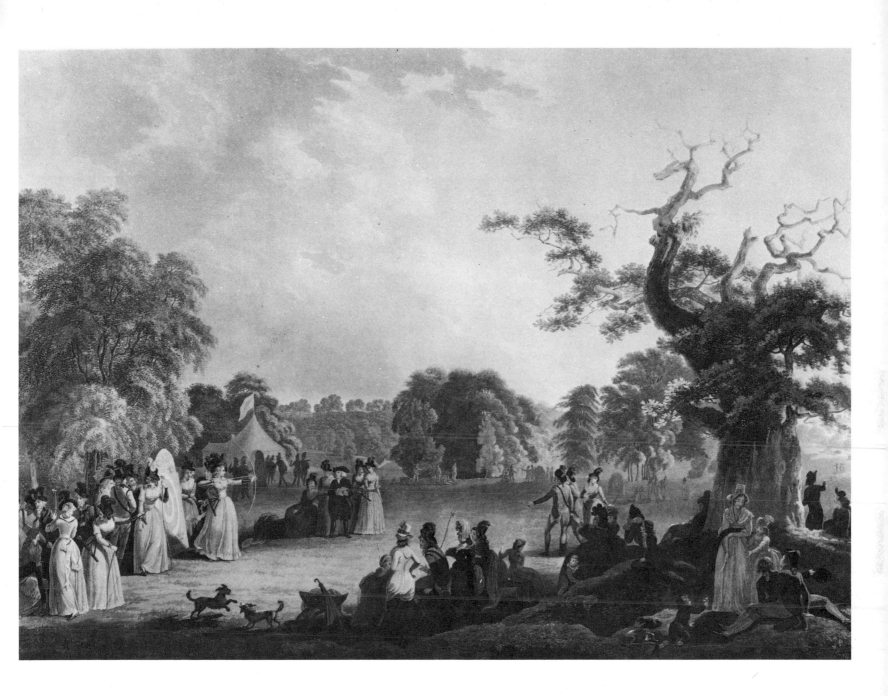

Archery. Amidst all this relatively stern emphasis on the refinement and general improvement of sport of all kinds, there was an unexpected revival of a sport as archaic as it was romantic – and thus in tune with the general feeling of the age. I refer to archery.

The Toxophilite Society was founded in 1781 by Sir Ashton Lever, though its inspiration came from his friend Thomas Waring, who, through overwork, contracted some sort of chest complaint that his doctors were unable to cure. In earlier days Waring had studied the art of bow-making at the hands of an old bowyer; he resolved to try archery and did so with such good effect that Sir Ashton, who was already a keen sportsman, became inspired to follow his example. (Sir Ashton Lever had an unusual gift for training animals: he was

said to have trained his horses to open and shut doors as well as to fetch and carry at his command.)

Within a few years the young Prince of Wales (the future George IV) had become patron of the new society (and of several others); as well as giving prizes he became a keen shot as had both Queen Elizabeth and Charles II before him. Based as it was in London, the Royal Toxophilite Society had an inevitable problem in finding a suitable ground over which to shoot and, for a few years, used Mr Lord's cricket ground.

Although the longbow, and particularly the crossbow, had been used for sport until their supersession by the gun, there was during the revolutionary wars at the end of the eighteenth century a serious suggestion that, for speed and economy of re-arming, the longbow should be revived in combination with the pike (following an idea first put forward 150 years before). It isn't only the countryman, it seems, who is prone to archaic ideas. The last offensive use of the longbow was probably in Edinburgh in 1791 – a duel when two gentlemen loosed three arrows at each other without recorded effect.

The fashion for archery was relatively short-lived. None the less it has a place here as it was the progenitor for several remarkably fine prints. These were principally inspired by the activities of the Royal British Bowmen, founded in 1787 and flourishing only until 1794, when the members resolved that 'on account of the several military employments which many of the members of this society have entered into . . . meetings [shall] cease till peace be restored, and our bowmen more at liberty to attend the noble science of archery'. Like all archery societies, much emphasis was laid on the conviviality of the gatherings and on the importance of uniforms, which had to be worn on all occasions. Unlike other archery societies, however, the Royal British Bowmen included women as well as men amongst its members, preferring to have no formal dealings with those that 'consist of gentlemen only, who meet at inns'.

In this connection it is worth remembering that by the end of the eighteenth century both hunting and racing had become predominantly bachelor and drinking sports. Thus both inadvertently heralded their decline and change in the face of new customs and ideas, derived from urban ways of looking at the countryside.

Flintlock gun. But there was a new sound in sport – the whirring of wings, the crack of powder, the rustle of a dog: for the new kind of gun could hit a flying bird. The stimulus of the Civil War had had the usual effect on weapons, improving some, discarding others. The hawk and the bow were now effectively doomed in favour of the flintlock gun.

By the last part of the seventeenth century the new sport of shooting birds in flight seems to have become fairly general. Once again, it was a foreign invention that provided the stimulus. The basic problem lay in the ignition of the powder in the breech of the gun so as to blow the ball or hailshot out. The simple matchlock (already described) was

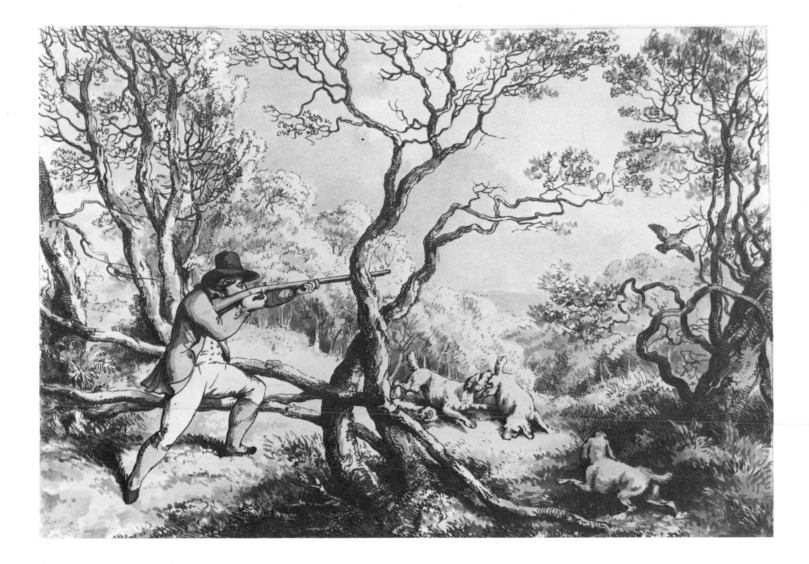

SAMUEL HOWITT (1765–1822): *Woodcock-Shooting*. 1791. Etching, sepia wash added by hand, 17·8 × 25·4 cm. London, British Museum

Howitt was Rowlandson's brother-in-law and an enthusiastic sportsman. He was a master of line, too, for at first glance this etching could easily be taken for a drawing. Here the game has been flushed from cover by the spaniels, and whilst the shooter's stance would not meet with general modern approval, it would be reasonable in the woodland conditions which make their own special demands on the sportsman's skill.

at its most effective on a still, warm day. These are uncommon conditions anywhere in northern Europe, whether for sportsman or soldier. How then to make a more certain ignition spark? In the early sixteenth century in Nuremberg the wheel-lock was invented, which essentially caused a spark by friction between pyrites and a whirling metal wheel. This was a better method but still relatively inefficient and considerably more expensive than the matchlock, so it remained little used in late Tudor and early Stuart England except amongst the ranks of the most wealthy sportsmen.

The next development came in the late sixteenth century from Holland, where it was said to be the invention of poachers, frustrated no doubt in the early alarm given to their prey by the shower of sparks from the wheel-lock. Their idea was the snaphaunce, in which there were two hammers facing each other, one of steel, the other holding a flint; the first was lowered into the flashpan containing the priming powder and was struck by the other when the trigger was pulled, thus creating a spark.

It was the Spanish a little later (before the end of the sixteenth century) who refined the idea of the snaphaunce and invented the true flintlock, in which the steel hammer was joined to a flashpan cover that protected the priming powder from rain, damp and spillage. Only one hammer now remained – that which held the flint – and when the trigger was pulled, the hammer (and its flint) was released and flew forward to strike immediately on the steel, causing a stream of sparks and knocking the steel forward and open so as to ignite the powder.

The flintlock was effectively unchallenged until the beginning of the nineteenth century, though it was continually refined and made safer; for instance through the idea of the half-cock, whereby the hammer was effectively locked and could not be fired without being drawn back to its full extent. This made loading, and the carrying of

HENRY ALKEN (1785-1841): *Partridge-Shooting*. Pencil and watercolour. 26·7 × 36·8 cm. Photograph by courtesy of Christie's

It would be hard to improve on the feel of this picture, with the kind of rough shooting that countrymen still enjoy 150 years on, and light years away from the organized shoots that now dominate the sport and that had already begun in the early years of the nineteenth century. As guns were still fairly slow of action it was not yet possible to shoot birds unless they were flying away from the shooter, though there had by now been sufficient improvement to shoot them flying rather than on the ground. Alken's watercolours and drawings have a direct charm of their own.

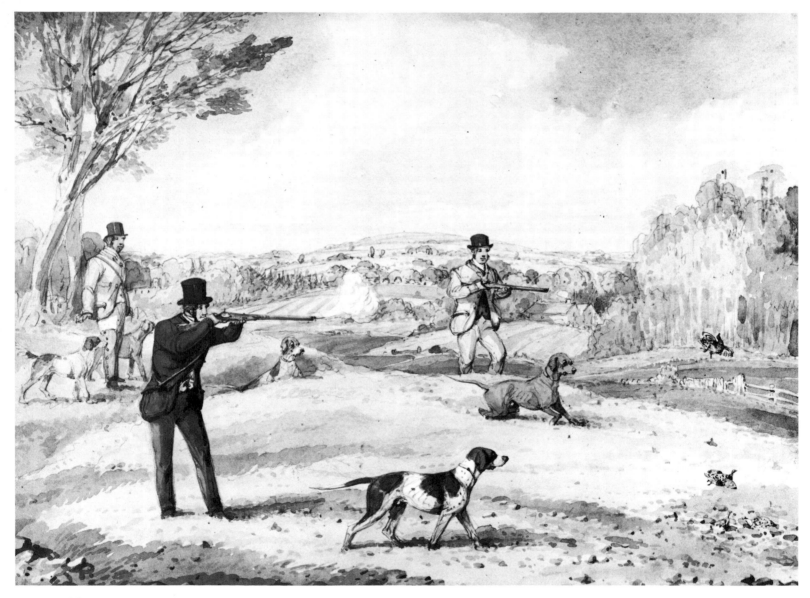

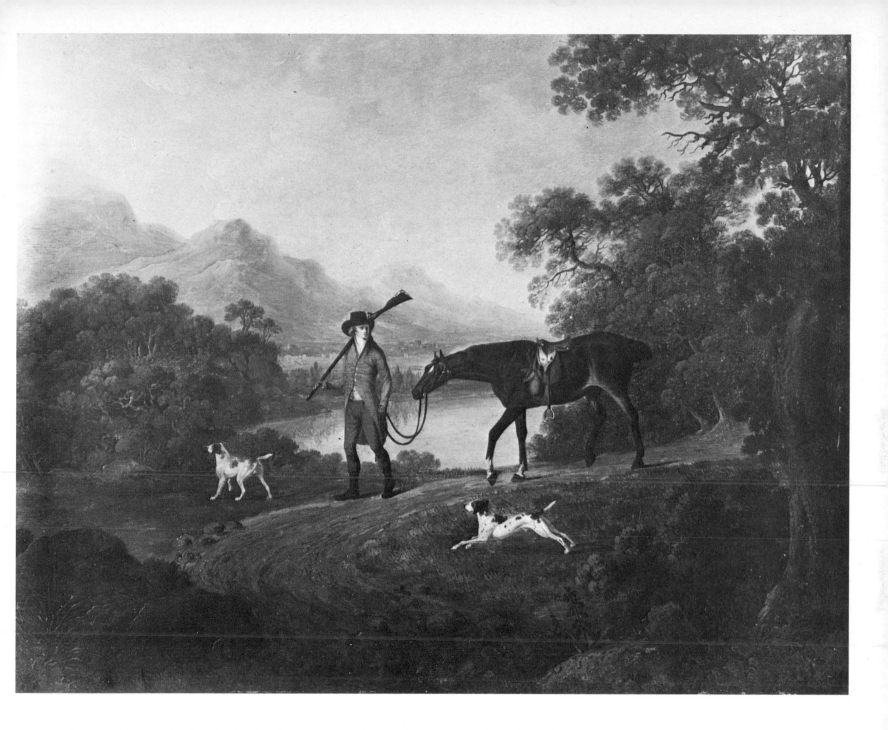

CHARLES TOWNE (1763–1840): *Gentleman Returning from Shooting*. Signed. Panel, 30·5 × 38·3 cm. Liverpool, Walker Art Gallery

In the hands of a lesser artist this painting would have dissolved into sentiment. But Towne combines landscape, companionship and sport in rare and attractive harmony. Only the brutish will ride a tired and lame horse after a successful day out, and here man and beast are united in a kind of contented weariness. (Why else would the sportsman carry his gun that way?) Dogs always seem to have a burst of energy left.

the loaded guns, much safer. None the less the loading procedure (generally by way of the muzzle) of priming then charging with powder, bullet or shot was slow and complicated. Accidents amongst beginners were inevitable, caused from over-charging, loading at full cock, forgetting to withdraw the ramrod or even to prime the flashpan. It is no wonder that the military developed a drill in which the whole process was made to follow a regular sequence; this was promulgated amongst amateurs by a number of different series of engravings showing the process.

Exiles returning to England after the Restoration had already savoured the delights of shooting birds flying. Our own guns were beginning to improve, to the extent that English gunsmiths had the

confidence and skill to sign their weapons. A new phase began in 1672, when the Gunsmiths' Company was given the powers to rest and proof all barrels with a double charge of powder and shot. Whilst we inherited silver inlay and elaborate engraving from guns made on the Continent – the French in particular making the best guns as well as being the best shots – the English were quick to develop the sleek and chastely decorated gun that was, in its turn, to influence the designs of the rest of the world. The pictures, and remaining examples, show the barrels to have been considerably longer than we are accustomed to today. But a barrel four-and-a-half feet long was an absolute necessity as the powder was relatively slow burning, and the ball or shot needed more time to accelerate before leaving the muzzle. Indeed, double-barrelled guns of the late seventeenth and eighteenth centuries are almost unknown as they were too heavy for practical use.

The new, broad acres of corn and root crops like turnips, by providing ideal cover, encouraged pheasants and partridge to flourish. Although the flintlock gun was relatively slow, it was accurate and efficient enough to be used against a bird on the wing – at least one flying away from the shooter and thus presenting a longer and straighter target than a bird flying across or towards the gun. But with the advance of skill, the challenge of sport, and the aid of a well-balanced gun, it was not long before the more difficult shots were being made as well at birds passing directly in front or overhead. The guns were fine looking and they were expensive, and as deer were few and the hawk outmoded, shooting became the landowner's sport.

Birds as food. It must never be forgotten that birds were for all sections of society a more or less essential food. The many ancient dovecotes still standing throughout the land are testimony to this. Even Cromwell's army was not above poaching tame pigeons (or domestic warren rabbits). The decoy was a method of gathering wild duck for the larder: it took the form of a long, tapering tunnel made from net, with tame, pinioned birds at the entrance to attract their wild brethren which, once brought to earth, would be worked up to the narrow end by a dog. Another, and much more widely used, method of catching birds (for the table especially) was by netting them, either when transfixed and held to the ground by the stare of a pointer or setter, or by a dog working a covey quietly into the net. The birds principally caught were pheasants, partridges, woodcocks and, in the north, grouse and blackgame. Smaller birds – such as the wheat-ear or thrush – would be snared or limed. The game laws forbade (in the interests of sport) the indiscriminate burning of bracken and heather thereby protecting not only birds but the hare.

Dogs. As the paintings uniformly show, dogs were very important to all levels of country society. As with horses, cattle and sheep, so thought was given to the improvement of dogs, for they were largely working animals, however companionable many might be as well.

At first, when game had to be taken on the ground or on the water – and only after being stalked and then shot by crossbow or matchlock

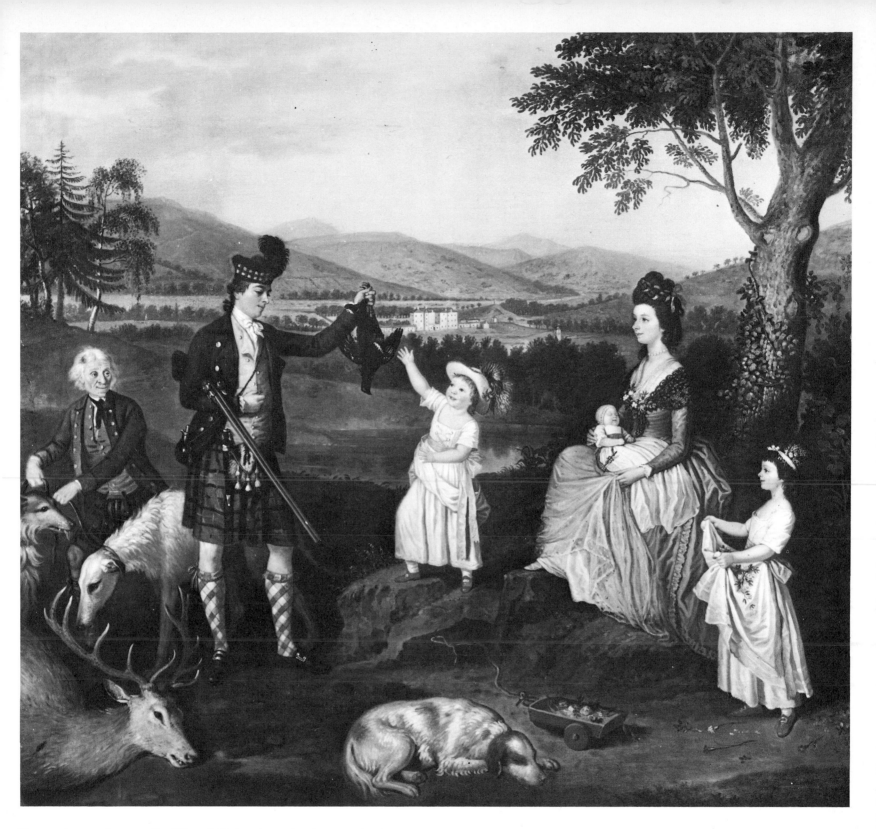

DAVID ALLAN (1744-96): *The 4th Duke of Atholl and Family*. 1780. Canvas, 91·5 × 101·5 cm. Private Collection

Here the Duke offers a blackcock to his son in a delightful family scene that is more informal in nature than the artist's chosen grouping and sitters' best clothes might indicate. The snoozing house-dog is the clue in the way that it remains unimpressed by the great stag or even by the exhausted deer-hounds. The sporting opportunities presented by the Scottish Highlands did not become widely known until Colonel Thornton toured them later in the same decade, taking the artist George Garrard in his train. David Allan was born near Edinburgh and spent more than a decade in Italy, where he acquired the friendship and patronage of Sir William Hamilton, whose wife subsequently secured immortality through her liaison with Admiral Nelson.

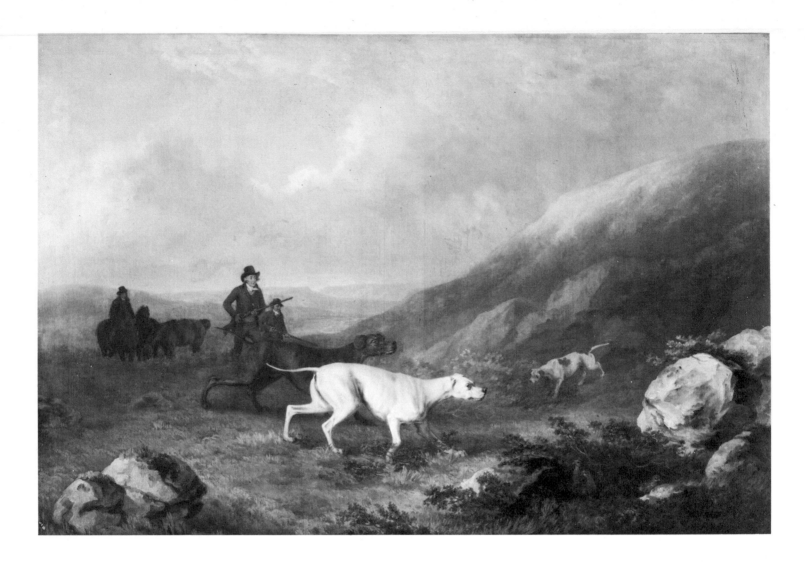

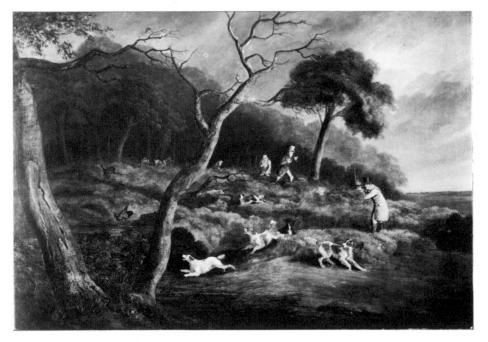

SAWREY GILPIN (1733–1807) AND GEORGE BARRET (1732–84): *Colonel Thornton with his Pointers, Juno and Pluto.* 1770. Canvas, 112 × 160 cm. Private Collection

Here animal artist (Gilpin) and landscape painter (Barret) work in concert to portray Colonel Thornton shooting partridge – lurking, as the dogs indicate, in the shelter of the boulder in the right foreground. The pointer was originally introduced from Spain about 1730; crossed with the foxhound in England to give it strength and stamina, it was made popular largely through the advocacy of sporting heroes like the Colonel.

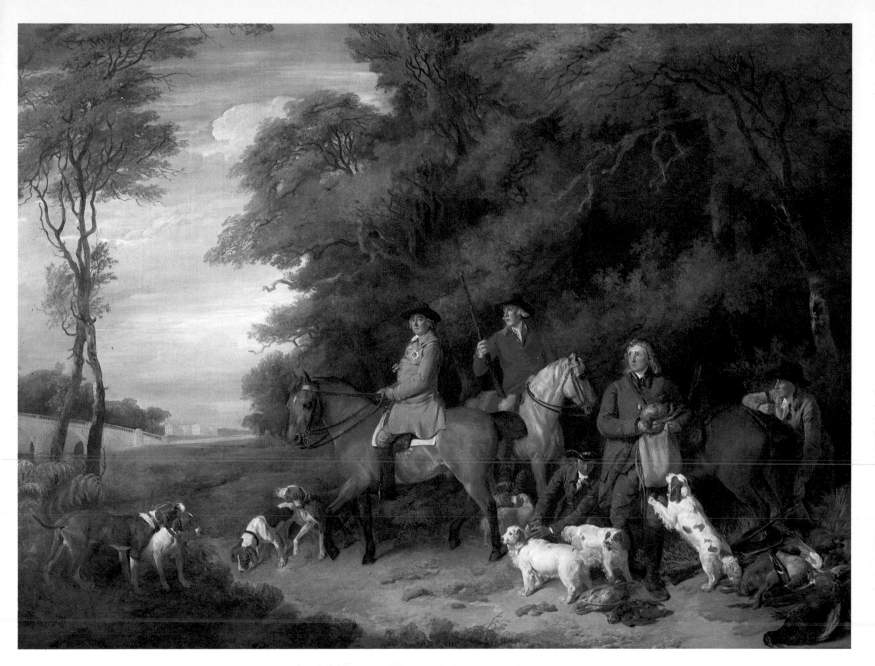

FRANCIS WHEATLEY (1747–1801): *The Return from Shooting.* Signed and dated 1788. Canvas, 156·2 × 209·5 cm. Trustees of the 7th Duke of Newcastle

Although modern experience and manners have obscured the point, the relationship of master and servant is a professional one that depends on mutual respect. Here the 2nd Duke of Newcastle, astride a sturdy shooting pony, is shown in easy companionship with his friend Colonel Litchfield, who rides behind; his gamekeeper Mansell; underkeeper Day, with the gamebag; and, to the right, Rowlands, his valet. William Mansell bends down to the special breed of spaniels – cock-springers – originally a present from the Duc de Noailles and since named Clumbers, after Clumber House seen in the distance.

(opposite, below)
SAMUEL ALKEN (1756–1815): *Pheasant-Shooting.* 87 × 124 cm. Liverpool, Walker Art Gallery

Son of Sefferin and father of Henry, who was the best known of the family, Samuel was a splendidly accomplished sporting artist. Pheasants know the value of undergrowth and need to be driven up and out of their lurking places by setters or other kinds of specially trained dogs. This same type of cover was equally sought by foxes and so there were inevitable clashes between the shooting and hunting interests – the former dependent on game being preserved (largely from foxes).

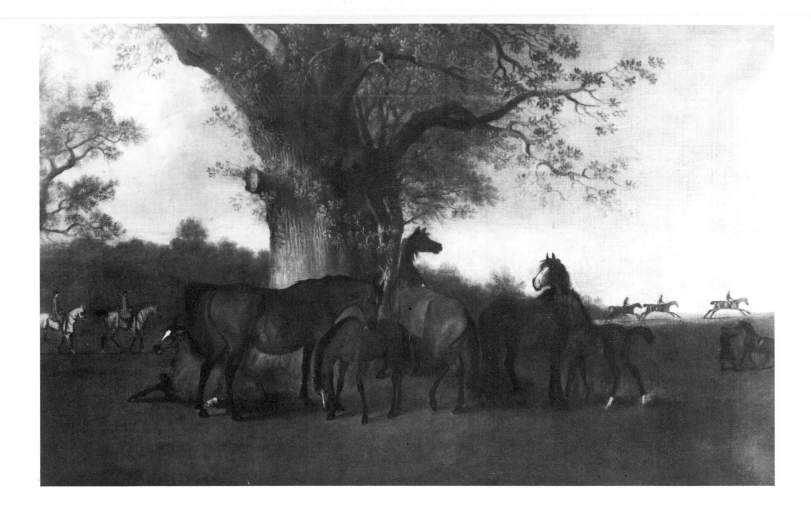

gun – then the ideal dog was a retriever. Better guns and experience of Continental methods led to the importing of pointers, which were able to find and point to birds on the ground but hidden, and afterwards to retrieve any successfully shot. The setter was a further development of this idea, and was a dog with more strength and stamina. Finally, as guns and shooting skills improved, the springer was evolved – a spaniel whose job was to flush, or spring, a bird from deep cover.

Bloodiness. To many modern eyes it is the bloodiness of sport that most appals. An analysis of this distaste shows that, more often than not, it is the idea rather than the experience that is most distasteful. One painting that represents for many everything that is wrong with field sports is Sawrey Gilpin's *Death of a Fox* (p. 104). Yet if you look at it objectively you will quickly see that it is more about defiance than it is about death; indeed it includes no blood of any kind. It is unlike, say, the animal-hunt paintings of Rubens, in which blood and gore are plentiful and obvious, and are generally discounted by the observer in the name of high art. The comparison is instructive, for it is one of the hitherto hidden marks of the Englishman's art that it is much more sensitive, more humane even, than the partial equivalents of other cultures. This is not to deny that ours was a rumbustious, earthy kind

SAWREY GILPIN (1733–1807): *Cypron with her Brood*. 1764. Canvas, 91·5 × 157·5 cm. Royal Collection. Reproduced by gracious permission of Her Majesty The Queen

Gilpin was an important animal painter in his time who now suffers rather by unreasonable comparison with the genius of Stubbs. In the context of a nation then besotted by the idea of breeding ever better, ever faster racehorses, the composite picture of a mare and her successful foals takes on a more immediate meaning. The theme made famous by Stubbs in a number of variations (see p. 58) is not really so much about maternity as ancestry: for a proven mare might be covered by a number of stallions and her progeny therefore very valuable. The general point is made in the background here by the scenes of horses training and racing.

of art; but this was the character of the time and the inevitable mould from which the artists drew their ideas.

Sawrey Gilpin. In the latter part of the eighteenth century people began to notice nature effectively for the first time; that is to say, they began to take account of it as something to be admired, sought out, relished and discussed. One form of this new interest was the so-called Cult of the Picturesque, whose prime apostle, the Reverend William Gilpin (1724–1804), was brother to the painter Sawrey Gilpin (1733–1807). In our own day the reputation of Sawrey has been somewhat submerged by that of Stubbs, particularly as so many of the subjects he painted were inevitably the same. Sawrey Gilpin had three particularly important patrons – the Duke of Cumberland, who was a major force in the drive to improve the breeding of racehorses; the famous sportsman Colonel Thornton; and Samuel Whitbread, the first of the great brewers. One factor that has helped to deny Gilpin his rightful place as an influential and innovative artist is his practice of painting so many of his pictures in collaboration with others, whose reputations have since risen as his has undeservedly declined; one such, for instance, was the portrait painter Johann Zoffany (1733–1810).

Romance. Part of this new view of art took the form of a new elevation in the status of animals; they became beings capable of assuming specifically heroic or aesthetic roles. Even Stubbs, in his art usually as straightforward as he was consistently wonderful, was influenced by these new ideas: for instance, his series of paintings of a lion attacking a horse – based, significantly, on an ancient Roman prototype. Other and lesser painters gave to their animals a whole new and romantic

GEORGE MORLAND (1763–1804): *Inside a Stable.* 1791. Canvas, 148·6 × 203·8 cm. London, Tate Gallery

Although most widely known today for his romantic, almost idyllic, views of rural life, there is a more direct side to Morland's work. In this picture, for instance, any modern farmer will recognize the signs of reasonable prosperity in the condition of the building and in the well-fed appearance of the working horses. The little saddle-pony was a convenient method of getting round a large farm and the sturdy wooden wheelbarrow (to the right of the stable door) would have been quickly and easily made from local materials. It is only our contemporary ignorance that makes us think of these kinds of men as yokels; smocks, for instance, were a very efficient kind of overall.

GEORGE GARRARD (1760–1826): *Greyhounds in a Landscape*. Signed and dated 1789. Canvas, 76·2 × 101·5 cm. Collection of Peter Johnson

Although greyhounds were not yet bred to the form that is most favoured today, their alert dignity here is well contrasted with the ever-curious and bustling attitude of the terrier. This is hare-coursing country and well understood by the painter. Garrard was the pupil and son-in-law of Sawrey Gilpin; he accompanied Colonel Thornton (portrait on p. 109) during the latter's sporting tour of Scotland in the 1780s.

JACQUES-LAURENT AGASSE (1767–1849): *Lord Rivers Coursing*. Canvas, 73·7 × 61 cm. Trustees of the Lane Fox Settlement

Born in Geneva, Agasse studied in Paris under the great neoclassical painter, Jacques-Louis David. Returning to Switzerland he met Lord Rivers, who eventually brought him to London. He is best known today for his paintings of exotic animals like elephants and giraffes. In his sporting pictures he brings an elegance and style unique in the history of this English art.

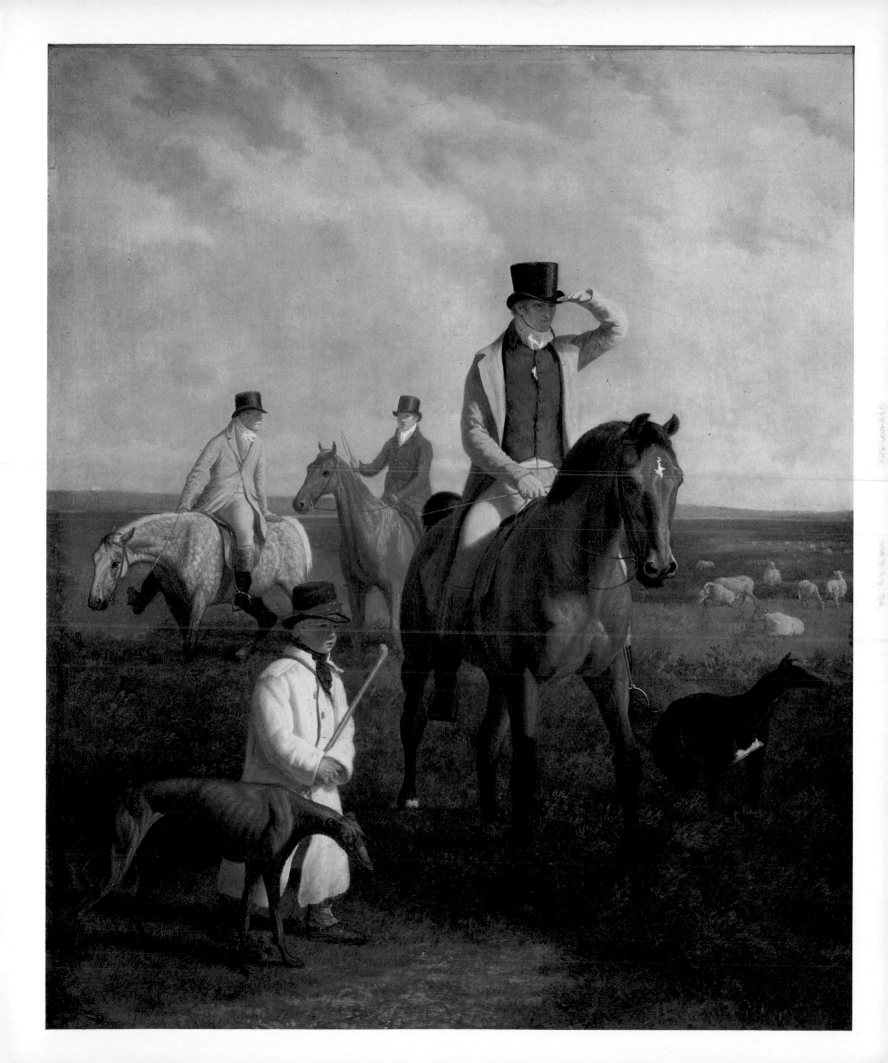

appeal meant to arouse our sympathy whether in the form of compassion or of hate, two extremes of an infinite number of variations. Once again these ideas inevitably sprang from an urban consciousness; the countryman always has, and indeed must have, a much more matter-of-fact view of animal life.

George Morland. This romantic idea even went so far as to affect the artist's view of the countryside – witness George Morland (1763-1804), for whom a bucolic existence was one of simplicity and quietude. This was in sharp contrast to his own life, which was no idyll as he followed an increasingly erratic path in an effort to pay off his debts and avoid his creditors, and at the same time indulged in those extravagant escapades that were always attracting his wayward fancy.

THOMAS GOOCH (exhibited 1778-1802): *The Life of a Racehorse*. About 1783. Each canvas, 30·5 × 45·5 cm. Private Collection

These are the first and the last of six paintings that, in line with the steadily advancing attitude of sentiment towards art and life in general, and sport and the countryside in particular, sought to impute human feelings and emotions to animals. The influence of such ideas was spread through engravings: six based on these pictures were published in 1792. The foal with his mare does not have the conviction of, say, any of Stubbs's portrayals of the same idea. In the ghoulish death scene, the cart

is interesting: it was an old, efficient and practical method of transport. An additional note of callousness is included with the rope-wound windlass (centre foreground), which seems to have been mounted on the inner ends of the shafts as an aid to hauling on unwieldy loads.

He had been soundly taught by his father, who was a painter, picture dealer and restorer, and Morland consequently maintained a prolific output though of a very variable standard.

Thomas Rowlandson. Even the wicked and affectionate pen of Thomas Rowlandson (1756–1827) was never wholly free, amidst the laughter and buffoonery, of a romantic view of country life. Although relatively little is known about Rowlandson's life, he seems to have been blessed with enormous energy and to have travelled a great deal in England and on the Continent, sketching all the while. Whatever the intentions of his drawings, there is much in them of interest to us, for naturally enough he found his inspiration in what was in front of him, whether it was the pack-horses that once were the major form of

SAWREY GILPIN (1733–1807): *The Death of the Fox*. Canvas, 67 × 91·5 cm. Collection of S. C. Whitbread

Curiously enough this picture is far from typical of the English school of sporting art; rather it is in the tradition of an earlier period exemplified by the seventeenth-century Flemish painters, Rubens and Snyders, who themselves drew on ancient ideas of the animal hunt. In the context of late eighteenth-century English society – industrial, romantic and realistic by turn – it is a masterpiece of colour and movement, of defiance and expectation, and a reminder that death is for all an integral part of life.

Other painters at other places and in other times would have filled this picture with blood and gore; this explicitness is not a characteristic of the Englishman's art, a fact often overlooked by its critics.

JACQUES-LAURENT AGASSE (1767–1849): *Sleeping Fox* (detail). 1794. Oil on paper, 21·9 × 28·9 cm. Winterthur, Switzerland, Oskar Reinhart Collection

In the past the fox preyed on such as rabbit and partridge, which were important and freely obtainable parts of the normal diet of country folk – the majority of the population. When guns were slow, uncertain and expensive, the best way to control the fox was by hunting it with hounds. It is easy to be censorious in modern times, but it is not only sportspersons that find a reason for present-day actions or ideas in long-past motives, or intentions.

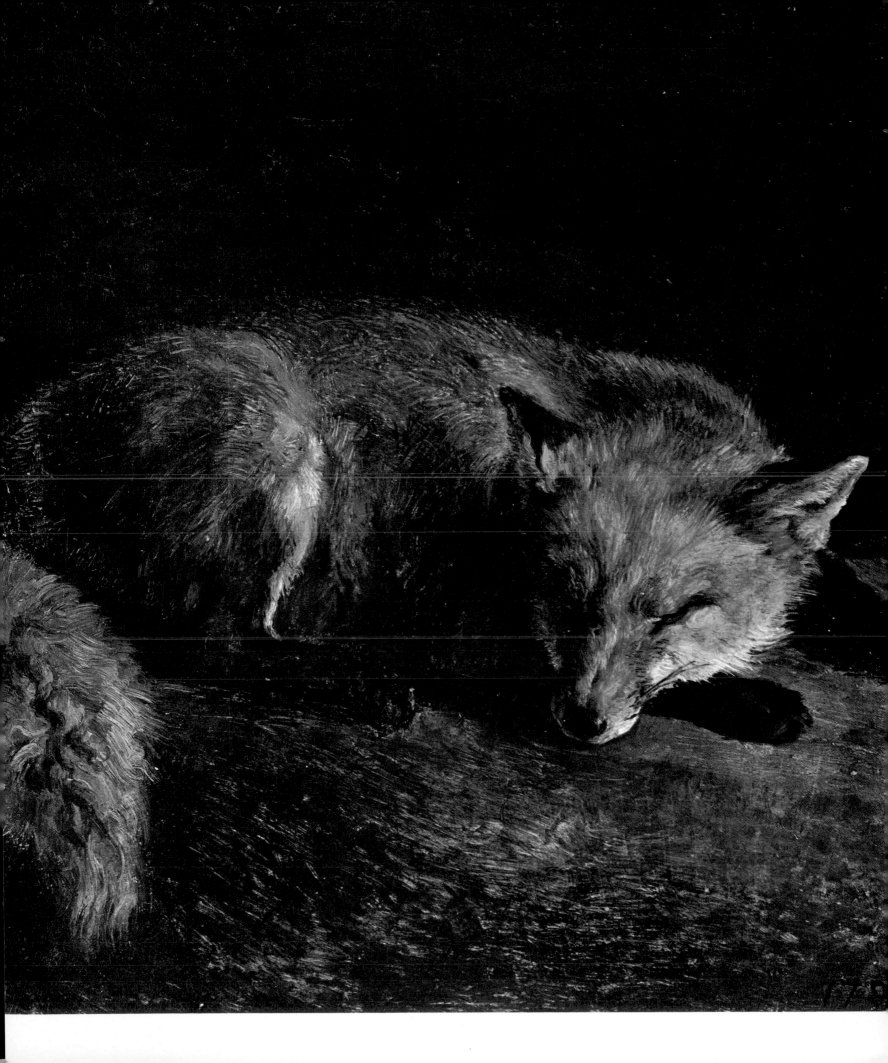

SNIPE SHOOTING.

G. Morland pinx! C. Catton jun! fecit

transport of goods over land and which few other artists have bothered to record, or the multitude of private conveyances. Like so many creative people of superabundant energy, he was lucky to find a sympathetic, yet firm, guiding hand: in Rowlandson's case that of the great publisher, Rudolph Ackermann, who commissioned and inspired him to produce a brilliant series of prints, particularly etchings.

Revolution. The new view of the countryside also affected Stubbs. His scenes of harvest of the 1780s retain the clarity and unsentimental attitude of his earlier work, with an added hint of a decorative

GEORGE MORLAND (1763–1804): *Snipe-Shooting*. Stipple by C. Catton, 1789, 32·7 × 38·3 cm. London, British Museum

Printed in colour, this pretty engraving represents, in an idealized, almost sentimental form, the handsome sportsman: slim, masculine and sensitive. As unlikely in practice as the feathery dog, the image is nevertheless appealing now to all who find country life attractive when viewed from the comfort and safety of a town.

106

THOMAS ROWLANDSON (1756–1827): *Showing Off in Rotten Row*. About 1785–90. Inscribed; pen and watercolour over pencil, diameter 30·8 cm. Museum of London

For two centuries the most fashionable place to be seen riding in London has been in Rotten Row in Hyde Park. A young, spirited and attractive girl knows how to use her horse to her own advantage; and a side-saddle is uniquely well suited to a quick and tantalizing display of a female ankle.

THOMAS ROWLANDSON (1756–1827): *The Road to Fairlop Fair*. Signed and dated 1818. Pen and watercolour over pencil, 27·7 × 42 cm. London, Victoria and Albert Museum

Fairs are of ancient origin and privilege granted by individual charter; usually annual, they provided convivial, social and commercial opportunities as well as the chance to change jobs or to hire new labour. Here a tremendous press of people and vehicles are converging on Hainault Forest, near Ilford, Essex, on the first Friday in July. They would have set out early and will be home very late, for the days are long at that time of year.

SHOWING OFF IN ROTTEN ROW

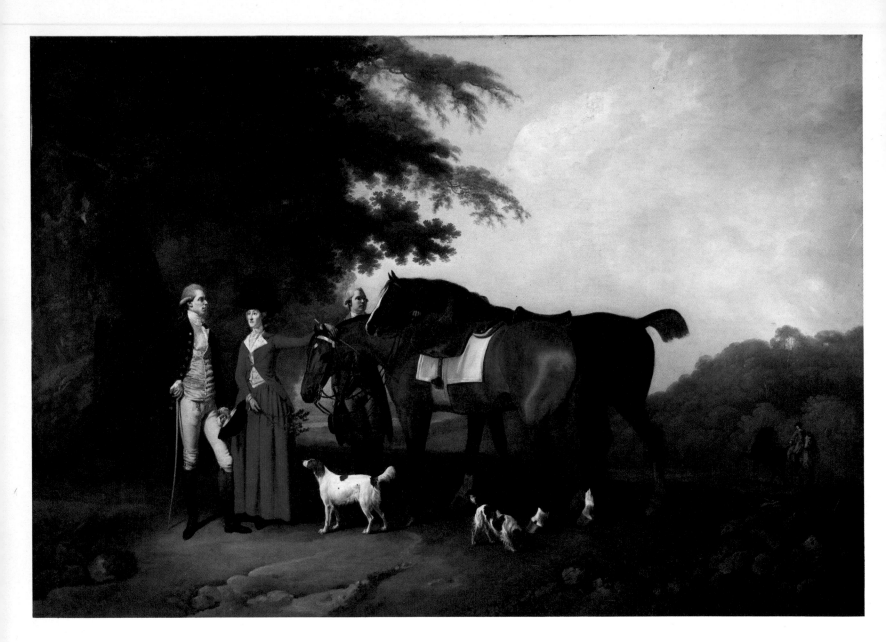

SAWREY GILPIN (1733–1807), JOHANN ZOF-
FANY (1733–1810) and JOSEPH FARINGTON
(1747–1821): *Henry Styleman and his first
Wife*. Canvas, 182·2 × 259 cm. Collection
of Lady Thompson

What a delightful picture containing, as
it does, touches of shy dignity, informality
and affection; this last is particularly well
expressed in the way that the stallion arches
its neck across the mare. It was not unusual
at this time for major painters to work to-
gether – Gilpin the animal artist, Zoffany
the portraitist, and Farington the landscape
limner. Two rare details are worth noticing:
an early side-saddle with a double pommel
(for the right leg) and stirrup for the left
foot; and the chance of seeing a woman's
riding habit full-length.

PHILIP REINAGLE (1749–1833) and JOHN
RUSSELL (1745–1806): *Colonel Thornton*.
Signed and dated 1792. Canvas, 61 × 45·5
cm. Private Collection

Here sporting artist and portrait painter
combine to delineate the sensitive features
of one of the most remarkable of all the
famous English sportsmen in the late eight-
eenth and early nineteenth centuries. Born
to an enormous fortune, Colonel Thornton
(about 1755–1823) was as liberal in his
patronage of sporting artists as he was an
enthusiastic follower of every kind of sport –
particularly racing, hunting, angling, shoot-
ing and hawking. He was largely respon-
sible for the revival of falconry, which
doubtless appealed to him as the most diffi-
cult and delicate of all field sports.

idyll. Nor was the scientific eye immune. Joseph Wright of Derby (1734–97) was to find light and wonder in a number of landscapes, notably one of darkness which eulogizes the simple life of the earth-stopper, whose sole purpose was to close, in the early morning before sunrise, those refuges that might be sought by a hunted fox (p. 111).

In brief, therefore, the notion of revolution – intellectual and political – was abroad, but in Great Britain it manifested itself mainly in industry.

Landscape changes. Hand in hand with a new awareness of landscape – self-conscious and urban-based as it might have been – went some profound changes in its aspect. These were less natural in the sense that they were physically more demanding and obtrusive than all the agricultural improvements made in the century that had gone before. Canals, hedges and mills are three examples.

Take mills first. Those engaged in coal-mining, for example, would probably have lived in a relatively open settlement, each cottage with its own piece of land and a few animals. Those who made their living from cloth-making might have lived in a similar situation, infiltrated by the country: spinning and weaving at home, and keeping, on their

GEORGE STUBBS (1724–1806): *Reapers*. Signed and dated 1784. Canvas, 90·2 × 137·2 cm. London, Tate Gallery

With his customary genius Stubbs here places a series of meticulously studied individual portraits into a rhythmic group, sinuous and informal yet at the same time touched with the stillness of fashionable neoclassical ideas and even the arcadian attractions of the rococo *fête champêtre*. Tempting though it may be to analyse in this way the form of the painting, there is no denying the basic Englishness of the scene and the rural nature of its inspiration. Who can fail to be touched by the simplicity of this masterpiece?

JOSEPH WRIGHT OF DERBY (1734-97): *The Earthstopper on the Banks of the Derwent.* Signed and dated 1773. Canvas, 96·5 × 120·6 cm. Derby Art Gallery

Wright was fascinated by scientific experiment and in particular by the effects of light and candlelight. Here he unites a common country pursuit with visual ideas developed from the new interest in learning that burgeoned in the latter part of the eighteenth century. The job of the earthstopper was to go out the night before a hunt was to take place and close up all the holes in which a fox might possibly hide. In earlier times foxes run to earth would be dug up or pursued into their earth by terriers, but better horses and hounds with keener scents now demanded a longer-running, less checkered kind of sport.

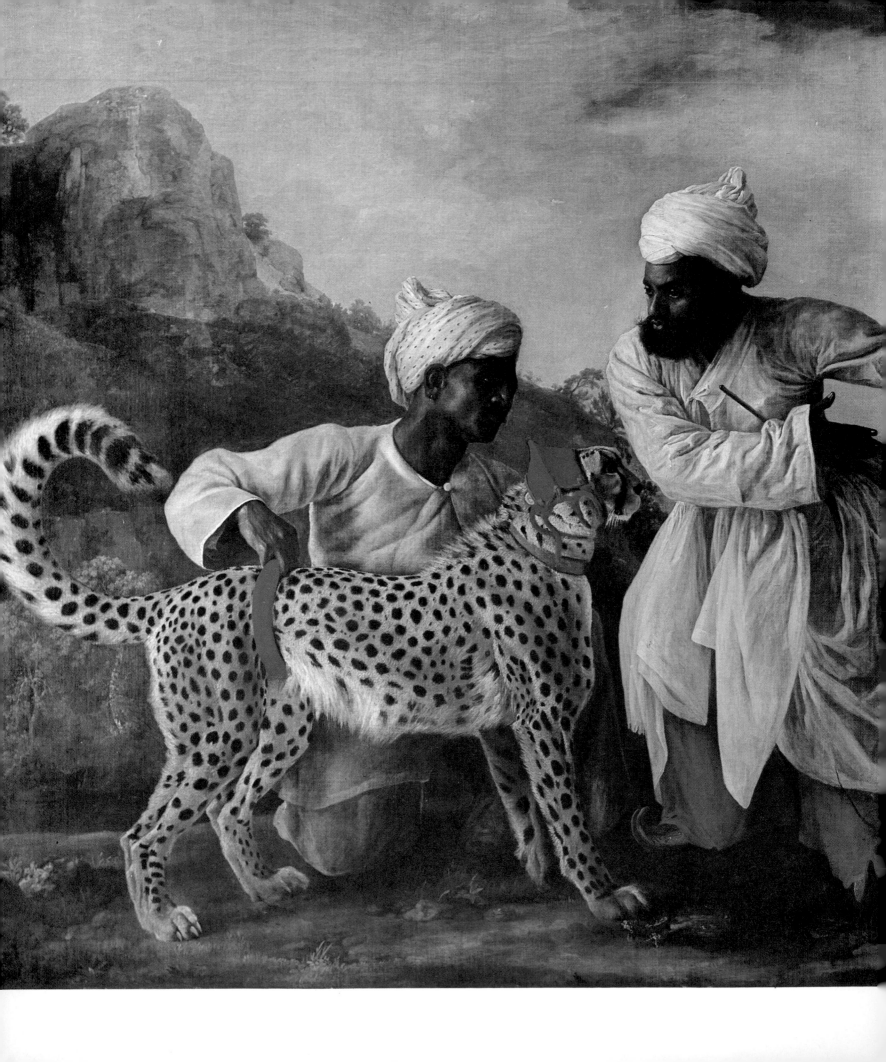

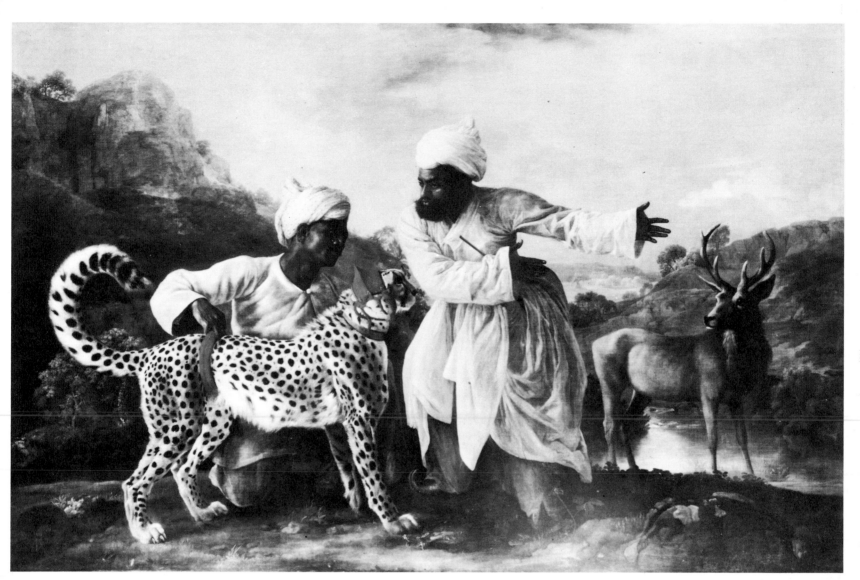

GEORGE STUBBS (1724–1806): *Cheetah with Two Indian Attendants and a Stag.* 1764–5. Canvas, 205·7 × 299·7 cm. Manchester, City Art Gallery

The archaic design of this picture (which harks back several centuries) serves to emphasize the glorious eccentricity of the subject. Sir George Pigot, Governor of Madras, sent a tamed cheetah to George III, a suitably exotic and royal present that would also have fascinated the ever-curious monarch. The animal was intended to show its incredible, lithe speed by hunting a stag in Windsor Great Park; its blindfold was pushed back but despite the persistent urgings of its trainer and its keeper, the cheetah remained as puzzled by the whole affair as the stag. The hunt was a failure.

own land, horses to carry the cloth to market and to bring back wool and provisions with the proceeds.

The development of water-power gave a stimulus to the building of what we still recognize today as the first true factories, built in the last three decades of the eighteenth century. It was no accident that they were built in those situations that had themselves been just newly discovered, by amateur and professional artists alike, as possessing a romantic appeal.

These remote areas would only have been visited before, most likely, by an occasional mounted sportsman. But for the new industrialist they provided a good head of fast-moving water: the large new forges and mills were expensive, and continuous production was only possible with constant and reliable water-power. Hard, therefore, on the walls of the new factory buildings were built houses for the workers who were to man them – and in line, too, with new thoughts, these

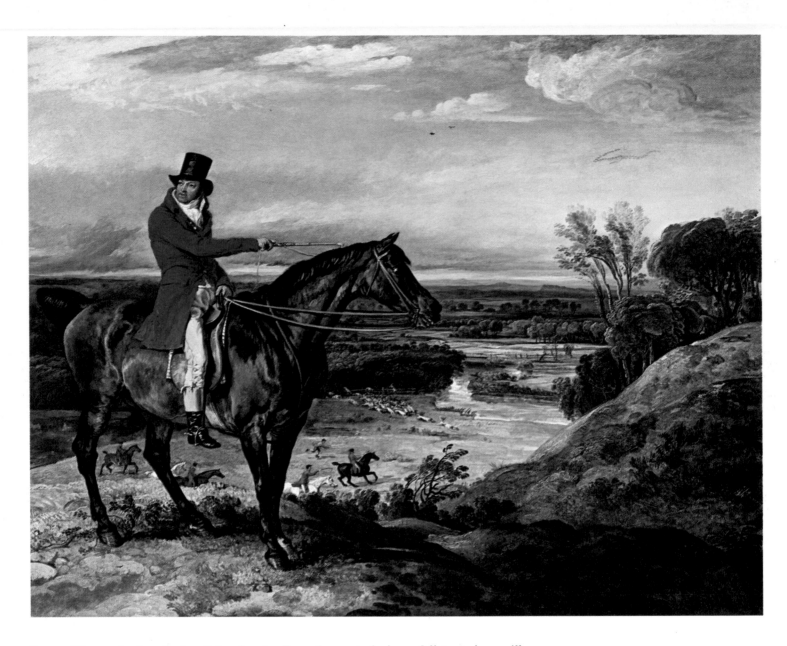

JAMES WARD (1769–1859): *John Levett Hunting in the Park at Wychnor*. Signed and dated 1817. Canvas, 102 × 127 cm. Private Collection

Ward was a famous painter of cattle, sheep and pigs, as well as of those subjects of a more obviously sporting nature and of pure landscape or history pictures. In this masterpiece of early nineteenth-century English art Ward conveys in an exciting and original way something of the enjoyment and pleasure associated with an open-air life in general and hunting in particular. The true sportsman has always had to be something of a naturalist, for, without such an intimate knowledge and sympathy, there can be no real understanding of the interconnection of man, animal and land.

Even the most glorious of distant views will quickly revert to wilderness without expert management.

GEORGE STUBBS: *Three Racehorses*. Detail from *The Duke of Richmond's Racehorses Exercising at Goodwood*, page 123

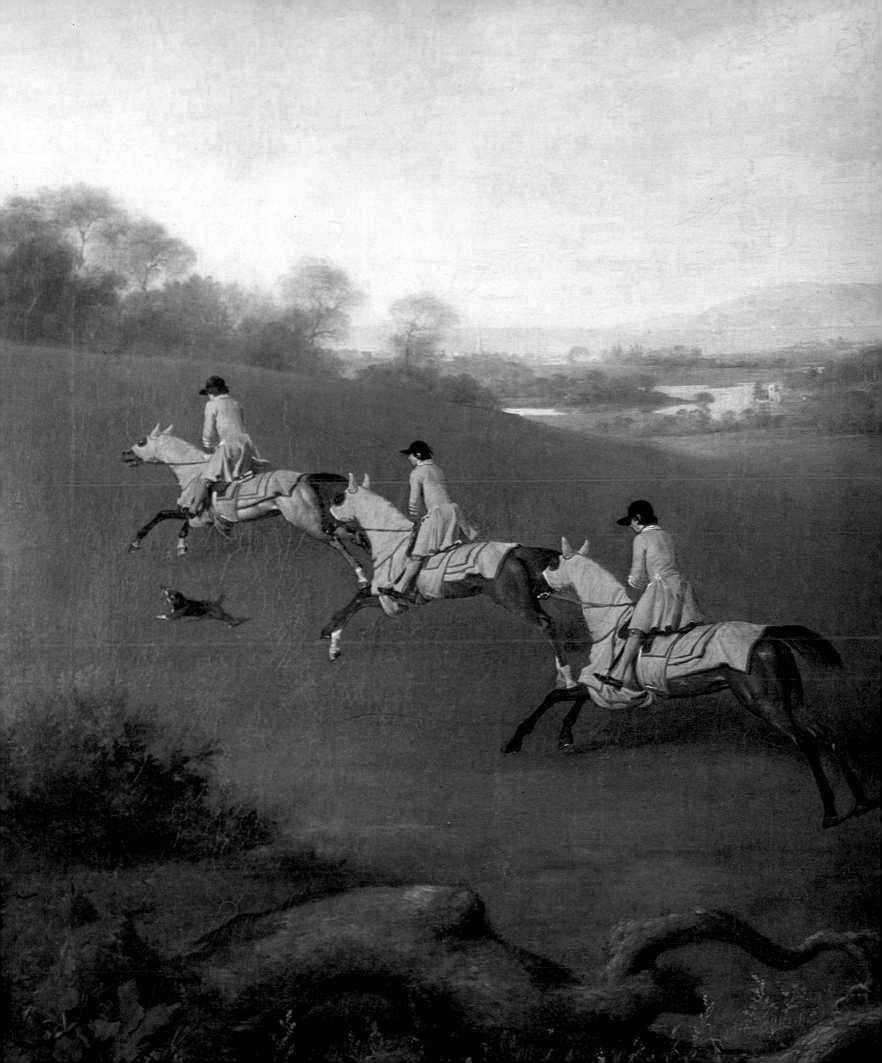

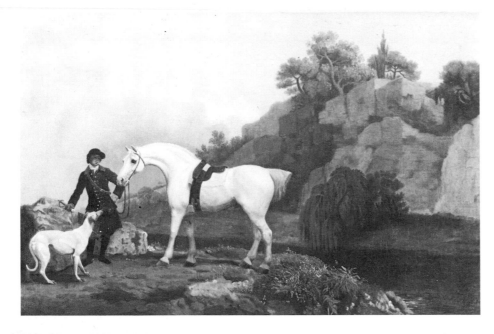

GEORGE STUBBS (1724–1806): *A grey Hack with a white Greyhound and Groom*. Canvas, 44·5 × 67·9 cm. London, Tate Gallery

The matter-of-fact modern title obscures the essential point of this marvellous little picture: the mutual dependence and trust of man, horse and dog. Every sportsman will recognize the bond of the companionship represented in the attitudes of the three figures. The strong and compact horse, the lithe greyhound and the wild, rocky setting all suggest hare-coursing – potentially the most skilful as well as possibly the most exciting of all forms of the chase. The hunter carries a spare stirrup-leather across his right shoulder, a detail that may well have given rise to the mistaken idea that he must necessarily represent a groom.

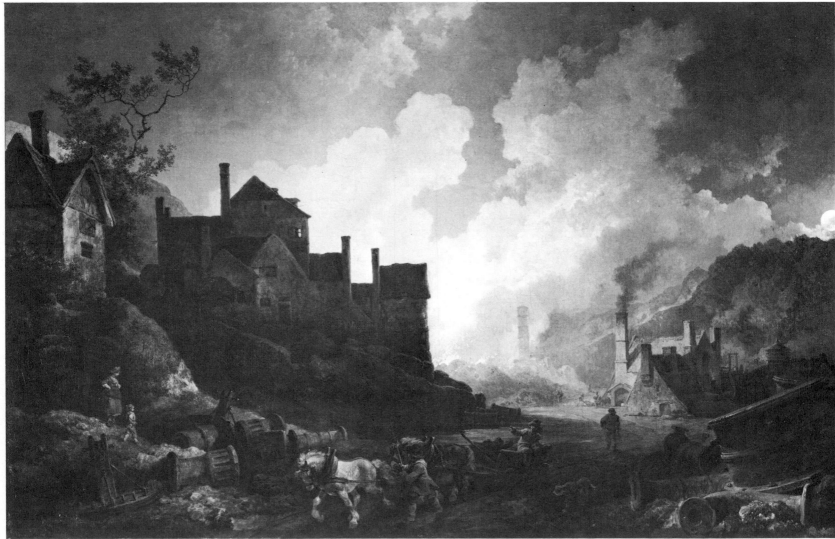

SIR FRANCIS GRANT (1803–78): *Queen Victoria Hunting with the Quorn.* 1838. Canvas, 91·5 × 152·4 cm. Private Collection

At first glance what else could this painting show but a fashionable meet of a famous hunt in the superb and gently rolling country of the Shires? Queen Victoria had been monarch for barely a year and was only nineteen at this time; she will be following the hunt in the small phaeton on the extreme left drawn by a pair of greys which she is driving herself. In some ways this might prove more exciting than riding, though apparently safer in the eyes of her elderly female relations.

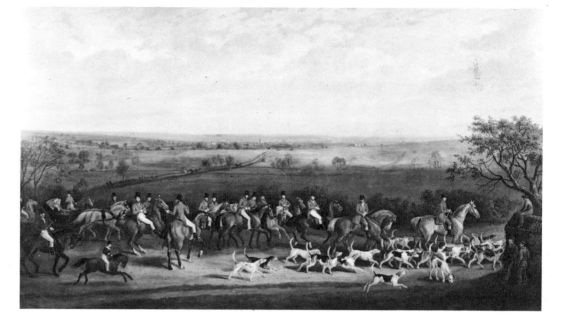

PHILIP JAMES DE LOUTHERBOURG (1740–1812): *Coalbrookdale by Night.* Signed and dated 1801. Canvas, 67·9 × 106·7 cm. London, Science Museum

By night the ironworks in the wild scenery of Coalbrookdale lit the sky with the glow of the fires from the continuously working furnaces. Romantically inclined tourists and many artists including Turner were attracted to the scene; none knew that it symbolized the beginning of the end of rural England. As the industrial revolution took hold, the great working horses, the descendants of those imported from the Low Countries to replace oxen in the late seventeenth century, were themselves to be replaced by steam locomotives, so aptly nicknamed 'iron horses'.

houses were placed as close together as possible in the interests of low cost and efficiency of building. Thus industry invaded the countryside often at an early stage, with the factory and workers' houses directly overlooked by the owner's new mansion and attendant stables.

Another considerable change in the landscape was made through the construction of the canals; some 3,000 miles of canals were built between 1760, when the first appeared, and the early part of the nineteenth century. This meant not only locks, aqueducts, cuttings, embankments and tunnels, but also wharfs and warehouses, all for the better carriage of ore, coal, stone, wood and slate, indeed heavy and bulky materials of all kinds.

New hedges. Of gentler but, paradoxically, more lasting and positive impact was the appearance of the new hedges – the boundaries of newly enclosed farmlands. The preference was for quickset (its very name immediately indicates why) more commonly known today as hawthorn. It had been used to make thick, animal-proof hedges since Saxon times; indeed its name derives from an old English word for hedge-thorn. The enclosure acts generally demanded that the new fields be fenced. The methods first adopted depended on the nature of the locality: either dry-stone walls where quarries were handy and numerous, or wooden posts and rails where trees were commoner (so, incidentally, considerably reducing the number of trees in hitherto thickly wooded areas). The new seedling hawthorn hedges of the latter part of the eighteenth century were protected by a rail on one or both sides against the depredations of animals; by the turn of the century many had grown high and thick enough to be cut and laid. In other cases the new boundaries were formed by digging ditches to an allotted depth: the earth was piled to one side to form a bank, on top of which, again, hawthorn would be planted or a fence set. All these kinds of

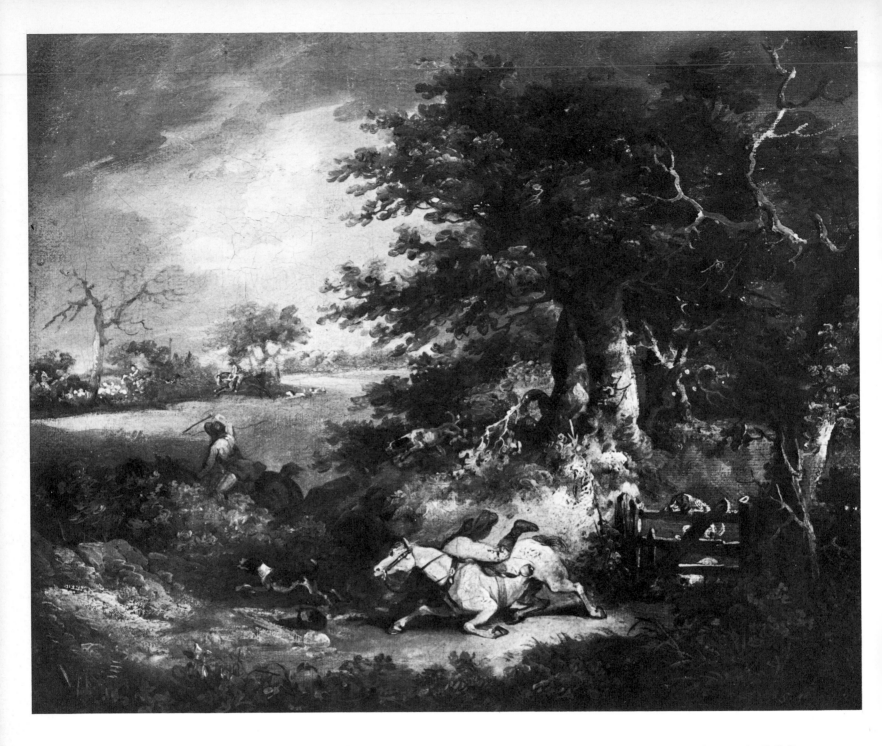

boundaries were to form hazards for the sportsmen, particularly in the early nineteenth century, and appear in many of the pictures in one form or another.

Even today it is not impossible to distinguish between the ancient hedgerows and those of the eighteenth and nineteenth centuries. The earlier hedges are noticeably thicker and often more irregular in line as well as being compounded of a larger variety of trees and shrubs: elder, hazel, holly and crab-apple for instance. The later hedges are dominated by hawthorn and three splendid trees – oak, ash and elm. The two most valuable elements are oak and ash: the former for its strength as a building material, the latter for its quick growth and use

GEORGE MORLAND (1763–1804): *Full Cry – and a Fall*. Canvas, 24·1 × 29·5 cm. London, Victoria and Albert Museum

Used as we are to seeing paintings of a hunt streaming across wide fields or checked at cover, this picture has more than usual interest in the way it shows so well the complicated circumstances presented to those following the less fashionable, less well-documented hunts.

JAMES WARD: *John Levett Hunting in the Park at Wychnor*. Detail from the plate on page 114

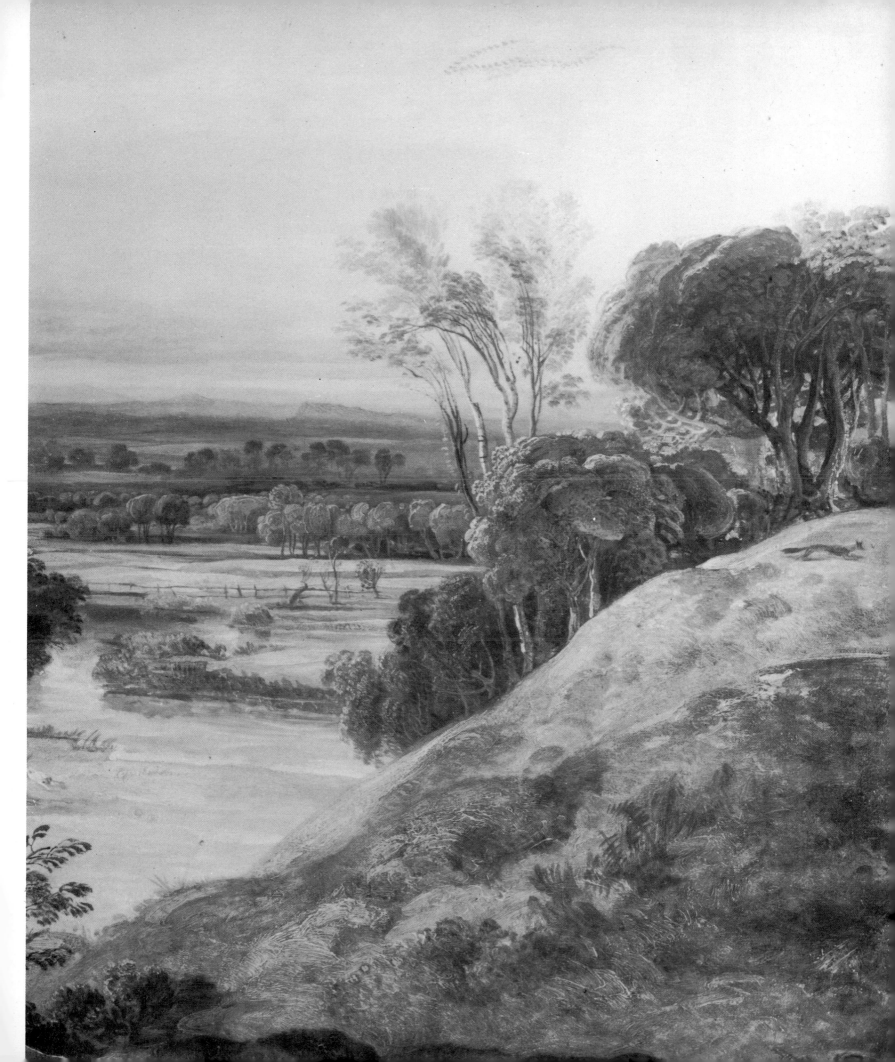

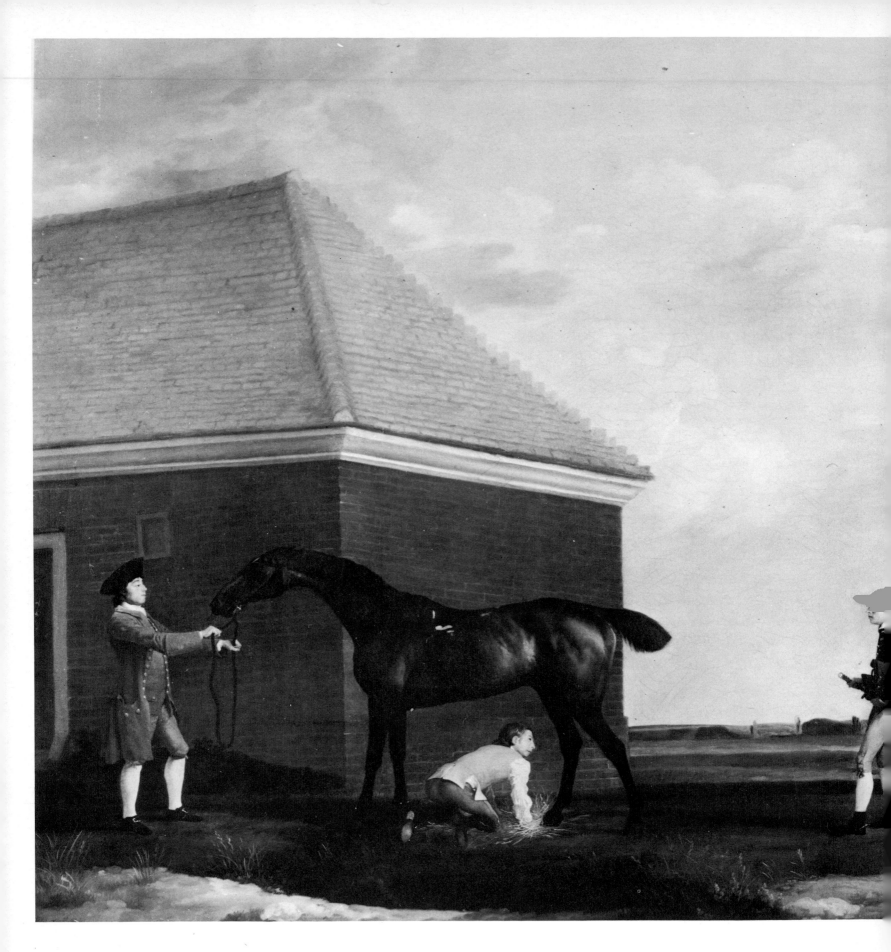

GEORGE STUBBS (1724–1806): *Gimcrack on Newmarket Heath*. 1765. Canvas, 101·6 × 193 cm. Private Collection

Here is a painting that is as much a masterpiece in its details as it is in its overall effect; the sense of movement springs from a crouching stable lad through to the distant scene of a race. Gimcrack's comfortable victory there contrasts with his portrait on the left: ears back, head and neck stretched, tense muscles and coat gleaming with foam and sweat after running; held by his trainer, he is being whisped, or rubbed dry with hay or straw.

for everyday essentials such as wheels and chairs. The dominance of elm may seem surprising to modern eyes, yet in many aspects it combined the virtues of ash and oak: the strength of the former and the fast growth of the latter. Moreover, unlike the oak, the elm grows almost anywhere and, unlike the ash, it permits grass or other crops to grow right up to the butt of the tree. The durability of elm under water was another factor contributing to its popularity during the revolutionary wars of the late eighteenth and early nineteenth centuries, when it was used for ships' planking, and even for keels when oak became scarce; in towns it was used for drain-pipes and water-mains. It should not be forgotten that these hedgerows were not the result of haphazard seeding but of deliberate planting as a way of making good use of land.

Artificial coverts. For the sportsman, clearances of woodlands and enclosures of land created their own problems and provided new opportunities. One result was the disappearance of natural cover for the fox. The remedy employed by those landowners with the necessary interest in sport and influence was to replace the natural patches of gorse with artificial covers in odd corners of common land or pasture. Some were planted with gorse and others with trees, which were fenced round for protection, making a spinney. The regular shape of such covers distinguish them from natural woodland to this day – and can also be seen in the paintings of the past.

At the other extreme the still virtually impenetrable woods were being affected as well – through the cutting of special rides. This did not find favour with everyone (inevitably) as it assisted the poacher and gave (it was said) the hunter an unfair advantage over the fox.

Conventions and customs. However little one's knowledge there is much that is strange in the sporting paintings. First there is the odd 'rocking-horse' method of showing horses at a gallop; this was adopted by all artists, even the incomparable Stubbs, although it has no possible foundation in fact. The origins of this convention are lost in the mists of pre-history and remain a remarkable example of the survival of a practice that practical experience, knowledge and common sense had long shown to be a physical impossibility. None the less it remained an excellent method of showing speed on a flat, static surface and was only to disappear from painting with the invention of photography and in particular with the pioneer photographs of Eadweard Muybridge as late as 1872 showing animals in movement.

Other unexplained customs find their place in the pictures: for example, the cropping of a horse's ears, and the docking, or even nicking, of its tail – a cut at its root so that it was carried higher. No doubt these were themselves the result of fashion, in particular of the idea that the best horses had a long back and a tiny head, attributes that would be emphasized by such customs. The relatively gaunt appearance of the racehorses is also the result of past practices. They were rigorously trained to be rid of all surplus flesh. This was done by a programme of sweating (the horses were kept heavily rugged in heated

GEORGE STUBBS (1724–1806): *The Duke of Richmond's Racehorses Exercising at Goodwood,* 1760–1. Canvas, 127·6 × 205 cm. Goodwood House, Earl of March

The 3rd Duke of Richmond was a great connoisseur and patron of artists – Canaletto and Stubbs amongst them. Here with his wife and sister-in-law he watches his racehorses in training – being galloped in heavy blankets and rubbed down afterwards. The movement up and away of the string of horses to the left is a daring visual device, one that must have appealed for its shock value to knowledgeable patron and confident artist alike. That Stubbs used the impossible rocking-horse action to indicate a gallop must be judged against the fact that as a way of showing speed on a static surface it has barely been surpassed even yet. Amidst all the grandeur of the ducal ménage there are some delightfully domestic dogs.

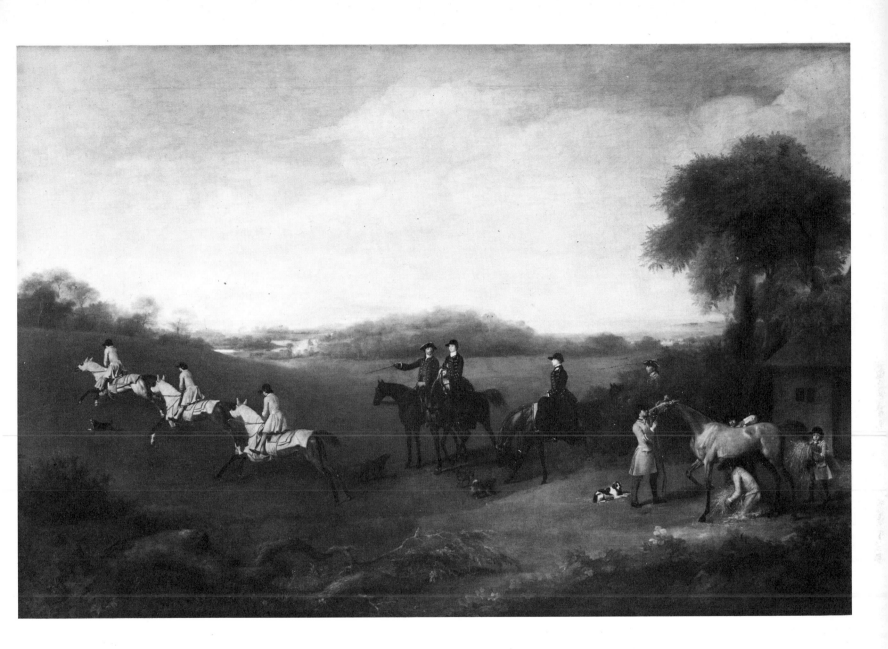

and unventilated stables); they were gorged and then purged; they were worked hard outside in heavy clothing; and, lastly, they were kept fit by trials over the full distance of a forthcoming race.

Matches and plates. In many racing pictures (the most famous example being those of Newmarket) the rubbing house is a prominent feature. Its importance sprang from the manner in which racing was conducted. Until about the middle of the eighteenth century, the principal races were divided into two kinds: matches between only two horses often with their owners as riders; and plates (cups or dishes of silver), competed for by larger fields. Where competition was very keen and fields large, there would be a series of heats with the less successful horses eliminated after each. Those placed would be given a half-hour rest at the rubbing house, where they would be wiped of sweat with a rubbing board and whisped dry with hay or straw.

Out of the match came the idea of handicapping, or an independent assessment of the qualities of two horses of different merit, which could then be equalized by such means as a weight-for-age scale. Hence the importance of weighing both jockey and harness before and after, so as to make sure there had been no illegal shedding of weights during the race.

Another idea to develop from this was the sweepstake. The winner of a match had perforce to provide half his own winnings. Instead, therefore, of a larger field racing only for a plate, each of the owners subscribed a given amount, the eventual winner taking a handsome prize of which he had contributed only a relatively small proportion. It is worth noting again that the races were consistently longer (four miles and more) and the horses older (upwards of five years) than is the modern-day practice.

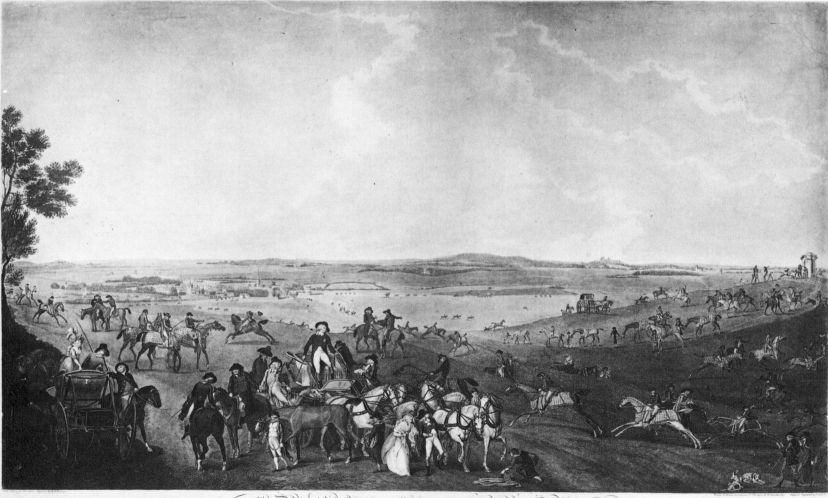

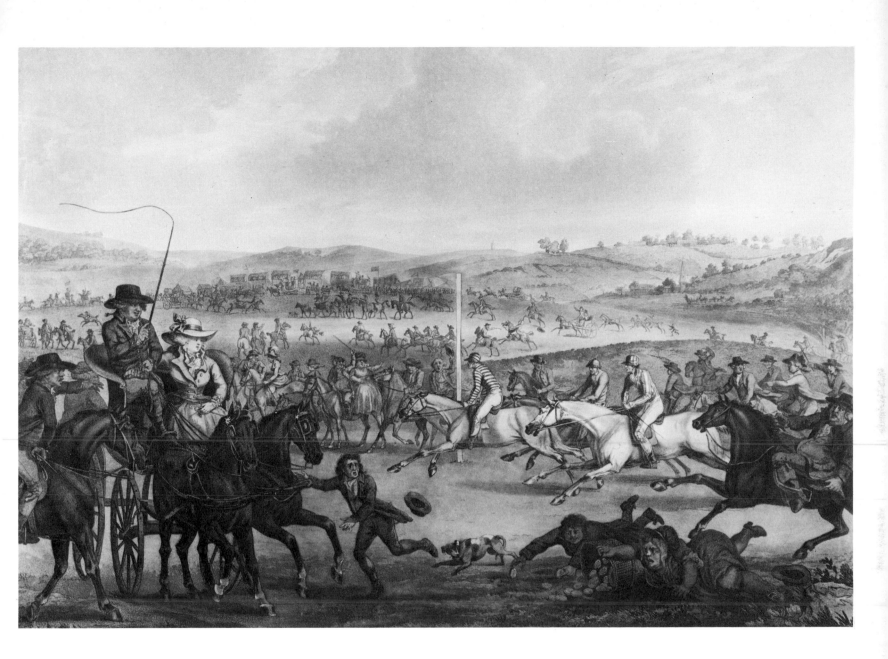

JOHN BODGER (*fl.* 1790): *Trains of Running Horses, Newmarket.* 1791. Aquatint, 39 × 66 cm. Photograph by courtesy of the Parker Gallery

This is the scene of Warren Hill, east of Newmarket, where the young and dashing Prince of Wales, surrounded by friends, commands a view that was famous for the number and beauty of the horses that were regularly seen exercising there. The Prince had a large and successful string of race-horses of his own – running horses, was the current term. He stands in a tall phaeton, a highflyer, drawn by no less than six horses, which he drove himself, as much an indication of his daring as of his considerable expertise as a whip. He was a very loyal

person: that same year he was to give up racing when his jockey, Sam Chifney, was accused of chicanery by the stewards.

W. MASON (1724–97): *A Country Race Course with Horses Running.* Etching by J. Jenkins, aquatint by F. Jukes, 1786, 48.9 × 64.5 cm. London, British Museum

This is an affectionate rendering of the inevitable and enjoyable chaos of a small local meeting, of which there were dozens at the time. The superior beau driving the stylish pony phaeton on the left is about to have his lady and his equilibrium upset by the fleeing urchin, who has tripped over the pastry-seller and brought one of the mounted followers of the race off his horse. This engraving has a title in French as well as English, for there was a considerable trade in prints between the two countries at that time.

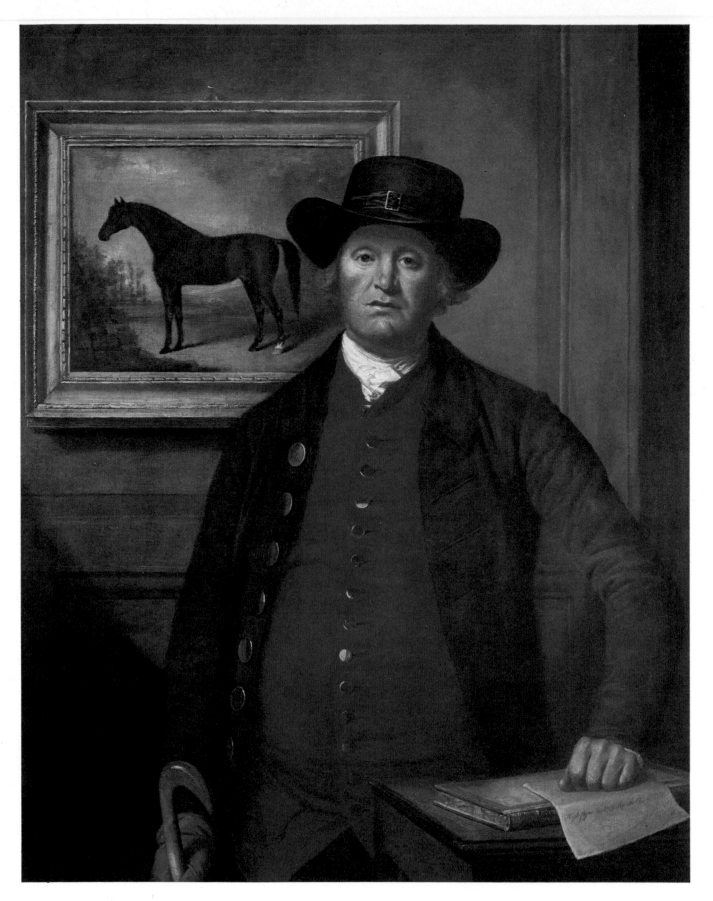

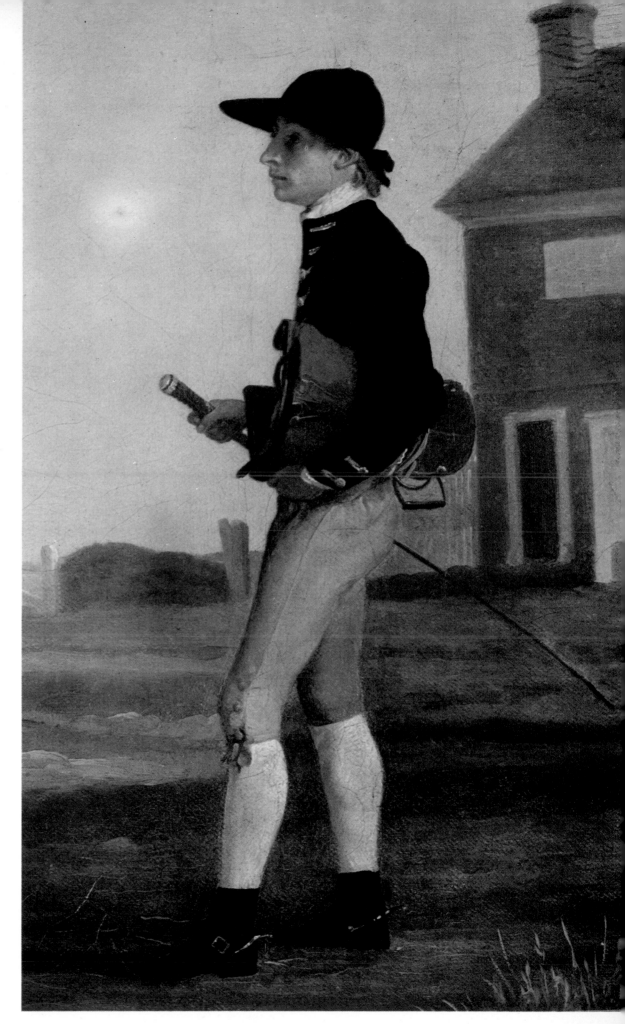

THOMAS BEACH (1738–1806): *Richard Tattersall with Highflyer in the background*. Canvas, 125 × 98·3 cm. Private Collection

Through his knowledge, integrity, excellent judgement and shrewdness, Richard Tattersall (1724–95) established himself on the edge of town at Knightsbridge as the principal dealer in England in horses, carriages and hounds. He provided a London base for the Jockey Club (their headquarters being at Newmarket) and opened a subscription room, where bets could be laid and settled in comfort; its committee was to become the final arbiter of disputes. Tattersall owned the famous racehorse and stallion, Highflyer.

GEORGE STUBBS: *Jockey*. Detail from *Gimcrack on Newmarket Heath*, page 120

Gambling mania. There was immense public interest in racing and in the outcome of the more spectacular matches. There was, however, no formal organization, no commonly applied rules and thus huge opportunities for trickery and fraud. All classes were so much affected by this gambling mania that the whole nation seemed to be besotted by betting. Race meetings were burgeoning at such a rate that in 1740 an Act of Parliament restricted races to those with a prize worth fifty pounds or more – except at Newmarket, one more example of its peculiar and special prestige. There Charles II had been able to intervene and settle disputes, and his niece, Queen Anne (reigned 1701-14), who shared his interest in racing, was responsible for the appointment of her own representative at Newmarket. This was Tregonwell Frampton, who remained Keeper of the Royal Running Horses until his death in 1728, in the reign of George II. His notoriety sprang as much from the prestige of his position and his iron-willed influence in the supervision of racing and settling of disputes, as from his own considerable skill in the often dubious arts of matching horses and backing them to his own large pecuniary advantage. But, in all this, he is as likely as not to have been no better and certainly no worse than many another of his time.

THOMAS ROWLANDSON (1756-1827): *Weighing In at the Races*. Pencil, pen and grey ink, watercolour, 21 × 17·1 cm. Photograph by courtesy of Sotheby's

The title is modern and not entirely accurate, for this busy little scene shows the aftermath of a race. The winner in the foreground is being wiped of sweat with a rubbing stick, while his jockey is being weighed clutching his saddle in his lap. Handicapping systems then being developed allowed horses of different ages and degrees of proven success to be matched against each other by the addition, or subtraction, of penalty weights.

JOSEPH WRIGHT OF DERBY (1734-97): *Mr and Mrs Thomas Coltman*. About 1769-73. Canvas, 127·1 × 101·6 cm. Private Collection

This picture expresses affection – of man for wife, and indeed horse for dog.

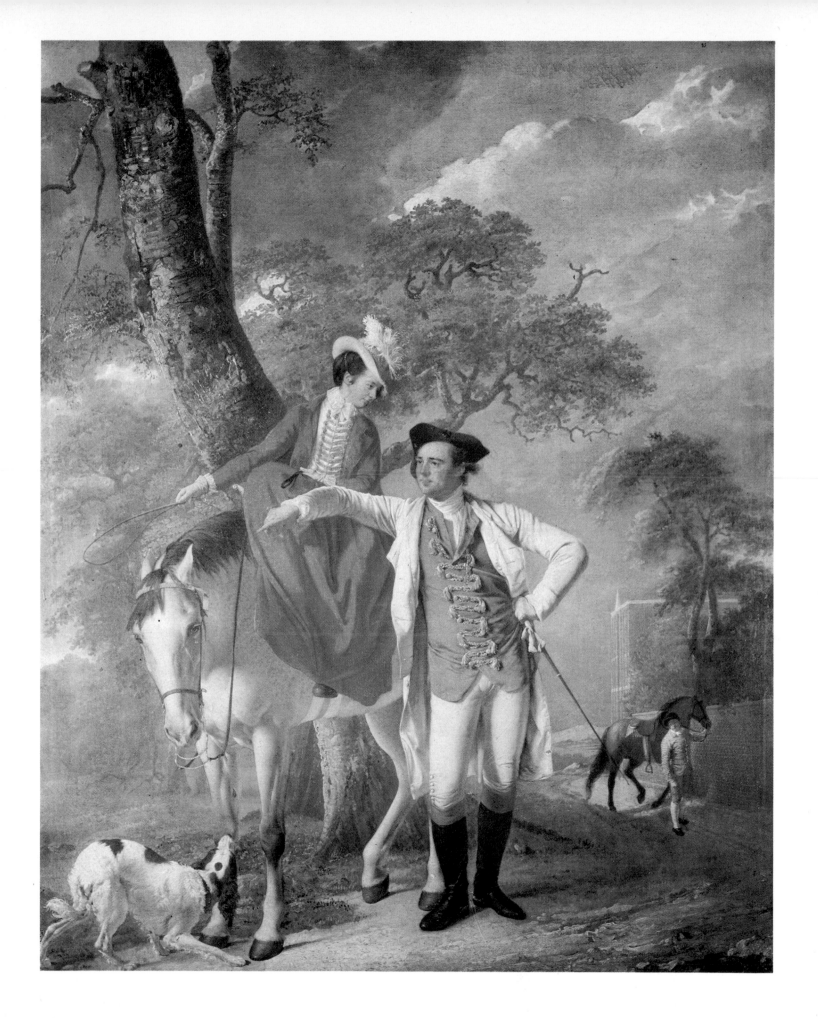

The Jockey Club. In the end, and in the most pragmatic and sensible way, it was racing itself that brought order into chaos through the interest of its most influential owners. They formed themselves, naturally enough, into a club – the Jockey Club, which from about 1752 slowly and steadily developed towards its present-day position of undisputed power and influence. The owner who contributed most through his personal prestige to the growth in the moral authority of the Jockey Club in the last part of the eighteenth century was Sir Charles Bunbury, owner of the immortal Gimcrack, breeder of High-flyer and winner of the first Derby.

Tattersall. Highflyer was the best stallion of his time and his eventual owner was Richard Tattersall (p. 126), who made a fortune from buying and selling horses of all kinds, as well as hounds and carriages, in a way that did not compromise his own judgement and honesty. He provided a London base for the meetings of the Jockey Club (their headquarters are still in Newmarket) and another room for those willing to pay for the privilege of laying and settling bets in comfort; this latter eventually led to the formation of a special committee to settle gambling disputes.

The matter of accurate records was also becoming of increasing importance – naturally enough when identity might have to be proved or established, and breeding or racing performance proved. There were a number of attempts (the first in 1726) to establish an accurate calendar of races and a stud-book. But it was not until 1773 that, significantly again, the Jockey Club authorized James Weatherby to publish a calendar, which has continued ever since.

Racing developments. It was the Jockey Club, too, that in 1791 stood up to the Prince of Wales in condemning the conduct of his

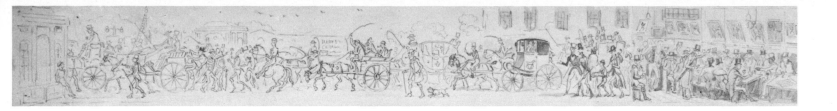

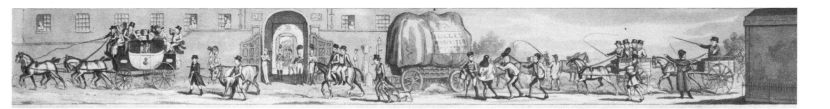

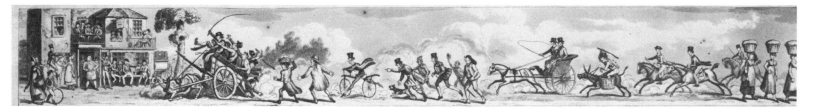

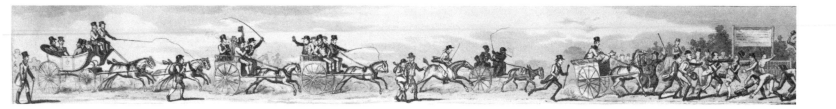

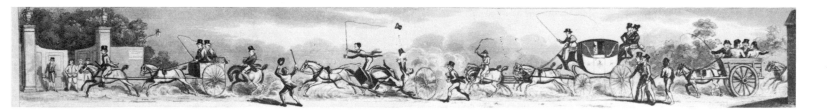

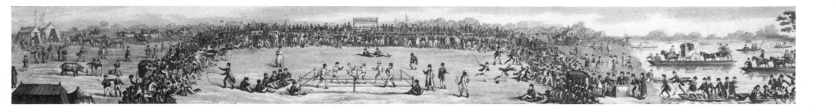

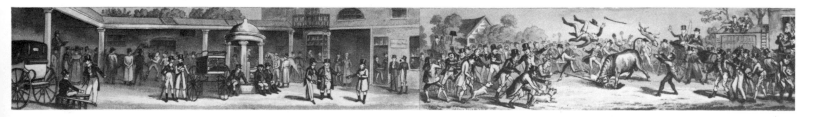

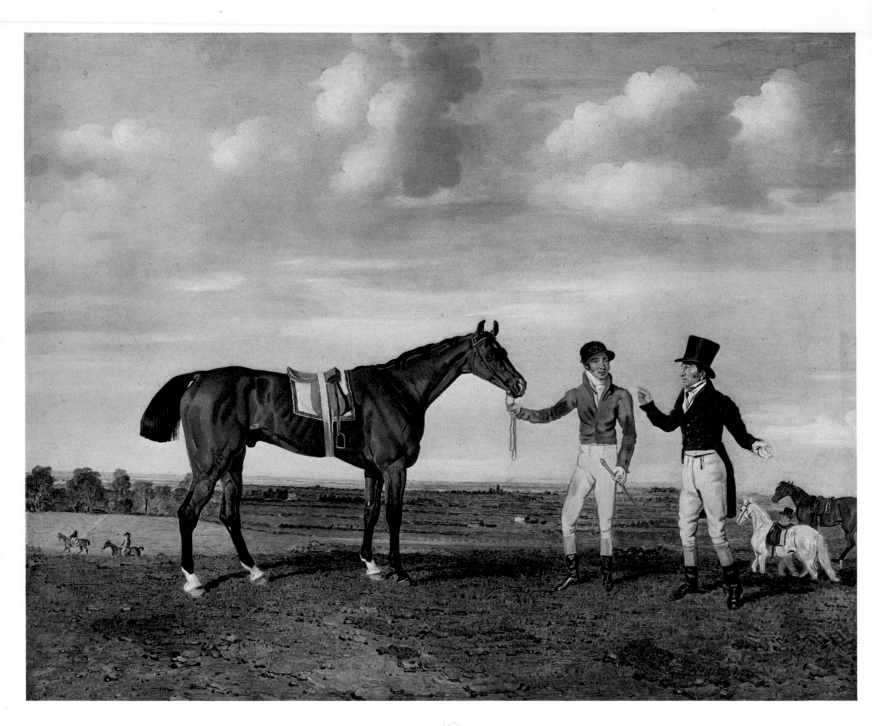

BENJAMIN MARSHALL (1768–1835): *Zinganee, held by Sam Chifney junior, with the Owner, W. Chifney, at Newmarket.* Canvas, 103 × 125 cm. Private Collection

Sam and Bill Chifney were brothers and respectively jockey and trainer, both notorious in a notorious age and brilliant like their father, the elder – and equally roguish – Sam, who had been the first great professional jockey. The younger jockey was considered a paragon in his prime and was wont to win his races by holding back until the last possible moment, when he would propel his mount into what became known as the 'Chifney rush'. Zinganee was foaled in 1825 and won the Ascot Gold Cup for Lord Chesterfield in 1829.

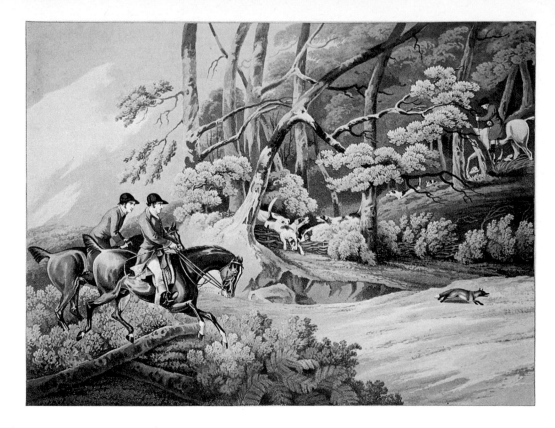

HENRY ALKEN: *Breaking Cover* (see page 146)

JAMES POLLARD (1792–1867): *Epsom Grand Stand: the Winner of the Derby*. Hand-coloured etching and aquatint by R. G. Reeve, 1836, 28·2 × 37·5 cm. London, British Museum

The monumental grandstand and elegantly clad figures, female as well as male, make very clear the changes in the character of racing during the first part of the nineteenth century. Whilst still attracting a vast and varied crowd of people, firm administration had freed the sport of the most blatant forms of corruption and chicanery, as well as the taint of too close an association with cock-fighting, bull-baiting and the pugilistic arts.

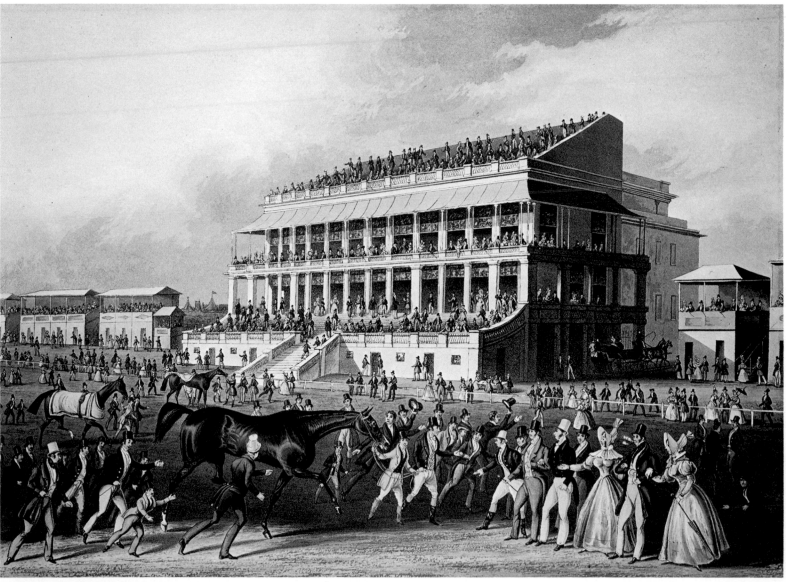

jockey, Sam Chifney (p. 132), at Newmarket. The club won an important moral victory; for though the Prince left the turf in a huff out of loyalty to his rider, the use of professional jockeys was only then becoming widespread and some kind of regulation was obviously necessary.

The one thing that has never changed in racing is the social side – those who go not so much for the sport as for the eating, drinking and dancing. In the past, the very large numbers of people attracted to the race meetings also brought the promoters of other sports that combined spectacle with an opportunity for gambling – for instance, boxing and cock-fighting.

The principal racecourse remained Newmarket though there had been racing at Doncaster, for instance, for much longer, since the sixteenth century in fact. And it was at the latter in 1776 that there was a significant departure from the then common practice: the establishment of a sweepstake race over a relatively short distance (two miles) for relatively young (three-year-old) horses. This was to become the St Leger. Epsom had had regular racing only since 1730 but was uniquely convenient for London. The idea of a sweepstakes for three-year-olds was taken up there in 1779 by the young Earl of Derby and his friends: it was restricted to fillies and named after his house near the course, the Oaks. Then the following year they ran a third sweepstakes, over only a mile and for both colts and fillies – the Derby. Another still fashionable racecourse, Ascot, was founded by Queen Anne. After her death it declined until the Duke of Cumberland established a stud in Windsor Great Park, revived the near-by racecourse at Ascot and finally confirmed its status with the patronage of his brother, George III.

Agricultural experiments. George III was remarkable in many ways; he had an insatiable curiosity and interest in experiment of all kinds. He was not dubbed Farmer George by his people for nothing: it was he who established the model farm at Windsor and who sought the improvement of wool through the importation of merino sheep. He went so far as to contribute (under the name of his shepherd at Windsor, Ralph Robinson) to the *Annals of Agriculture*, a monthly publication founded in 1784 by Arthur Young, the most formidable protagonist of improved agricultural practices of his time. Indeed it was Young who, through his travels and writings, was largely responsible for carrying information about new ideas the length and breadth of the land.

Although the industrial revolution of the late eighteenth century is well known, there were equivalent, if less spectacular, changes on the farm. The process of land enclosure continued, speeded by the demands of the long revolutionary wars; though even this was not completed until half-way through the nineteenth century. An improved design of plough was invented that needed only two horses and a man, but there were still those that clung to ancient ideas demanding six horses and three men to a plough. The breeding of stronger horses also

JOHN CONSTABLE (1776–1837): *Study of Two Ploughs.* 1814. Oil on paper, 17 × 26 cm. London, Victoria and Albert Museum

This kind of detailed study was as important for Constable as was animal anatomy for Stubbs. The English countryside as we still know it was largely made by the kind of plough shown here. The great beam, supported on a pair of wheels, helped the ploughman regulate the depth of his furrow. Attached to the beam can be seen the coulter, a kind of vertical knife which cut the soil or turf to the desired depth; the ploughshare is the flat, half-arrowhead shape which made a horizontal cut below the ground; finally, the mould-board, set at a slight angle, turned over the slice of earth and laid it alongside as the plough moved along.

JOHN CONSTABLE (1776–1837): *Landscape, Ploughing Scene in Suffolk (a Summerland).* 1814. Canvas, 51·4 × 76·8 cm. Private Collection

A summerland was a field left fallow for the summer only, after which it would be ploughed. Since the time of the first primitive clearances, the farmer's plough has determined much of the present shape of our countryside. The physical limitations of plough and horse or ox demanded that a field be cultivated between a series of pronounced ridges, each roughly twenty-two yards apart, with the intermediate furrows about ten times this length – a furlong. Before the enclosure of the vast open fields, individually owned lands (that is, strips approximately twenty-two yards wide and two hundred and twenty yards long) had their boundaries marked by wooden stumps or posts. Thus from the earliest times a fallow field possessed an effective natural measure for summer sports.

J. BARKER (*fl.* about 1800): *A Country Gentleman.* 46·4 × 56·5 cm. Photograph by courtesy of Sotheby's

The rhythm of country life, though ceaseless, is of a pace not conducive to speedy change. Whilst history records in admiring detail the successes of agricultural pioneers, little is said of the great majority of farmers, who looked with calculated suspicion upon all the new ideas. This determination to abide by what is old and tried is admirably illustrated in this rare portrait, and is emphasized by the gesture of the arm particularly. It is generally assumed that by now nearly all the oxen had been replaced by heavy draughthorses: it is just that those who wrote books and had their pictures painted were more often than not those who wished to promulgate their new ideas.

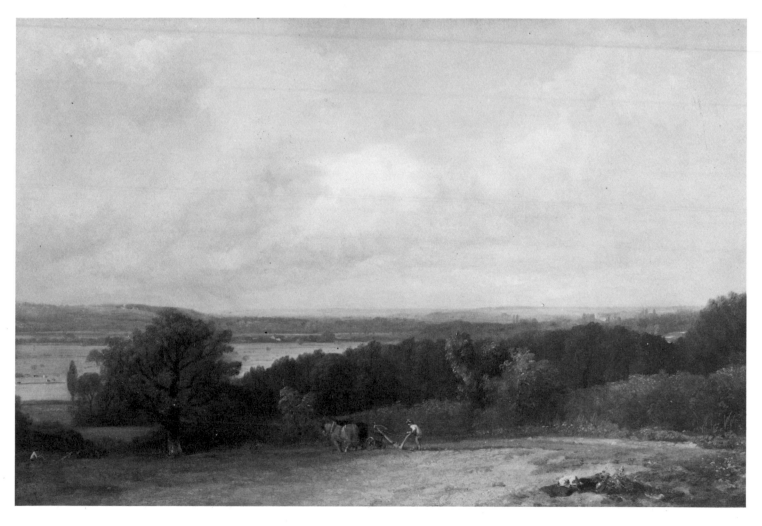

JOHN FERNELEY (1782–1860): *Run near Melton Mowbray*. 1824. Canvas, 61 × 122 cm. Kintore Trust

This is the kind of picture for which Ferneley is most famous. In size and proportion it was his own invention, doubtless stimulated by his early work as a decorative painter of wide and narrow wagon boards. Here he had the opportunity of painting those long runs after a canny, healthy fox that helped make the Shires so famous and exciting. The huge fields in- cluded every kind of horseman from the most expert and daring to the most fool- hardy and accident-prone. A sense of hu- mour is essential for the successful sports- man.

meant that larger wagons could be built. There were numerous patents for drills, reapers, chaff-cutters and turnip-slicers; agricultural societies were formed; there were cattle-shows, wool-fairs and ploughing matches. Great landlords like the Duke of Bedford and Thomas Coke experimented and shared their knowledge with all those who were interested. Iron gates and fences began to be used.

Right until the end of our period, however, despite the many improvements in farm machinery, hand labour was still largely responsible for gathering the crops. Corn was cut with a scythe or sickle, and each scytheman was followed by a gatherer, binder, stooker and raker. Haymaking was equally laborious through its many stages, the carts at the end followed by women scarcely allowing a blade to escape their rakes.

Consciousness in painting. For art and artists, too, ideas were changing and developing. The mood of romanticism already noted

BENJAMIN MARSHALL (1768–1835): *Lord Sondes with his Brothers and their Hounds in Rockingham Park*. Signed and dated 1815. Canvas, 44·8 × 216 cm. Private Collection

Ben Marshall is a major artist, becoming better known but still relatively neglected no doubt because of the sporting nature of his work. Born in Leicestershire and trained in London, he lived for many years near Newmarket, where the racing fraternity was the principal source of his commissions. In this picture Marshall's ability for catching a likeness is wonderfully shown in the faces of the four Watson brothers, and not least in the highly individual personalities of the hounds.

BENJAMIN MARSHALL (1768–1835): *Hap-Hazard*. Stipple and line engraving by W. & G. Cooke, 1805, 50·5 × 60·3 cm. London, British Museum

This print was published by the artist himself and it in every way illustrates the point that the finest prints of old were much more than straightforward reproductions; as works of art the best can stand on their own. Hap-Hazard was owned by the sporting Earl of Darlington and was unbeaten in four-mile races from 1801 to 1804. (Races in general were over much greater distances then.) The horse is portrayed beside a symbolic winning post with his trainer, Samuel Wheatley, and jockey, William Pierce.

was intensified and deepened; the paintings became more luscious and the demands of patrons more and more sophisticated in respect of compelling design and a more complicated interaction of figures with landscape. Such a development was inevitable in a society that was rich, prosperous, self-confident and intellectually invigorated.

James Ward. The artist who best represents this early nineteenth-century painting is James Ward (1769–1859). He had trained as an engraver with John Raphael Smith and then with his elder brother, William Ward, a famous mezzotinter. His brother-in-law, George Morland, encouraged him to turn to painting, and, no doubt inspired by the detailed grounding in the work of others that an engraver perforce acquires, Ward painted a series of marvellous pictures of both agricultural and sporting interest. He tried his hand at other branches

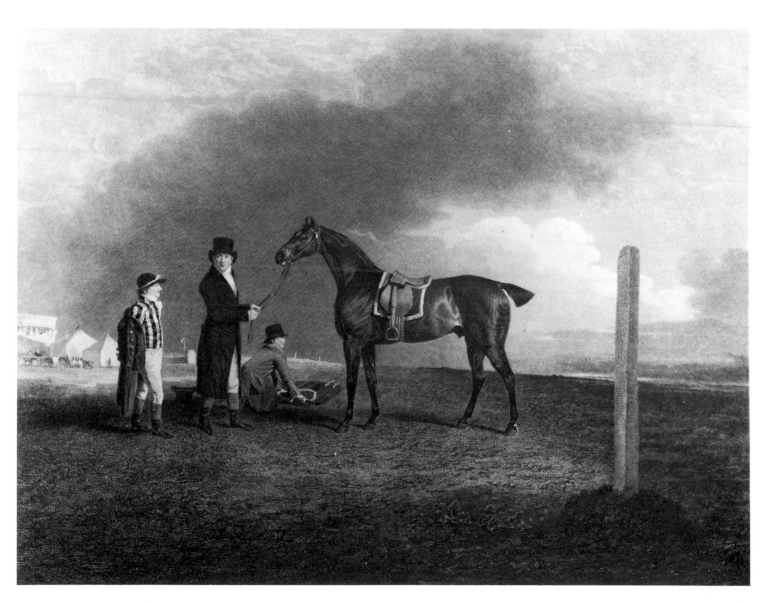

JAMES POLLARD (1792–1867): *The Birmingham Mail*. Lithograph by G. B. Campion, 1837, 27·3 × 37·4 cm. London, British Museum

The full title of this print is 'Scenes during the snow storm December 1836. The Birmingham Mail fast in the snow, with little chance of speedy release, the guard Banbury proceeding on to London with the letter-bags.' That great snowstorm of 1836 caused havoc through the length and breadth of the land, and such abiding fame through prints and paintings as to leave us permanently nostalgic for a white Christmas. This particular incident commemorates the proud tradition of the Post Office that the Royal Mail should not be delayed even though the passengers might be marooned. The print represents a commercial coup for its publisher, Ackermann, and printer, I. Graf, for it was produced and on sale barely five weeks after the blizzards that inspired it.

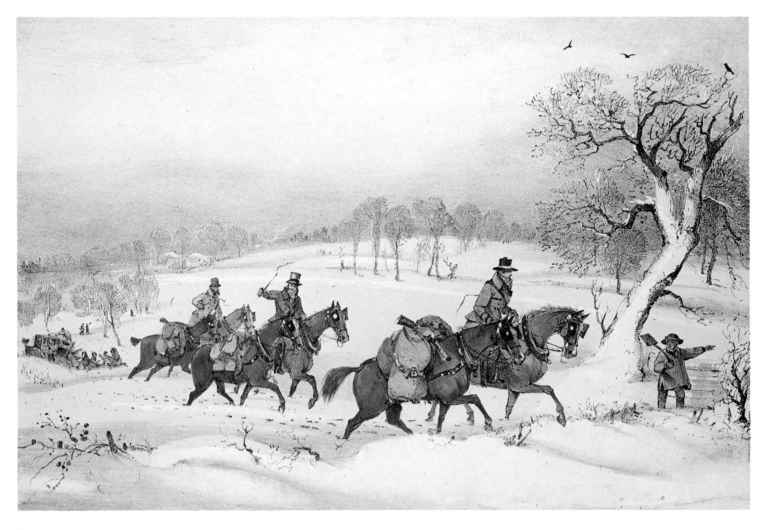

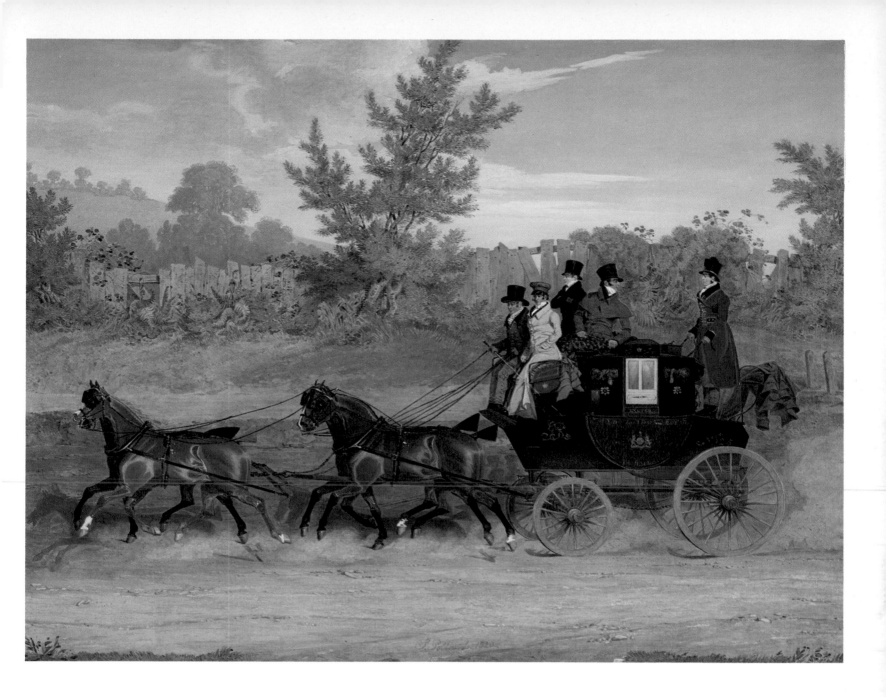

JAMES POLLARD (1792–1867): *The Exeter Royal Mail on a Country Road*. Signed and dated 1820. Canvas, 76·2 × 101·5 cm. Private Collection

In this painting Pollard has managed to combine exceptionally well the minute accuracy of detail that his patrons demanded with the feel of a sunlit autumn day. The technically minded can enjoy the meticulous representation of the harness, and the correct thickness of the wheels, so often shown by other artists as unnaturally thin, no doubt in the interests of conveying an impression of speed. The privileged person travelling on the box beside the driver looks as if he is about to negotiate a turn with the reins. There is little dust, perhaps subdued by early morning dew or rain; the road looks as if it has been properly prepared in line with the tenets of Telford or McAdam.

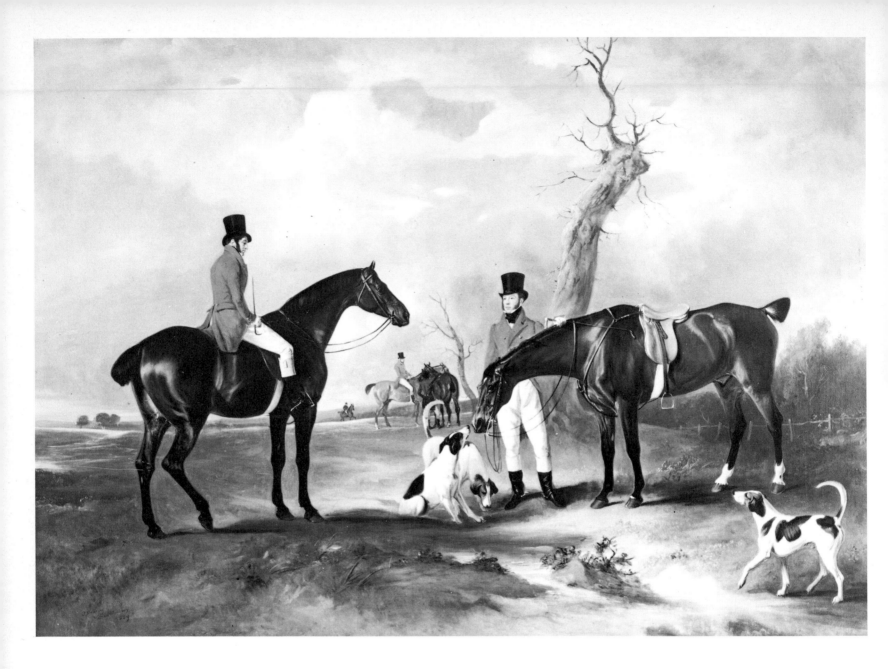

of painting, too – historical and religious themes, for example – but without the same kind of success.

Benjamin Marshall. Another important artist was Ward's close contemporary, Benjamin Marshall (1768–1835), who was born in Leicestershire and moved to London, where he trained briefly with the portrait painter Lemuel Francis Abbott. He soon established himself as an outstanding painter of racing and hunting scenes that are uniformly distinguished by their close understanding of character, both human and animal. He eventually moved to Newmarket, for, as he said, 'the second animal in creation is a fine horse, and at Newmarket I can study him in the greatest grandeur, beauty and variety.' His career was finally brought to an end in 1819, when he was seriously injured in a mail-coach accident.

John Ferneley. It fell to a younger man, John Ferneley (1782–1860), to portray in an unrivalled manner the last and greatest days of

John Ferneley (1782–1860): *Sir Francis Mackenzie, 5th Baronet of Gairloch, and Mr Mackenzie*. Signed and dated 1829. Canvas, 104·1 × 147·3 cm. Private Collection

Ferneley was the son of a Leicestershire wheelwright and showed such early promise that the Duke of Rutland arranged for him to be apprenticed to the painter Ben Marshall. Ferneley eventually settled in Melton Mowbray, where he made a successful living with commissions, like this, of rich and fashion-conscious sportsmen. The beautiful hunters would have cost perhaps two hundred guineas apiece: each sportsman would need ten or so, if hunting regularly, which would have cost another thousand guineas to stable for the season.

JOHN FERNELEY (1782–1860): *The Hunt Scurry*. Signed. 87·6 × 142·8 cm. Photograph by courtesy of Phillips

Who could doubt that the scene is Ireland? Where else in the British Isles would such a large bridge be built over a small stream and then left unfinished? The fox, too, is Irish for it has run over the bridge whither it is pursued by the hounds urged on by Lady Rossmore standing on the arch; the rest of the hunt, led by Colonel Candy, obviously has the fox in sight but all will now have to wait for the pack to come to earth. This is Kilcoman Bridge, County Offaly, and the horses all possess the graceful, curved Irish neck.

hunting in the Shires, when fields had never been bigger, the enthusiasts more wealthy, and the horses more expensive. Ferneley was also born in Leicestershire, the son of a wheelwright. Whether he had wanted to or not, young Ferneley would have been involved in the hunting mania. The story is that he exercised his obviously natural skill as an artist on the foreboards of the wagons brought to his father for repair; clearly though, these were the origin of a shape of painting that he was to make his own – the 'scurries', long and narrow pictures in which a sequence of incidents could be brought together in a kind of panorama. This idea, on a huge scale and in special decorated buildings, was fashionable at the time but Ferneley's own paintings used the same idea in more manageable proportions. One such picture was brought to the attention of the Duke of Rutland, who arranged for him to go to London as an apprentice to Benjamin Marshall. After three years Ferneley travelled extensively (including a year in Ireland in 1808), finally settling at Melton Mowbray, the centre of fashionable hunting, in 1814; from here it was possible to hunt six days a week and his future was thus assured.

Henry Alken. Though the modern sportsman would always give the accolade to Stubbs, the other name on his tongue would be that of Alken. For those whose prime interest is art rather than sport this

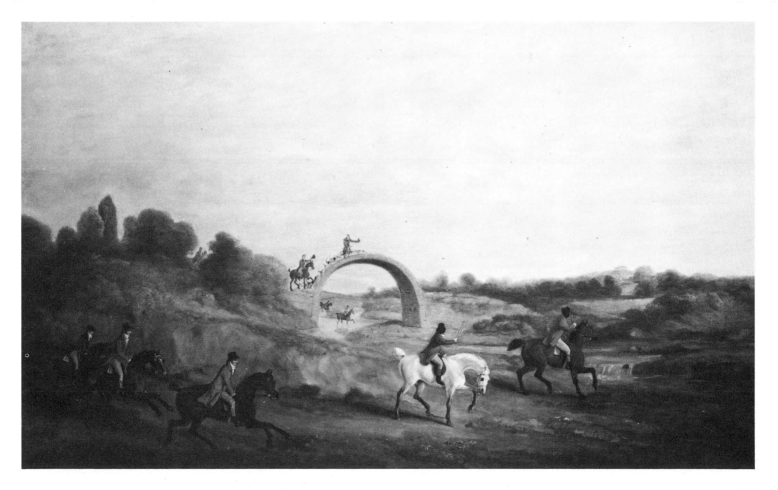

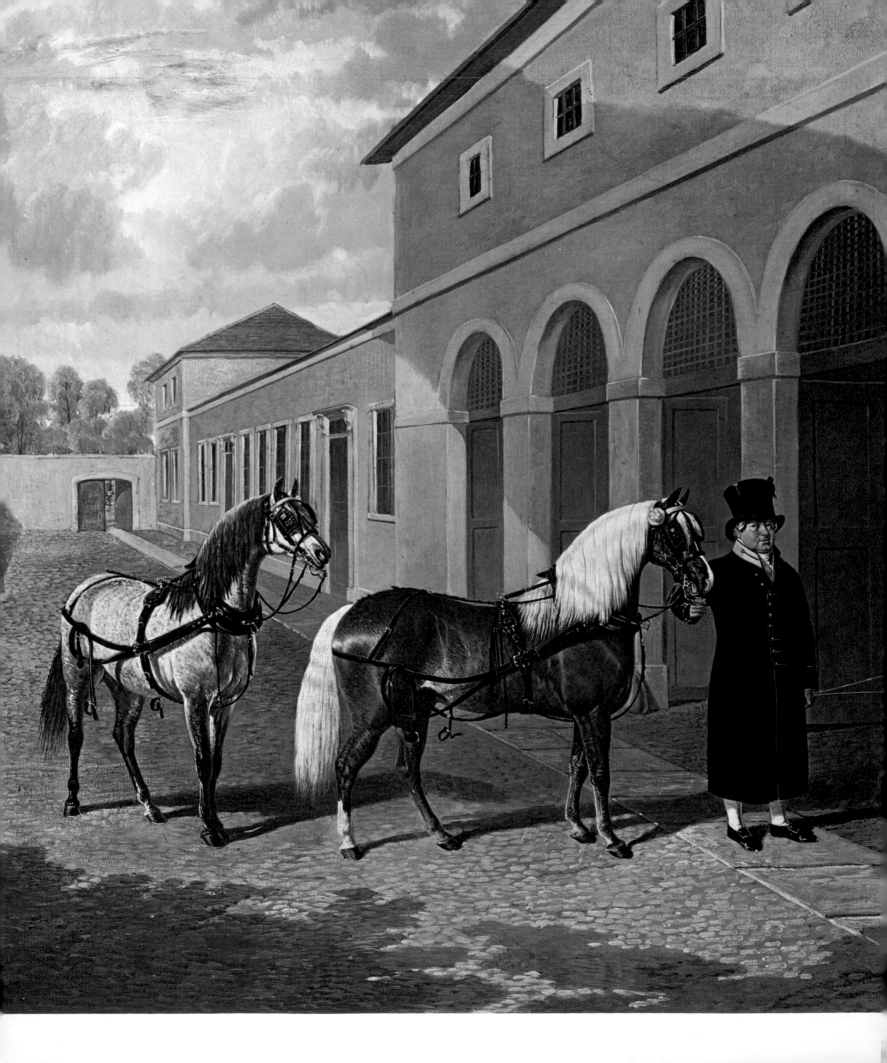

is always surprising: yet Henry Alken (1785–1841) represents something very important in a different way from Stubbs. He was the most famous of four generations of sporting artists, his fame resting on an amazing, indeed colossal, series of drawings and etchings of all aspects of sporting life. These prints range from the lyrical to the humorous, all with an attention to detail and atmosphere that inspires admiration and provides enjoyment to this day. It is easy to dismiss Henry Alken as some kind of pictorial sporting journalist, yet this would be to misunderstand his intention, which was, primarily, to communicate his own huge pleasure in and knowledge of sports of all kinds. Such a viewpoint need not be defended, merely understood.

Sporting prints. One of the things that stands in the way of even partial appreciation of the work of artists like Henry Alken is the fact that so much of their work is in print form. Without any doubt there is a paradox about sporting prints: for while there is a sense in which they are reproductive, they are not reproductions in the modern sense of a more or less faithful imitation of an original oil painting. They are primarily illustrations or, perhaps more fairly, a kind of document or record, which will be examined closely and critically by those interested in the subject portrayed. Therefore the methods used for making prints were vital to their success. All of these factors go some way towards explaining why prints have to be looked at in a different way to oil paintings, and why they need to be understood before they can be appreciated.

As most people in our period were either living in or dependent on the country, there was a very large potential demand for sporting prints. As a result there were a great many varieties published, many of which have survived. It was a strictly commercial operation. Those principally concerned were the artist, engraver, publisher, printer, paper-maker, colourist and printseller. Even these specialities were not exclusive: for instance an artist or engraver might act as his own publisher.

It was the publisher who organized the whole operation, bringing the artist and engraver together, providing the finance and arranging the distribution and publicity. Several engravers would have been responsible for prints of real quality, the repetitive or basic work being given to apprentices. The major outlining or toning would have been done by the man actually named on the print as the engraver. The splendid, sometimes even rather beautiful, inscriptions found on the best prints would have been worked on the same plate but by a specialist engraver. The colouring was the responsibility of another team of specialists, though they worked to a master pattern supplied by the artist. The matter is complicated by the practice of printing in colour, a process generally done in combination with hand-colouring. More often than not the prints were entirely hand-coloured. Many of the best prints were the product of artists who were their own engravers and who were also keen and knowledgeable sportsmen in their own right. None the less the vexed question of what exactly was

JOHN FREDERICK HERRING: *The Duchess's Ponies.* Detail from plate on page 150

145

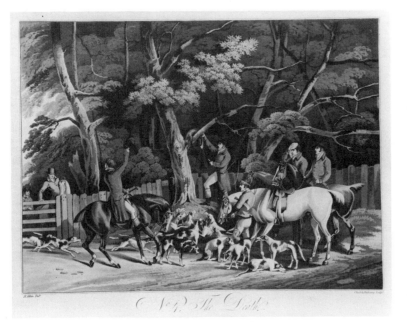

HENRY ALKEN (1785–1841): *Throwing Off*; *Breaking Cover* (on p. 133); *In Full Cry*; *The Death*. Etchings and aquatints by Clark and Dubourg, 1813. London, British Museum

The rise in the popularity of hunting more or less coincided with the invention and perfection of the hand-coloured aquatint. At its best it can be hard to distinguish from an original watercolour, though several dozens of virtually identical prints could be produced if the demand warranted. Apart from the artist a number of different specialists were involved – here the letter-engraver has spelt Alken's name as 'Alkin'. The phenomenal popularity of the sporting print allowed a number of them to be published in sets or series, in which the idea of movement as well as of the passing of time could be indicated. (Panoramas were another and rather more unwieldy example of the same principle.) This set of four is particularly attractive and of a drawing-room elegance in design as well as in the lack of crude humour or bloody incident. Two details are worth noting: the tiny terrier accompanying hounds in *Throwing Off* (No. 1), which came into its own should the fox go to earth; and the 'treeing' of the dead fox in *The Death* (No. 4), which was a short-lived practice that advertised the professional huntsmen's success and gave them the chance to cap the field for tips.

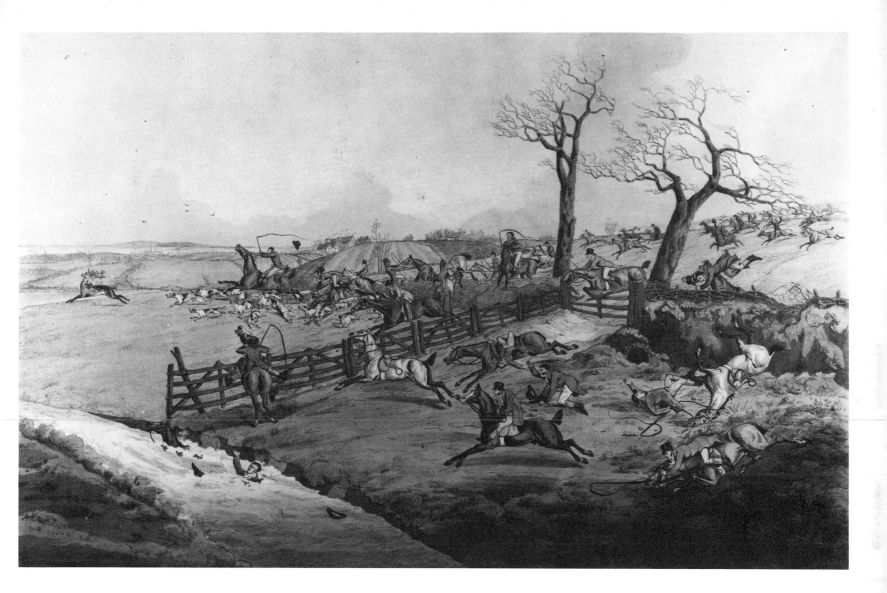

HENRY ALKEN (1785–1841): *Easter Monday.*
Etching by the artist, 1817, 34·2 × 43·8 cm.
London, British Museum

Henry Alken was the son, father and grandfather of sporting artists. Sometimes, as here, he used the pseudonym Ben Tally Ho, and when on form he could raise the sporting print to a great height of pictorial journalism. This is a splendid example based on the annual Epping Forest hunt when it had degenerated into a kind of wild day out for Londoners. The riders were mostly without skill and so undisciplined as to endanger the hounds by galloping amongst them. Their quarry was a carted (that is, domesticated) stag, whose benign spirit and undignified position are suggested by the large bow tied round his neck.

the original inspiration for a print is surprisingly difficult to answer. Though some were obviously taken from particular paintings, often as a means of making more money from the original, in other cases a finished watercolour, or the merest sketch, would be enough for an engraver to work from, especially if the artist was his own engraver. At the other extreme, a very successful print might lead to a commission for a painting based on the print. There might even be several versions of a drawing or watercolour, any or all of which might quite reasonably be an original for a print, in the sense that individually they were the designs for the several stages necessary to the making of a print.

One last point is worth noting: the date on a print is no guarantee of its being an original, that is early, impression. Copperplates, for instance, can have a very long life; some still exist today bearing the original publisher's name and date.

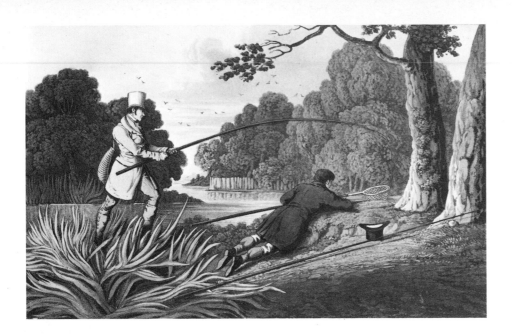

HENRY ALKEN (1785-1841): *Pike-Fishing*. Etching by I. Clark, 1820. Photography by courtesy of the Parker Gallery

The pike is a large and wicked fish, best caught with the aid of a companion to gaff or net it. These anglers are using heavy rods, seemingly unjointed, and with a rudimentary reel.

(*opposite*)
HENRY ALKEN (1785-1841): *The Toast*. Etching by the artist, aquatint by George Hunt, published 1824, 29·2 × 40 cm. London, British Museum

This kind of celebration was a relatively new development depending·on a large, exclusively male field, and a late (mid-morning) start.

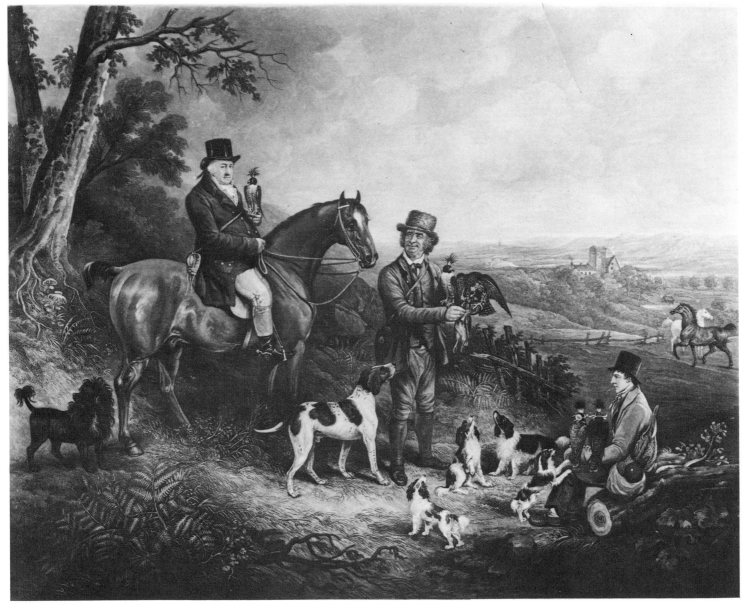

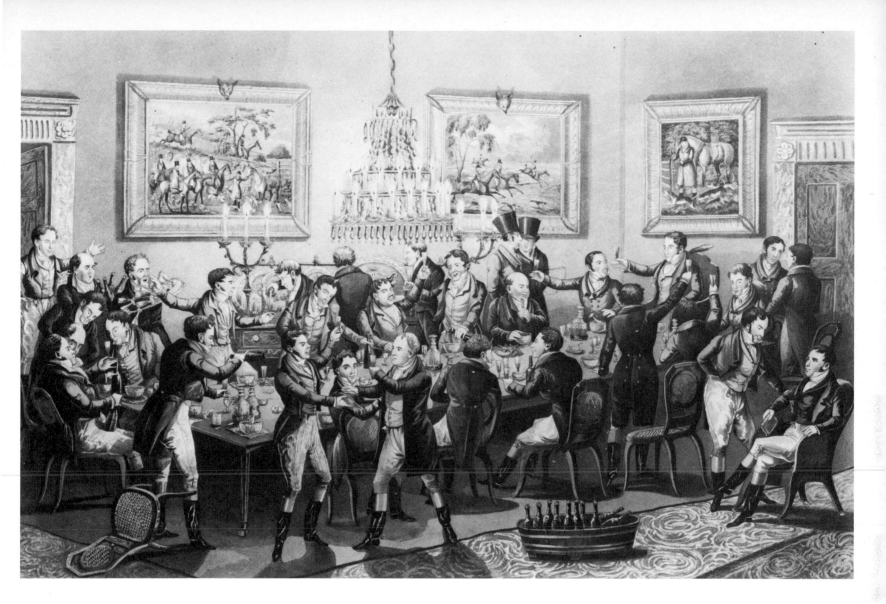

JAMES HOWE (1780–1836): *Hawking*. Mezzotint by Charles Turner, 1816, 54 × 60·3 cm. London, British Museum

The relatively wild Scottish countryside provides better opportunities than England for hawking and for the breeding of hawks. This picture dates from the height of the revival of interest in the sport in the early part of the nineteenth century. In the centre stands John Anderson, whose character is written on his face and who was so celebrated as a falconer that the American naturalist, John James Audubon, paid him a special visit. His master, Malcolm Fleming of Barochan, rides on the left and his assistant, William Harvey, sits to the right. Howe specialized in animal painting, well shown here in his observation of the many varieties of dogs.

Improved roads. The relatively long legs of the cattle and sheep seen in the earlier pictures were no accident, for the roads were terrible and pack-horses universally used. Whilst improved farming methods may have been slow of adoption, the difficulty of movement between one part of the country and another was no encouragement and indeed in many cases an active hindrance. The principal reason for the lack of improvement of the roads was the method whereby they were maintained. Essentially each was the responsibility of the relevant parish, which was able to set its own standards of design and maintenance. The establishment under statute of Turnpike Trusts improved the situation by the levying of tolls. But the trusts were not everywhere and were themselves often unpopular because of the irregular and not always strictly fair way that tolls were collected; the right to collect the tolls was often farmed out to anyone convinced that there was money to be made from the practice. Everyone agreed that the whole system was in need of reform, though it was not until 1827 that John McAdam was appointed surveyor general of roads in Great Britain. The relative simplicity and cheapness of his system of road-making,

JOHN FREDERICK HERRING (1795–1865): *The Duchess's Ponies*. Signed and dated 1823. 66 × 90·2 cm. Executors of the late Lord Barnard

This is the stable yard of the Duke of Cleveland (formerly Earl of Darlington). The attention paid by the whole family to their animals is evident in the elegant grooming and glittering harness of these carriage-ponies. The whole effect is complemented by the sombre smartness of the coachman – undoubtedly a shrewdly feminine touch. But it is too easy to get carried away by the details, for in its way this is a remarkable picture in the manner of its design.

JAMES POLLARD (1792–1867): *Hyde Park Corner* and *Grand Entrance to Hyde Park Corner*. Aquatints by R. and C. Rosenberg, 1828 and 1844, 44·5 × 61·2 cm. and 42·5 × 61·6 cm. Private Collection and London, British Museum

The passing of a plate from one publisher to another was not uncommon and if any alteration was made it would generally be only to change the name and date. In this instance the second publisher was intent on updating the original version: the three vehicles in the foreground show a sleeker, more rakish design in the later print. From our perspective, the two prints provide a unique record of a change in fashion in carriage design over relatively few years.

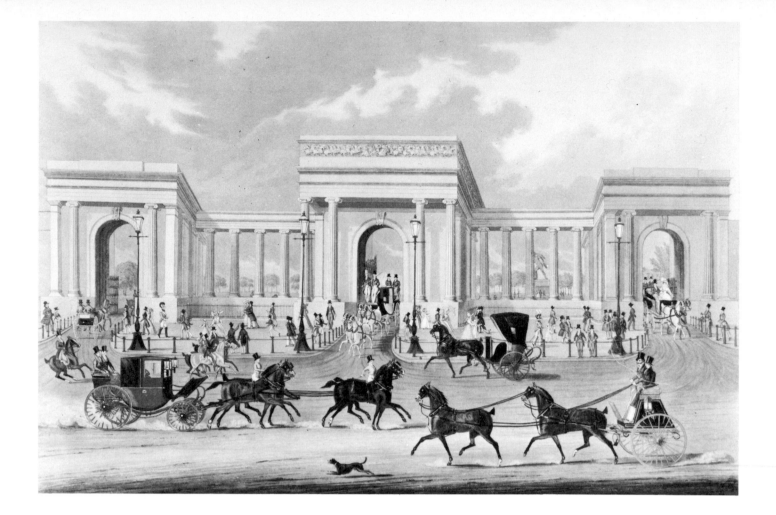

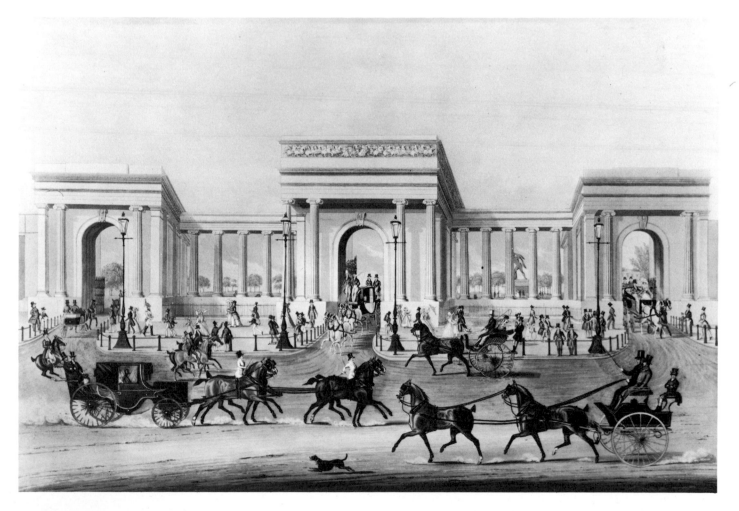

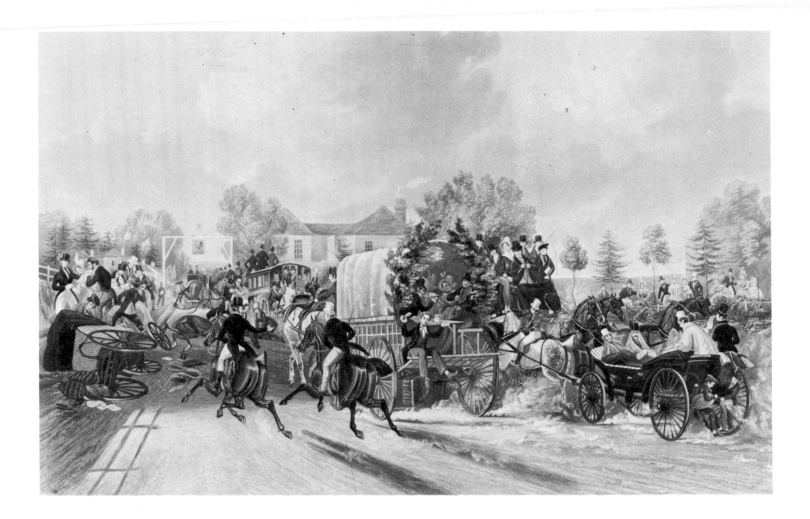

his drive and energy, made him able to persuade the turnpike trustees to repair and improve their roads to a uniform standard. Over the previous quarter of a century both McAdam and Thomas Telford had been slowly making their mark upon the roads of the nation, with the support of money voted by Parliament.

From our point of view, the irony of this important revolution in travel lies in the fact that one major aspect of the pictures now indissolubly associated with the era of sport and countryside, those of coaching scenes, date in fact from a very short period – barely twenty years. For by 1840, the coaches had nearly all been superseded by the railways, by then a decade old and already sprawling across the land.

Early coach travel. The history of coach travel was not without its moments. It is salutary, for instance, to be reminded from a pamphlet found in John Evelyn's library that at the end of the seventeenth century Parliament was being asked to suppress stage-coaches on the grounds that they were destroying the breed of good horses 'and making men careless of attaining to good horsemanship, a thing so useful and commendable in a gentleman'. None the less, by the middle of the eighteenth century they had survived this, and no doubt other such onslaughts. Yet such was the state of the roads that it was con-

JAMES POLLARD (1792–1867): *The Cock, at Sutton*. Aquatint by J. Harris, 1838, 36·2 × 49·5 cm. Private Collection

Improved roads made a trip to the races smoother if no less liable to accident amongst the cheerful participants. This is a day out in the country for townspeople using an assortment of vehicles or other modes of travel. The wagon in the centre has been turned into a kind of travelling inn, the leafy branches forming an ancient symbol of bibulous hospitality. A single stage-coach passes in the opposite direction; within a few years there would be none as they gave way to the challenge of the railways.

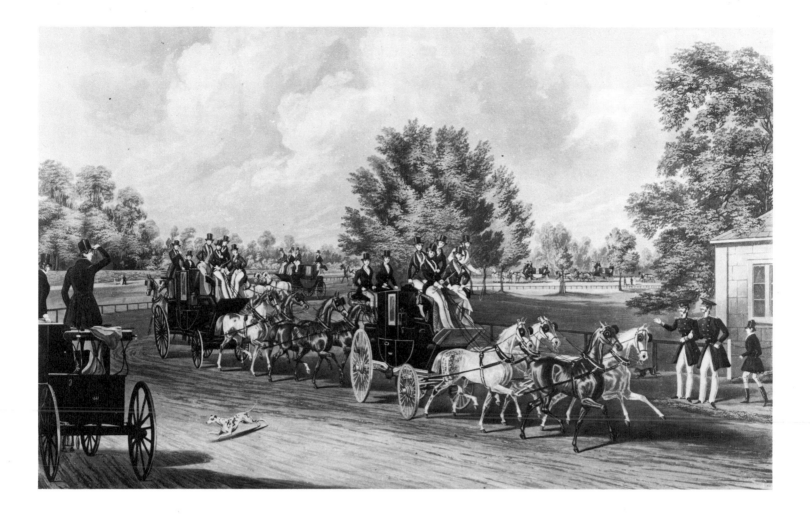

JAMES POLLARD (1792–1867): *The Four-in-Hand Club, Hyde Park*. Etching and aquatint by J. Harris, 1838, 39·7 × 54·6 cm. Private Collection

It was a logical progression from the horsing and driving of public coaches to the building by the aristocracy and gentry of their own private versions, called drags. There was tremendous competition not only in the skill and accuracy of the driving, but in the smartness of the turn-out and the careful matching of the horses, as much in their strength and pace as in their appearance. Driving, as a sport, has seen a strong revival in modern times with enthusiastic royal support.

sidered a wonder that a coach proprietor could advertise the journey from Manchester to London as taking only four-and-a-half days. In 1760 it took four days to travel from Exeter to London (170 miles); within a few years this was shortened to two days, but it was not until 1784 that the journey was cut to thirty-two hours.

One contribution to this speeding up of the service was steel springs – prominently and proudly displayed, for instance, by the phaetons that feature in so many eighteenth-century pictures. But even more important than improved springing were better wheels. The giant, broad-rimmed wheels supporting the stage-wagons are commonly thought to be the direct result of the bad condition of the roads; but they were as much the result of legislative prescription. Because the turnpike trustees were empowered to levy their tolls in a way that depended on the ratio of the weight of the load to the width of the tyre, the latter was often exaggerated. The skill required to make these huge wheels was considerable, particularly following the invention (probably sometime in the latter half of the sixteenth century) of dishing, which gave greater strength to the wheel than the simpler flat spoke. This idea provided another advantage: the sides of the wagon could be canted outwards to match the cant of the wheels, so increasing both

the width and capacity of the vehicle. These huge wagons – drawn by eight, even up to twelve, horses – continued in use into the early part of the nineteenth century.

The iron tyre – a welded hoop of iron – was used on carriages from the early part of the eighteenth century, whereas the broader-wheeled wagons and carts were shod with a succession of individual strakes. One way in which we are today in danger of being misled by the pictures of the past is in the method chosen by many artists of drawing the wheels; they are often shown to be much thinner than they possibly could have been, creating an impression of lightness and thus of speed. It must not be forgotten that, in very many instances, paintings

GEORGE STUBBS (1724–1806): *The Prince of Wales's Phaeton*. Signed and dated 1793. Canvas, 102·2 × 128·3 cm. Royal Collection. Reproduced by gracious permission of Her Majesty The Queen

The Prince's coachman, Samuel Thomas, holds one of a marvellous pair of powerful carriage-horses. Such noble animals allied to the lightly constructed phaeton meant an exciting drive; the comfort and efficiency of the harness were crucial to safety and quickly responsive control. The graceful yet easily shattered silver birch tree echoes the idea.

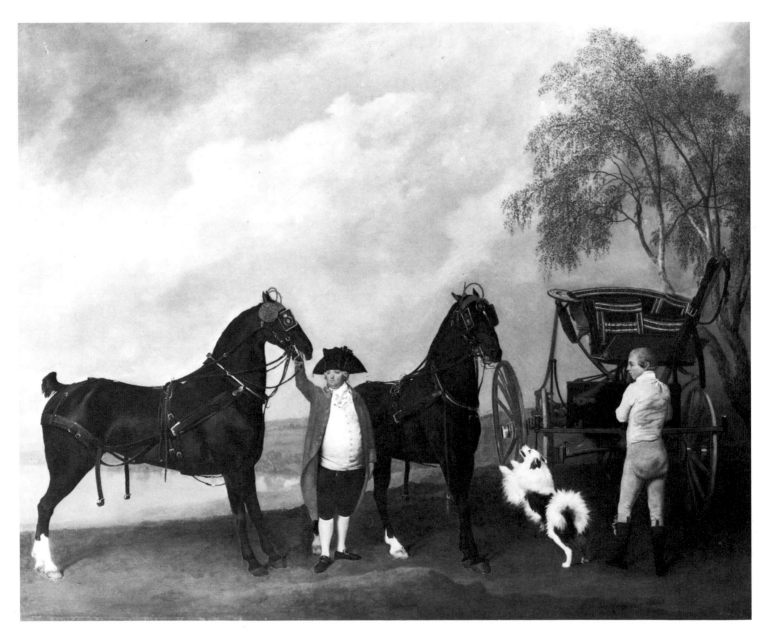

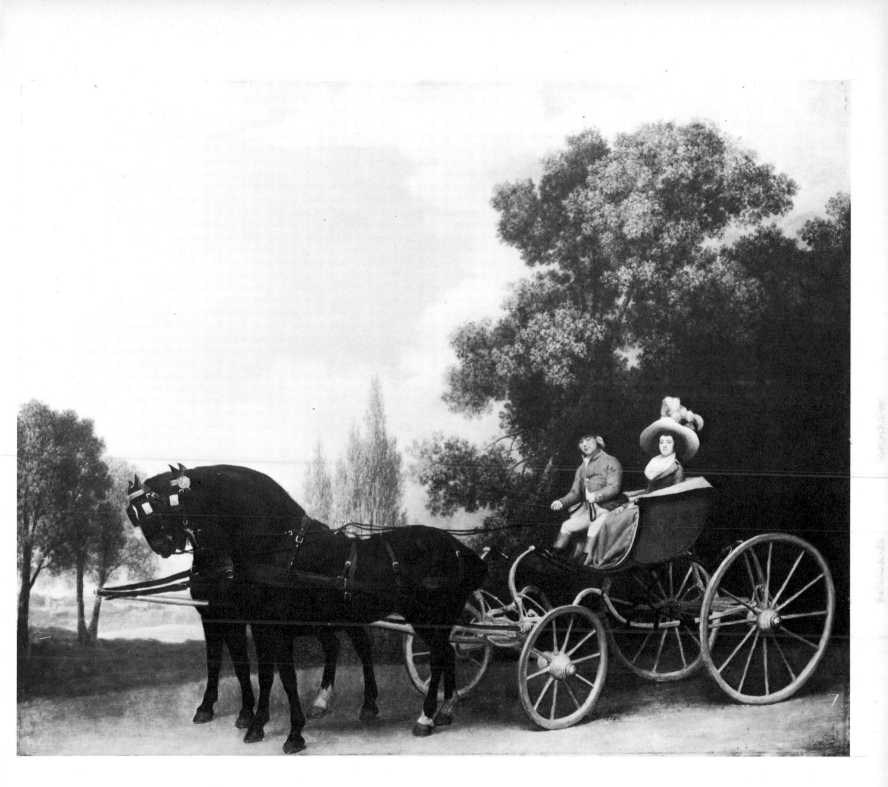

GEORGE STUBBS (1724–1806): *Lady and Gentleman in a Carriage*. Signed and dated 1787. Canvas, 82·6 × 101·6 cm. London, National Gallery

The idea of going for a drive has considerable extra attraction when allied to a graceful phaeton and elegantly matched horses. Such a light vehicle could equally well be drawn by ponies, which were particularly suitable for town work and also served to emphasize the delicacy and height of the phaeton. Doubtless the pair in this picture served as carriage-horses as well. The phaeton was not only for the young, as this comfortably prosperous couple testify; but undoubtedly it was a sign of success and wealth, for possession would have meant the ownership of at least one other – closed – vehicle for use in inclement weather.

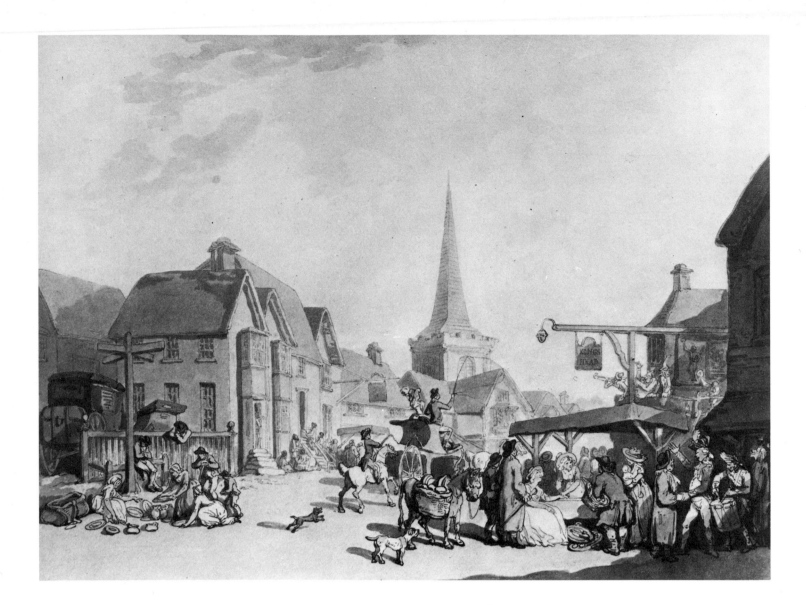

and prints were produced as much for publicity or propaganda as for record.

There is no doubt that for both artists and ourselves it is the designs of the various vehicles that are most enduringly attractive. Those wonderful phaetons, the highflyers, were driven as much for their excitement and danger as for their value as transport to the Prince of Wales and others who could afford them. They seem to be all wheels and springs; but the pictures are worth examining carefully, for it is noticeable that, however intricate the system of springing, it was in effect still relatively crude. The important point was that the springs were still interposed between body and chassis rather than directly, and more efficiently, between axle and chassis. The latter idea came into general use only in the early nineteenth century.

The tremendous contrast between the long, cumbersome stage-wagons and the short wheelbases of the public coaches is as much the

THOMAS ROWLANDSON (1756–1827): *Cuck-field, Sussex, at Fair Time.* 1789. Pen and watercolour over pencil, 23 × 30·2 cm. Liverpool, Walker Art Gallery

The main reason for anyone to come to town from the country was to buy and sell – from stalls, for there were very few, if any, shops in the smaller towns. Behind the proud couple in their tall phaeton (centre) rides their equally proud servant; in true country tradition they are being ignored by everyone except the dogs.

result of the relative ease of handling of the latter as of any aesthetic sense of design. In the course of time up to fourteen people were permitted to ride on top of the coaches, and the sway, not to mention the consequent danger of overturning, could be very alarming. Again this was something that was reduced by new ideas in springing.

Improved coaches. The most influential of all the coach-builders was Samuel Hobson of Long Acre, London. In the early nineteenth century he was responsible for introducing such refinements as folding heads for landaus, automatic folding steps, windows and blinds, as well as wrought iron in place of timber and iron in the basic construction. Other improvements of the time arose from the developing skill of the cabinetmaker – achievements such as invisible joints for roof-panels and quarter-panels that made them watertight without the need for leather covering; panels were rarely if ever flat, being curved in one way or another, and were not easy to make. Coach painting also rose to new heights – forty or fifty coats of paint before the final varnishing were not uncommon – with superb final effect. Such finishing was not only marvellous to look at, it had immense practical value in that the various woods used in constructing the bodies were rendered weather-proof and impervious to damp. It is also no wonder that so many artists learnt their basic skills this way.

The earliest stage-coach of about the middle of the eighteenth century was much the same in appearance as the private coach – no roof passengers, with the foreboot and boxseat rigidly mounted (and thus unsprung) above the front axle. Over the back axle a vast wickerwork basket, known as the conveniency, contained parcels, baggage, and half-fare passengers who could find room for themselves. The guard had a backwards-facing perch on the edge of the roof. By the end of the eighteenth century, the foreboot and the boxseat had been joined to the body of the coach; a similar hindboot now provided a forwards-

JOSEPH MALLORD WILLIAM TURNER (1775–1851): *Frosty Morning*. 1813. Canvas, 113·7 × 174·6 cm. London, Tate Gallery

The idea for this picture came to Turner whilst travelling in Yorkshire, and the greatness of the inspiration is only matched by the commonplace nature of the subject. The track portrayed here is what we would now describe as a main road, but at that time most country roads were not properly surfaced; therefore a frost brought a blessed hardness to the winter's mud and thus ease to the lot of the coach approaching from the distance on the left, and of the dung-cart discharging its cargo of manure on the right. The principal figure in the foreground carries a gun and the boy a dead rabbit – so there will be fresh food for the family this day.

facing seat for guard and passengers, with the fore and rear edges of the roof fitted with seats.

Mail-coaches. The swift, regular stage-coaches were the direct result of the success of the mail-coaches. These were the invention of John Palmer of Bath. Although the carriage of letters remained a royal monopoly, the business was open to contract, and the mail was carried on horseback between each centre.

The matter was brought to a head in 1782, when a new stage-coach service began to operate the Bristol–Bath–London route. The new coaches made the journey in seventeen hours as against thirty-eight for the riding post; they also carried parcels and there was nothing to stop anyone making up their letters into parcels. John Palmer's idea was to improve security as well as to speed the mail by using coaches – which would carry a guard – and eventually to lower costs by the carriage of passengers (inside only). After two years he succeeded in persuading the government that his plan could work – and proved it

HENRY BERNARD CHALON (1771–1849):
The Earl of Chesterfield's State Carriage.
Mezzotint by William Ward, 1800, 45·4 ×
57·5 cm. Private Collection

The Earl of Chesterfield was Master of
the Horse to George III, with whom he
shared many interests including that of
agricultural experiment and improvement.
His state carriage shows several advances in
design, most notably in its suspension – a
combination of steel springs and leather
straps. The superbly matched horses, ex-
pensively liveried coachman and frisking
Dalmatian (originally bred as a carriage
running dog) are all marvellously captured
in this masterpiece of the printmaker's art.
The mezzotinter, William Ward, was one
of the best of his time; the quality of the
print is further emphasized by the inclusion
of the printer's name, I. Shore, in the title –
an extremely rare honour.

not only by organizing the necessary contracts for the supply of horses,
but by providing a service, using a converted stage-coach, that was one
hour shorter even than the new flying coach. By the end of the century
the mail-coach idea had successfully spread to many of the major
routes in the country and, with the improvement in the condition of
the roads, became effectively nationwide by about 1820.

Timekeeping was strictly enforced; for instance, twenty-six hours
and fifty-five minutes only were allowed for the 261 miles from London
to Holyhead – including twenty-seven changes of team. This regu-
larity brought about another small but important social change: a
single standard time throughout the country. The new officially
approved mail-coaches – supplied like the horses by outside contrac-
tors – also set new standards of efficiency, comfort and smartness.

Stage-coaches. Such competition proved a fine spur to the enter-
prise of the stage-coach proprietors. In 1825 the aptly named 'Wonder'
on the London–Shrewsbury road became the first to be timed for so
long a journey in a single day. (The name did not apply to a single
vehicle but to the whole fleet providing the service.) Also, a pro-
prietor's chosen road was his 'ground' – divided into upper (nearest
the coach's home-town), middle and lower (the other end). Hence our
use today of the terms 'up to London' and 'down to the country'.

The competition was such and the cost so substantial – the building,
painting and maintenance of the coaches, the provision of horses at
the various stages, the organizing of booking-offices, the payments of
tolls and duties, the hire of drivers and guards – that it was common
for a ground to be shared by a syndicate. One exception was William
Chaplin, who, in the 1830s, was working out of five London yards,
with sixty coaches, 1,300 horses and 2,000 employees. The foresight
and enterprise of such a man did not desert him in the face of the suc-
cess of the railways, for instead of trying vainly to compete, he took
his coaches off the road and invested his money in the new London
and Birmingham Railway, an example followed by the best of the rest.

Horsing the coaches was an expert's business: the proprietor had to
balance the need to run a fast and reliable service against the cost of
the animals. Good horses were of necessity important and for the best
results they had to be sound and well matched. The wheelers (horses
nearest the wheels) were crucial as they had to be able to hold a coach
on a hill; but the leaders were also important for the reason that if they
kept going the others would follow. In all this it is not difficult to see
the importance of the driver – the coachman who, for a generation,
dominated the road and built a legend of independence, skill and
bawdy eccentricity that has remained to this day.

The skill needed to work a coach is hard to over-estimate, though
once again in its highest form it is relatively recent in origin. In the
first part of the eighteenth century, any coach – stage or private – with
four horses had the two leaders managed by a postilion; only a two-
horse coach would have been effectively driven in hand. About the
middle of the century, leading bars, or swingletrees, were added to the

pole between the two wheelers, allowing for the first time the possibility of controlling all four horses from the box. (Previously the traces for both pairs of horses had been taken direct from their collars to the front axle via the splinter bar.) Indeed one of the excitements of driving a phaeton came from the practice by expert whips of driving three horses at random – that is, in line ahead.

The glamour and speed of the stage-coaches, the skill needed to drive four in hand, plus the necessity of providing teams of horses, were soon to attract the gentry and aristocracy to a new and lucrative business in competition with the innkeepers. Soon they were wanting to drive the coaches themselves. Eventually this was to lead to the building of their own private coaches, or drags, with which they could show off their skill and compete in relative safety (as far as the general public was concerned) with each other, as only their own lives would be at risk.

At the height of the coaching era, in 1835, there were 700 mail-coaches, 3,300 stage-coaches, 35,000 coachmen, guards and horse-keepers and about 150,000 horses. By the following decade most had disappeared – so much so, that the roads of England were virtually empty of through traffic, though there was a corresponding increase in the number of private and commercial vehicles. For long-distance carriage and travel, both canal-boat and coach had disappeared; the railway was now king – and the towns dominant.

James Pollard. The artist we most closely associate with the coaching era is James Pollard (1792-1867). This connection is doubly appropriate, for not only has he left for us, in his many oil paintings and coloured aquatints, a multitude of representations of coaches in all kinds of situations, but he also lived in an area of north London that was associated with the major mail-coach routes. Indeed Pollard's

THOMAS ROWLANDSON (1756-1827): *The King's Arms, Dorchester, Dorset*. About 1790. Inscribed; pen and watercolour over pencil, 27·4 × 41 cm. Cambridge, Fitzwilliam Museum

A privately owned travelling chariot was the principal method of travel for the wealthy in the late eighteenth and early nineteenth centuries. The horses and their postilions would be changed at each stage of the journey – generally an inn. Here a trunk is suspended over the front axle, more luggage is carried on the roof, and beside them gallops their servant. The owner's monogram is painted on the chariot door.

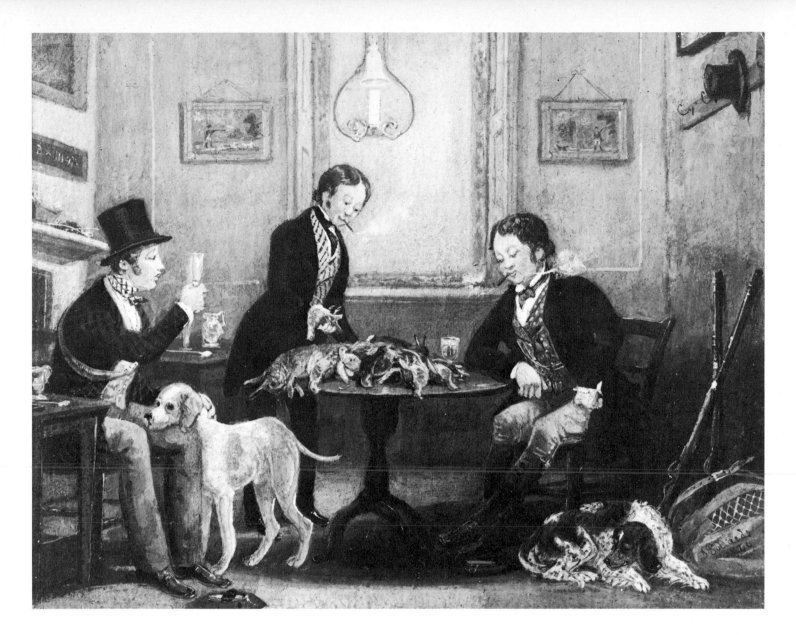

JAMES POLLARD (1792–1867): *The Painter, his Son and a Friend, after a Day's Shooting.* Signed and dated 1846. Board, 22·8 × 29·2 cm. Private Collection

This comfortable and relaxed scene will be familiar to all who find pleasure and companionship in the pursuit of game. Like so many of his peers, Pollard enjoyed field sports, especially angling and shooting, finding them complementary and useful to his own way of making a living as a painter.

father, who was a topographical artist and engraver, had encouraged James's early interest in horses. An early commission to paint an inn-sign – portraying a mail-coach, horses and passengers – changed his career: it was exhibited in a Bond Street window with great success and inspired a series of commissions. He was at the height of his career during the heyday of the coaches, and with their decline his work also declined, though he produced many fine racing and hunting pictures and prints.

John Frederick Herring. Another artist with a close, though markedly different, connection with the coaching era is John Frederick Herring (1795–1865). Again he drew for his own amusement from an early age; he chanced to fall in with a coach painter who was having difficulty transferring an Alken sketch on to the side of a new coach. Herring successfully did the job and this gained him employment as a coach painter: eventually he graduated to the driving of a stage-coach – all the time painting. He was finally persuaded to give up his work on stage-coaches and to move to London, where his pictures became

PHILIP REINAGLE (1749–1833): *Pheasant-Shooting*. 1807. Aquatint by Lewis and Nichols, 39·4 × 52·1 cm. Private Collection

A successful sportsman is more often than not a keen naturalist as well, a fact splendidly illustrated by this lovely print. The bracken and bramble that flourish on the edge of an old oak wood serve as cover for pheasant – but only until the bird is found and successfully sprung into flight by the trained spaniels. In this instance the sportsman, who is relegated to the background, is shown in the act of cocking his gun: the bird is going away from him so there may just be time for him to shoulder his flintlock and fire.

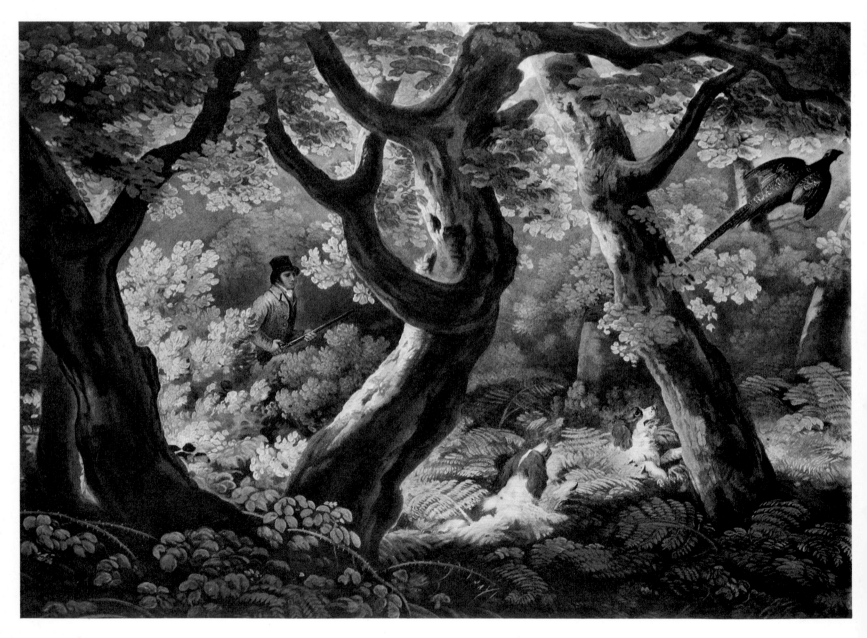

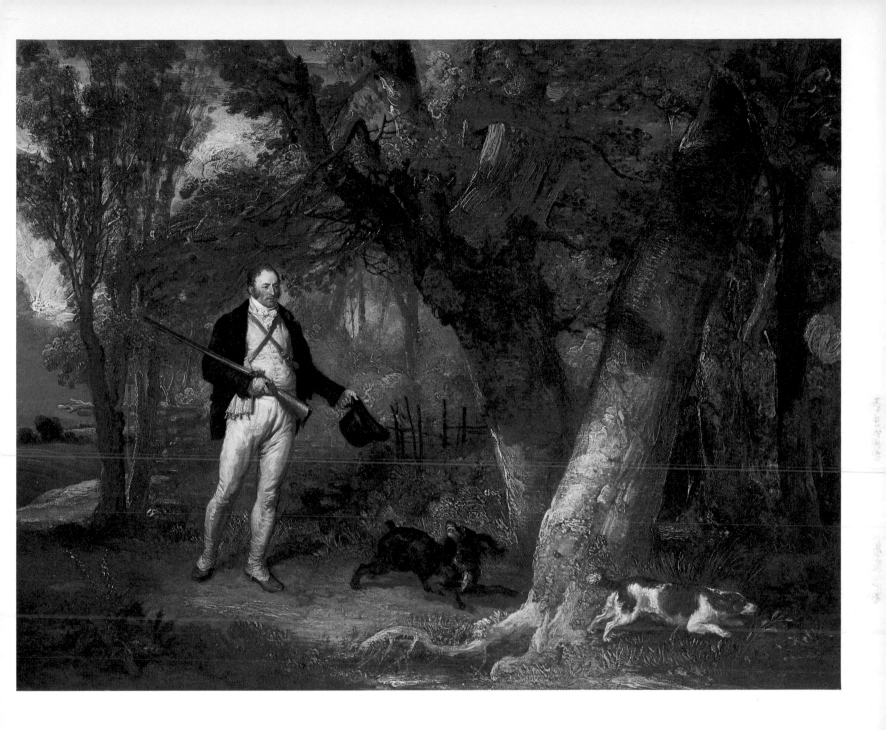

JAMES WARD (1769–1859): *The Reverend T. Levett and his Favourite Dogs Cock-Shooting.* 1811. Canvas, 71·1 × 91·4 cm. Edward Speelman Ltd

The excited dogs need little encouragement from the Reverend Theophilus Levett, a close friend of the artist, who also painted other members of the family, notably John Levett in the park at Wychnor (p. 114). The Reverend Levett's clothes might not meet with everyone's approval, but sportsmen are notoriously individual in their choice of attire, often putting comfort and warmth above elegance and cut with apparently careless but always studied effect. The cross-belts would have borne containers for powder and shot.

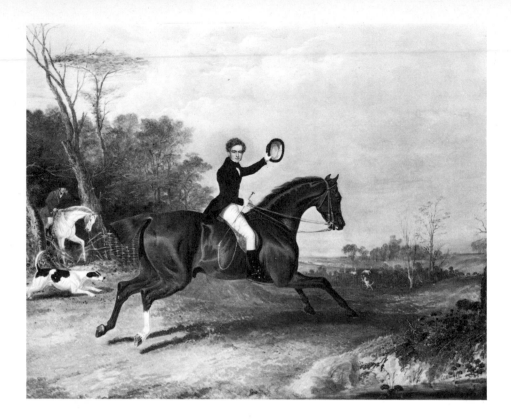

JOHN FREDERICK HERRING (1795–1865):
John Mytton of Halston, Salop. Dated 1828.
Canvas, 61 × 73·7 cm. Photograph by courtesy of Arthur Ackerman and Son

The bold and careless pose of the rider, his good-natured face, the magnificent hunter and the expensive clothes express Jack Mytton in the prime of his life. Six years later, aged only 36, he was dead, having got through two wives and gallons of port and brandy.

JOHN FREDERICK HERRING (1795–1865):
Rubini, before the Start of the Goodwood Gold Cup, 1833. Canvas, 100·4 × 67·8 cm. Private Collection

Herring's many portraits of successful racehorses brought him enormous popularity – through his shrewd exploitation of coloured aquatints of a very high quality. He had three sons, who painted in a similar style.

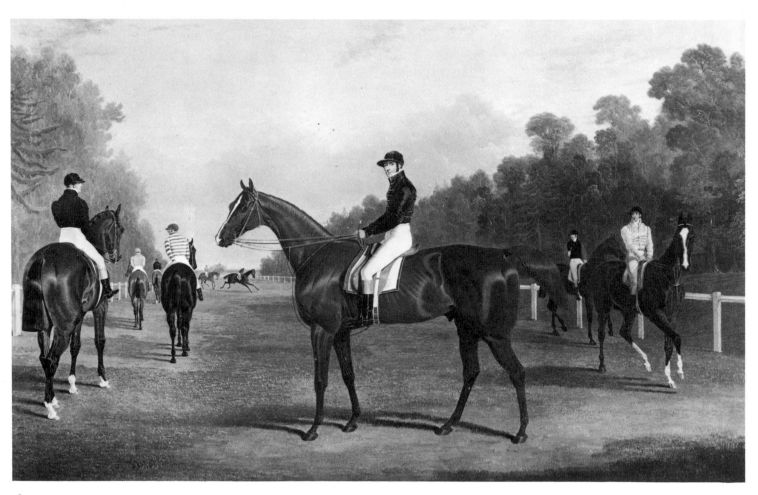

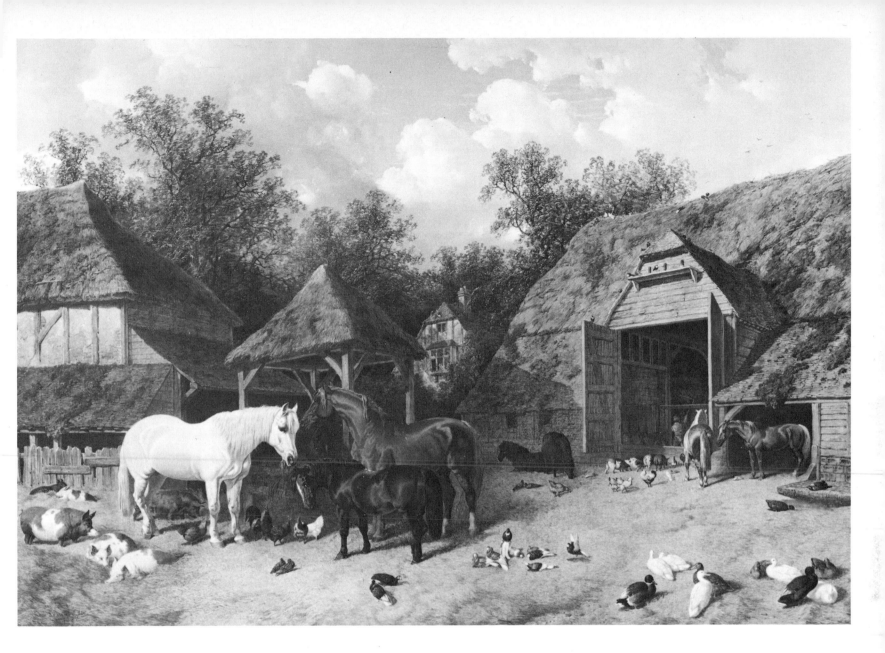

JOHN FREDERICK HERRING (1795–1865): *Farmyard at Meopham, Kent.* Signed and dated 1857. 89 × 130 cm. Photograph by courtesy of Ader Picard Tajan, Paris

Sunshine, sleek and contented animals, excellent thatch and lichen-covered tiles all betoken a large and prosperous farm, for times were good in the country again. Doves had become purely ornamental now and were no longer kept for their meat, so they have been relegated to a small cote in the gable over the barn doors. Herring and his sons painted a multiplicity of decorative farmyard scenes, though few are as unhackneyed as this.

immensely popular with everyone from the royal family downwards. His fame was increased by a shrewd use of very fine aquatint engravings, which are said to have influenced the work of the French painters Manet and Degas. At his finest, Herring's work ranks with the best; but in his last years he debased his art, in collaboration with his three sons, by a series of increasingly sentimental animal and farmyard scenes.

Shooting changes. Amidst all this activity, all these signs of a looser social fabric, broadening prosperity and general improvement in so many areas of life, it is strange to record that the flintlock gun was pretty well the same weapon at the end of the eighteenth century as it had been at the beginning. The method of shooting birds was generally much the same, too: walking over open country and the game quietly stalked, found by pointers and then shot sitting. The partridge was the favourite, found in coveys and flying only short distances if disturbed; it was shot in the open immediately after harvest in the long stubble

JAMES POLLARD (1792–1867): *Returning Home by Moonlight*. 1817. Hand-coloured etching and aquatint by R. Havell and Son, 35 × 46 cm. Collection of Donald North

Just how bright a full moon can be is an experience reserved to those out of range of street-lighting: it can extend a winter's day by several hours as this rarely portrayed scene so pleasantly shows. (Technically, as a print, it is an extraordinary piece of work.) The less enthusiastic riders have returned earlier no doubt, leaving four hardy souls to continue the hunt and eventually to savour the very special pleasure of moonlight, as well as the contentment that suf- fuses mind and body after a period of hard physical exercise in the open. Both hounds and horses are looking for their meals.

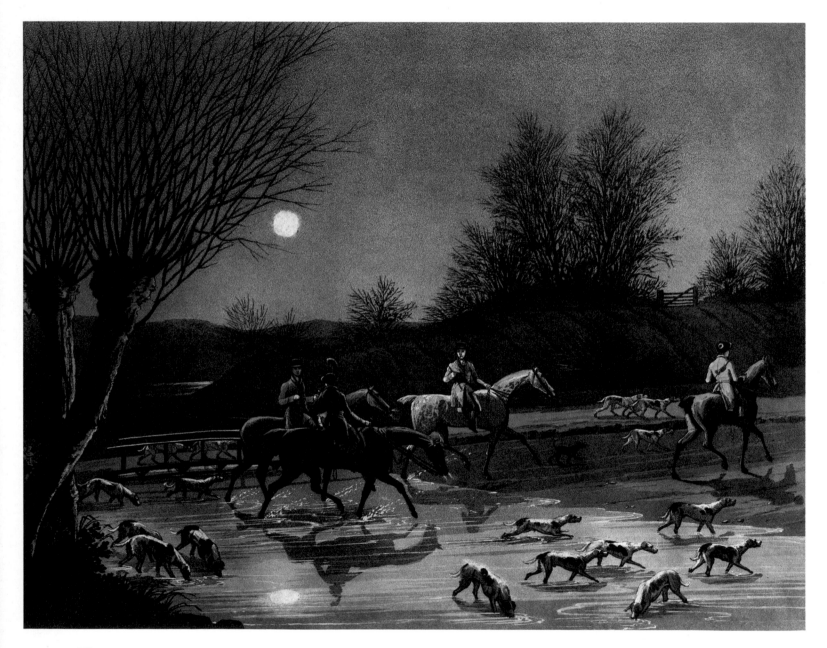

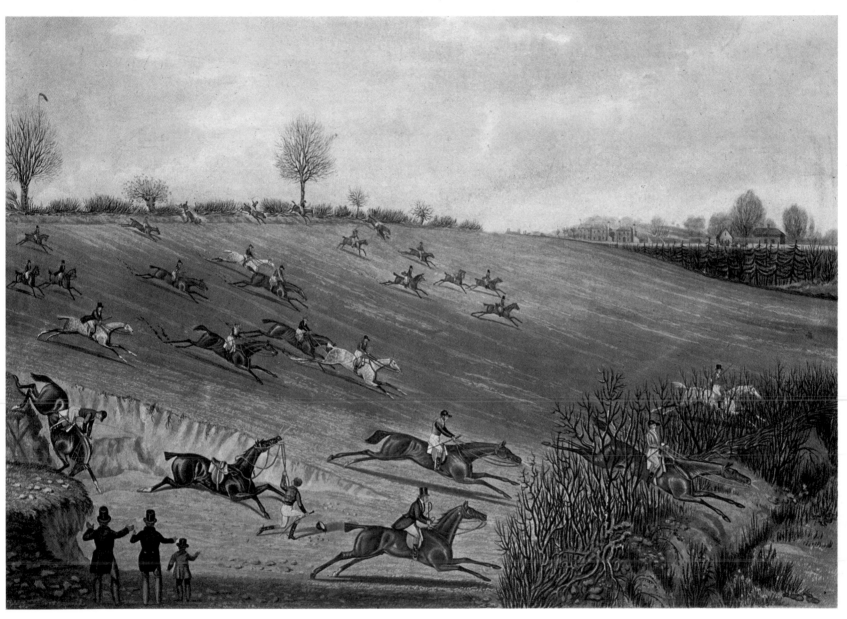

JAMES POLLARD (1792–1867): *St Albans Grand Steeple Chase, 8th March 1832*. Coloured aquatint by J. and C. Hunt. Photograph by courtesy of the Parker Gallery

It was at St Albans that modern steeplechasing first began in 1830 when Thomas Coleman, owner of the Turf Hotel, arranged a race across country starting and finishing near his inn. By 1832 the event was so well established as to attract vast crowds of spectators – good for business but bad for farmers, whose active hostility soon brought racing there to an end. This scene is near the finish of the race. The large hedge and ditch in the right foreground were relatively new and terrifying obstacles for horses and riders, consequent upon the enclosure of the old open fields throughout the land.

left by sickle or scythe. The origin of one ancient custom had already been lost, however: the opening of the grouse-shooting season on the twelfth of August derives from the days of the open fields, when the harvest had to be in by the feast of Lammas, the first of August; the additional days came from the belated change in the calendar in the mid-eighteenth century.

Whilst the partridge remained the favourite bird for the shooter, the pheasant was not always so well regarded; it preferred a woodland habitat protected by undergrowth less easy to negotiate by a sportsman hindered by a long and unsafe gun. A further general hazard came from an increase in the cultivation of turnips – less easy underfoot than stubble or grass.

But as already described, travel abroad and experience of better foreign guns had convinced the English sportsman that there was new skill to be learnt and challenge to be mastered in shooting birds on the wing. The new quickset hedges of the enclosures must have helped the idea along, as they provided ideal cover from which game could be sprung by a dog. Technical innovations also improved matters. William Watts's discovery of drop shot – made by pouring molten lead from the top of a tower – meant improved penetration and ensured

JAMES NORTHCOTE (1746–1831): *Grouse-Shooting in the Forest of Bowland*. 1802. Canvas, 145·5 × 217 cm. Private Collection

This remarkable picture was painted for Thomas Lister Parker of Brownsholme, who was a Fellow both of the Royal Society and of the Society of Antiquaries. He patronized many artists, including Turner and Romney, but especially Northcote, who here excels himself in his portraits of two of Parker's friends. The detail is a delight to the sportsman, and the daring composition is as much a tribute to the taste of the artist's patron as it is a challenge to connoisseurs.

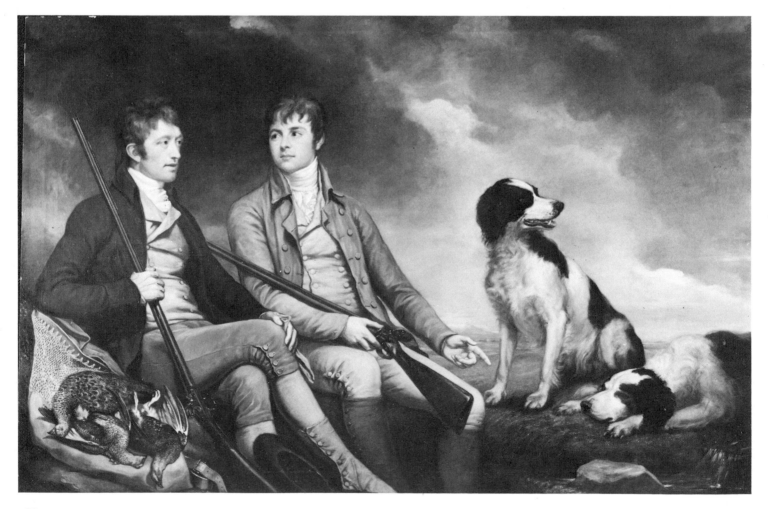

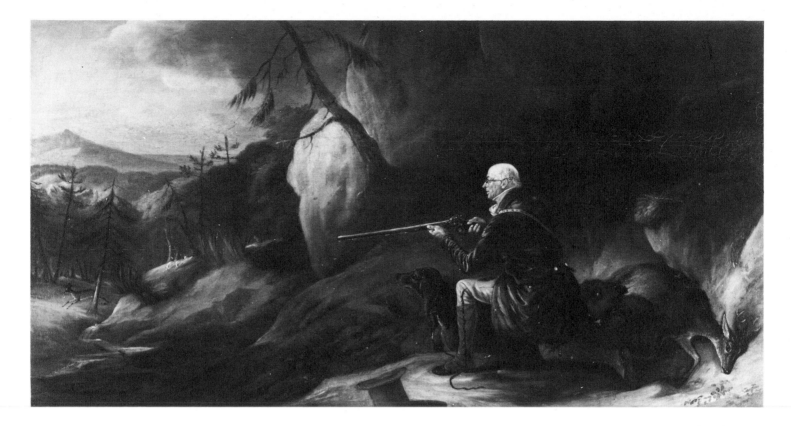

JOHN FERNELEY (1782–1860): *John Henry Bouclitch, Lord Kintore's Keeper, Shooting Roebuck at Keith Hall.* 1824. Canvas, 68·6 × 99·1 cm. Private Collection

Mr Bouclitch was head keeper for forty-five years and responsible therefore for managing the wildlife on the estate: a professional ecologist a century and a half before the term was generally understood. The culling of deer was an important part of his job. Evidently he was a magnificent shot and here he is preparing to use a double-barrelled flintlock gun whilst holding firmly under foot the leash of his hound; each must have understood the intentions of the other completely to have achieved such mutual trust at a tense moment.

some sort of regular size. Then the great gunsmith, Henry Nock, invented his patent breech, whereby the charge was ignited from the middle rather than from the edge, giving a faster and more powerful explosion. By such improvements the barrel length was reduced from about forty to about thirty inches, and the double-barrelled gun became a possibility because it was less heavy. In 1807 the detonator was invented – ignition being achieved by a blow rather than a spark – by the Reverend Alexander Forsyth, who was a keen wildfowler. Frustrated by the government and bureaucratic delay, he eventually set up in successful partnership with the gunsmith James Purdey. By the middle of the following decade the detonator had effectively ousted the flintlock, as it was quicker to load, more reliable, and more accurate over a longer range.

Methods of shooting also changed: the percussion-lock gun allowed quicker shooting of pheasant or woodcock flying between bushes or trees. To make them fly (for pheasants prefer to scuttle) the battue was invented: a line of guns beating a covert by walking towards a net, which turns the birds back and forces them into the air. From this came the modern method of beaters driving the birds towards the guns; flying overhead, high and fast, the birds are much harder to hit. The additional skill required was practised through trap-shooting – live pigeons released from a trap by the pull of a string – which became fashionable in its own right and attracted many bets. Though the original purpose of shooting birds for food had now sharply declined, it was still important and dovecotes were still common.

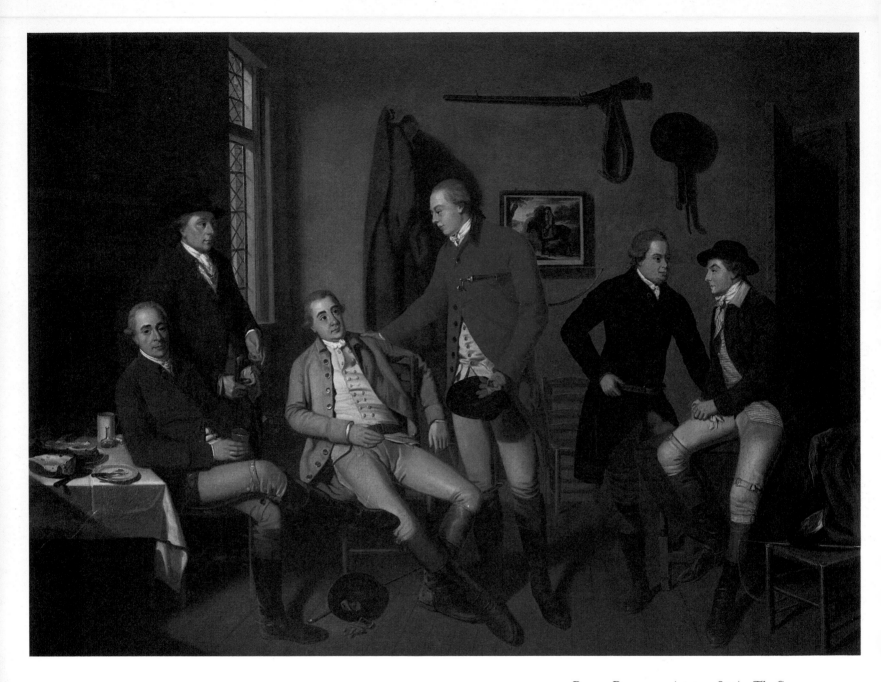

PHILIP REINAGLE (1749–1833): *The Carrom Abbey Hunt*. Canvas, 91·5 × 122 cm. Collection of Viscount Bearsted

After breakfast they will leave for the hunt: no idealized glamour here, no spectacular wealth; just a group of friends united in their enjoyment of sport and where the only uniform is comfort and utility, the only rules hospitality and companionship. Behind them on the wall hangs a mezzotint of Nathan Drake's *Earthstopper*; without his work there would be little chance of a successful hunt.

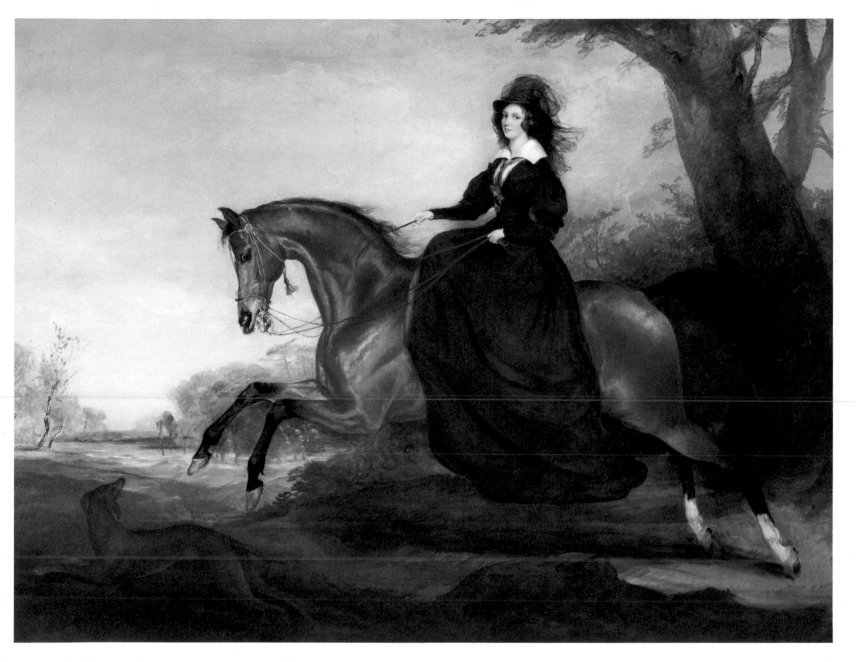

Sir Francis Grant (1803–78): *Lady Riding Side-Saddle with her Dog*. About 1840. Canvas, 111·8 × 141 cm. Private Collection

No one can fail to be attracted by the beauty and elegance of this picture, both as regards its subject and its style. How perfectly matched are girl, horse and dog. A pretty woman and a fine horse are a compelling combination, an aspect of life that happily shows no signs of decline – rather the reverse.

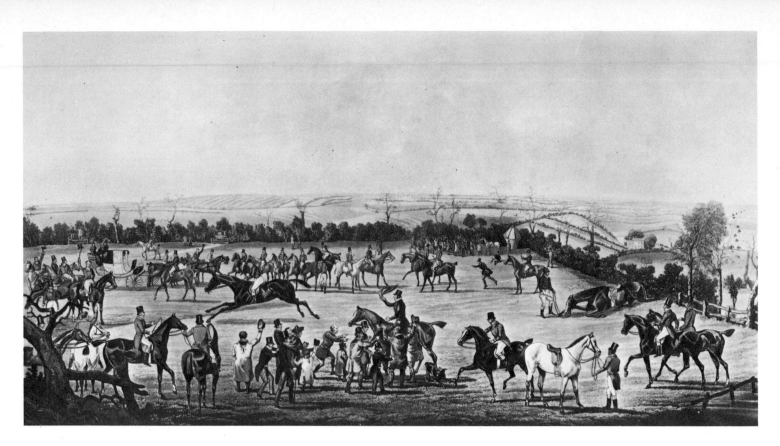

Steeplechasing.

Steeplechasing. Further evidence of the constriction of the countryside and a change in general attitude towards its ways can be seen in the invention of steeplechasing. This developed quite logically from the excitement attendant upon faster horses racing each other over the obstacles of any hunting field. Undoubtedly the basic idea is as old as riding, though in immediate origin the most likely forerunner must be the wild-goose chase of Tudor England. This was a match between two horses: both started together, and after a furlong (220 yards – an easy measure between the ploughed ridges of an open field) whichever horse was in the lead was able to choose the course, the other having to keep up within an agreed distance. If the leader managed to persuade his horse across a leap subsequently refused by the following horse, or indeed if he had managed to draw a distance clear,

E. GILL (*fl.* 1830): *Extraordinary Steeple Chase*. Aquatint by H. Alken and E. Duncan, 1830, 38·5 × 72 cm. Photograph by courtesy of the Parker Gallery

George Osbaldeston (1786–1866), universally known as the Squire, was perhaps the most famous of the all-round sportsmen. He excelled at cricket, rowing, tennis, boxing and athletics; he also hunted, raced, coursed and fished. This print commemorates a race for one thousand gold sovereigns between Osbaldeston on his own horse, Clasher, and Dick Christian (the foremost professional jockey of the day) on Captain Ross's Clinker. The race was over five miles and was close-run until Clinker fell at the last fence, as shown here, and Osbaldeston brought his own horse successfully home.

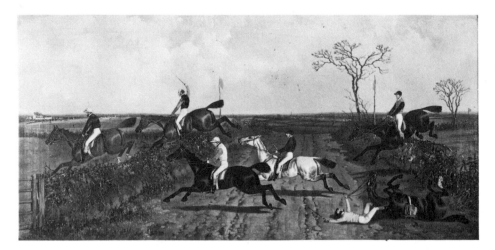

JOHN DALBY (*fl.* 1840–53): *A Steeplechase*. Signed and dated 1849. 45·8 × 63·5 cm. Liverpool, Walker Art Gallery

A combination of the risks inherent in hunting with the thrills associated with racing was barely twenty years old as an organized pastime called steeplechasing when this picture was painted. The course was still generally across country and marked by flags. Hazards and accidents such as the ones portrayed here are often shown by sporting artists, for no sportsman ever forgets them except to his cost.

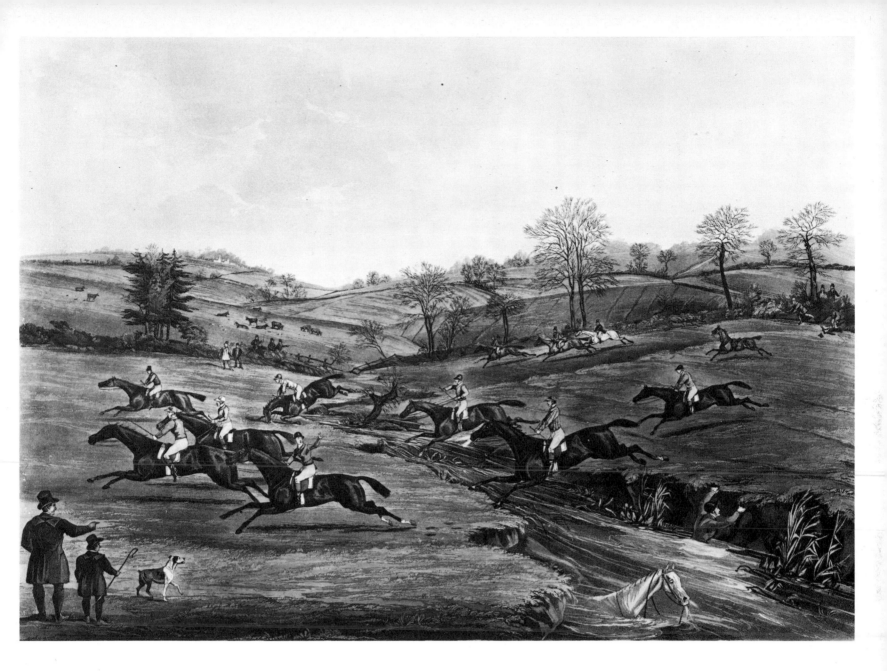

JAMES POLLARD (1792–1867): *Northampton Grand Steeple Chase*. Aquatint by H. Pyall, 1833. 35·2 × 42·8 cm. Private Collection

Modern steeplechasing dates only from 1830 with the inauguration by Thomas Coleman of the St Albans steeplechase. Instead of an arbitrarily chosen straight course, he settled on a marked one starting and finishing near his inn, the Turf Hotel. He attracted crowds of spectators together with better horses and professional riders encouraged by the lure of sweepstake prizes. The idea quickly spread, and was as quickly and violently opposed by a variety of factions, agricultural, sporting and moral, all in unusual union and with equally little success.

then he had won. This was rough, indeed crude, racing. In Stuart times, hunting matches became fashionable: these were races following hounds, themselves in pursuit of a stag.

Suitably enough it was in Ireland in the 1750s that the first literal steeplechase is recorded – that is, a race from an agreed starting point to a distant but visible object (a church steeple) across all intervening obstacles. The subsequent success of the new foxhounds bred from a cross of greyhounds demanded faster horses; the first thoroughbred hunters were also developed in Ireland and the combination of faster horses and hounds was bound to lead to opportunities for challenges and matches in the hunting field. In the first two decades of the nineteenth century steeplechasing in England became organized, distinct from both hunting and racing and with owners and professional riders competing on equal terms. But the steeplechases were still run in the old way of a more or less straight line from one point to another.

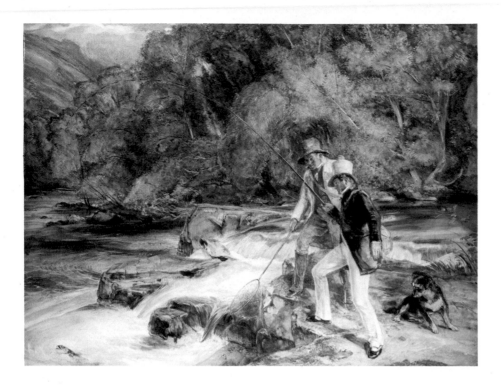

JOHN FREDERICK LEWIS (1805–76): *Sir Edwin Landseer R.A. in the Act of Angling.* Signed. Watercolour, 49 × 63·5 cm. Photograph by courtesy of Richard Green Galleries

Here, in a splendidly observed painting, one famous artist (best known for his exotic Middle Eastern scenes) has caught another at that most exciting yet perilous moment for the fly-fisherman, when a large trout or salmon has been hooked but not yet netted.

(opposite)
GEORGE ROBERT LEWIS: *View in Herefordshire.* Detail from plate on page 180

CHARLES TOWNE (1763–1840): *Fishing.* About 1810. Panel, 33 × 38·1 cm. Collection of Lady Thompson

Charles Towne, born in Wigan, was trained both as a coach painter and as a japanner specializing in decorative subjects.

The modern steeplechase was effectively the invention of Thomas Coleman, who bought an inn, the Turf Hotel, near St Albans, and in 1830 put on the first steeplechase, which had a course starting and finishing near the inn, marked by flags. Good prize money (on the sweepstakes principle) and a splendid spectacle meant that the idea was soon copied, notably at Cheltenham and then at Aintree. The first steeplechase at Aintree took place in 1836, though it was not until 1839 that a syndicate developed the race that is now accepted as the forerunner of the Grand National. The St Albans steeplechase lasted only five years: it attracted such large crowds that the farmers objected and the race had to be abandoned.

Improved racing. In racing itself during the first half of the nineteenth century, the principal changes lay in efforts to control malpractices. Betting was on a huge scale and the mobile bookmakers, or legs as they were then called, learned to lay off bets one with another, as well as to take advantage of laming, poisoning or otherwise interfering with a horse. The scale of such temptation can be judged from one race in 1806, two months before which, it is said, upwards of one million guineas had already been laid on the outcome. As off-course betting increased, so did the volume of money. Into the chaos, two autocrats successively managed to bring a form of discipline. Lord George Bentinck, through his management of Goodwood racecourse – the private property of the Dukes of Richmond – succeeded in making starts punctual and fair with the use of a visual signal: the dropping flag. He also ensured the ejection of bookmakers who defaulted on their payments. Admiral Rous went further and raised the art of

JOHN FREDERICK HERRING (1795-1865) with JAMES POLLARD (1792-1867): *The Doncaster Gold Cup, 1838.* Signed and dated 1839. Canvas, 111·8 × 205·7 cm. Private Collection

The winner is the Earl of Chesterfield's Don John. Another generation was to pass before the pioneer photographs of Eadweard Muybridge arrested the true movements of galloping horses, yet Herring, who painted the horses and riders, succeeds admirably in creating a sense of speed and straining animals. His work was widely disseminated by means of coloured aquatints and is said to have influenced the French painters Manet and Degas in their own racing scenes. The splendid grandstand on the right of this painting highlights the long importance of this municipal racecourse, for it was designed by the well-known architect John Carr and built by the town corporation in 1776. The buildings and background figures in this picture were painted by James Pollard. Such collaboration between specialists was not unusual in the past.

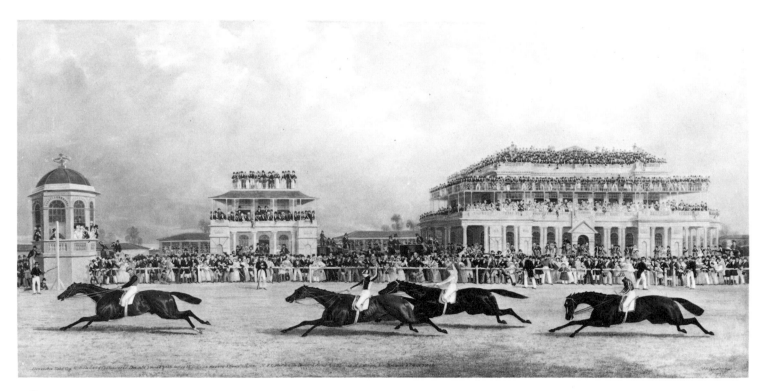

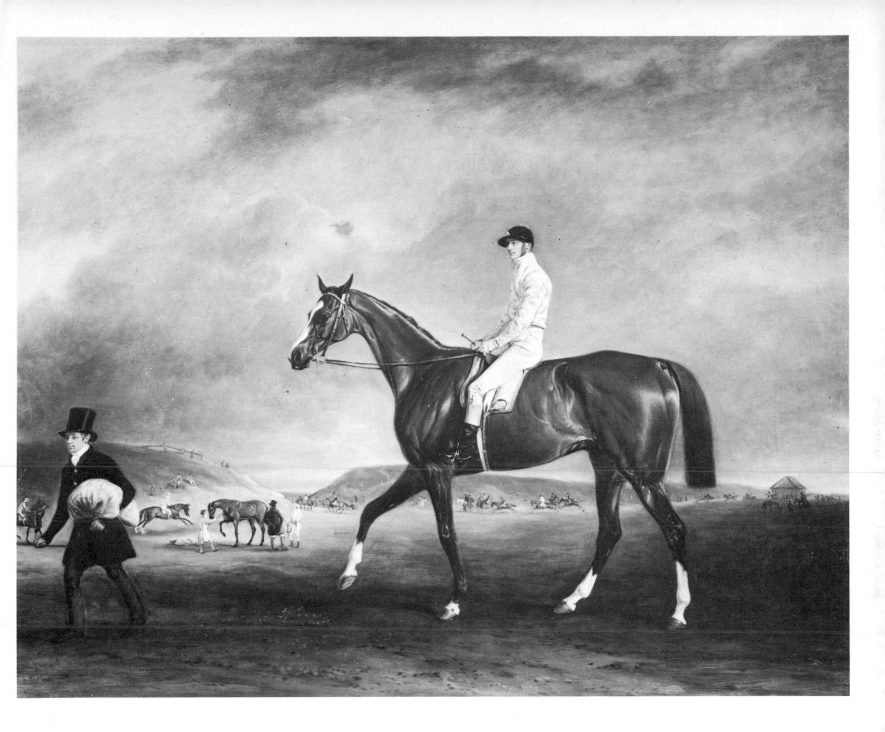

JOHN FERNELEY (1782–1860): *The Cur, Winner of the Brighton Stakes*. Signed and dated 1845. Canvas, 96·5 × 124·5 cm. Private Collection

Here Ferneley has captured supremely well the light, proud step and generally sleek air of the thoroughbred; the distinctive cock of the ears is no doubt characteristic of this horse. The upright seat of the jockey remained the accepted norm for another fifty years, until the modern racing crouch was introduced by the American, Tod Sloane. This brought the advantage of races run at a gallop throughout.

handicapping to new and more strictly controlled heights, based on long study of an individual horse's performance, condition and age. Both gentlemen contributed to the unique authority enjoyed by the Jockey Club in the settlement of disputes and the organization of racing, an authority that was eventually to become virtually absolute.

In the nineteenth century, in line with other sports, racecourses doubled in number: Horses ran at a younger age and over shorter distances. The horse van was invented, so that horses no longer had to be walked to the course, and old-fashioned methods of training gave way to less vigorous ideas. At the same time tipsters appeared and minor racecourses opened and shut with great as well as monotonous regularity.

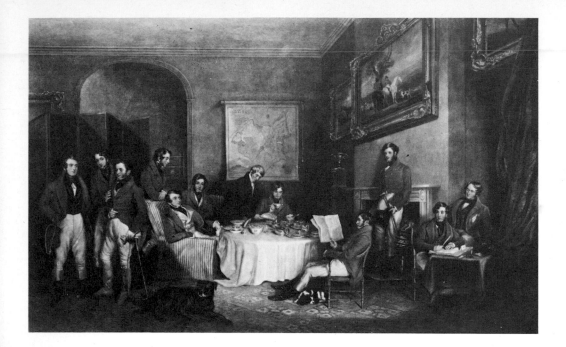

Melton Mowbray became the most famous centre of hunting for the practical reason that it was convenient for three fashionable packs: the Quorn, the Belvoir and the Cottesmore. Anyone so inclined, therefore, could have the opportunity of following hounds for six days a week. In these circumstances the right clothes became very important, giving rise to such refinements as the mud boots (third from the left) worn over the polished hunting boot and only removed at the meet. A map of Leicestershire hangs on the wall: in less well-regulated counties there was already squabbling over territory between rival hunts.

Fashionable hunting. In the hunting field, the prosperity of agriculture during the war years and the new wealth from industrialists buying into the land contributed to the last revolution – the transformation of hunting into a sport in which men rode for the sake of riding, for the competition and to be seen. Huge fields dominated the fashionable hunts, to the despair of the more serious followers, for the hounds were distracted or endangered by those out simply for a kind of exclusive entertainment. None the less, and paradoxically, it is at this time that several of the greatest of the sporting artists emerged. A near contemporary of John Ferneley was Sir Francis Grant (1803–78), who came of a wealthy Scottish family and spent a fortune on, amongst other things, hunting in the Shires. He became a fashionable portrait painter and was elected president of the Royal Academy.

To the hunting field the new wealth brought extravagances (or civilizing influences, depending, as always, on the point of view): the

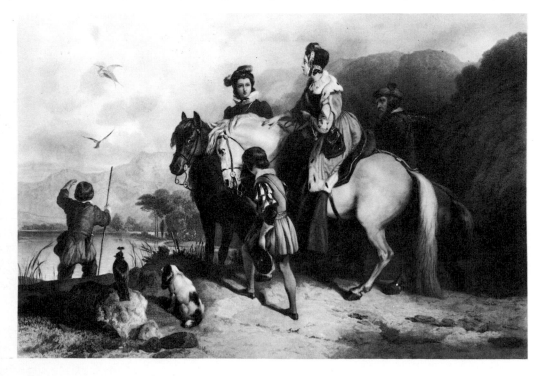

In the middle years of the nineteenth century there was much harking back to earlier periods of art and design. Ironically, these ideas were promulgated by the results of dynamic industrial innovation, which included methods of manufacturing larger sheets of paper and the building of more powerful presses, which were used to print those marvellous steel engravings that dominated the houses of prosperous Victorian England. This beautiful example is in inspiration unashamedly romantic, with its gentle yearning for beauty and elegance in person, animal and sport. The peerless heron is the falcon's prey. The sentiment is touching and as unlike reality as is the bloodthirsty or even the heroic.

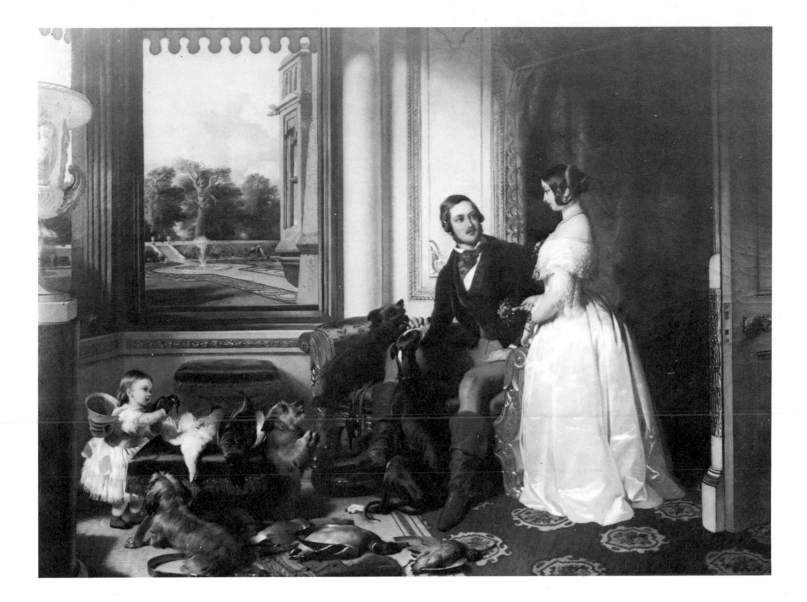

SIR EDWIN LANDSEER (1802–73): *Windsor Castle in Modern Times.* 113 × 143·5 cm. Royal Collection. Reproduced by gracious permission of Her Majesty The Queen

Although most commonly remembered today for his artistic insights and technological interests, Prince Albert was an enthusiastic sportsman. He is wearing the hunting boots of his own country, which he made briefly fashionable in England, and his favourite greyhound, Eos, is shown here at his knee. It was the happy family life that was modern – Queen Victoria and her husband have eyes only for each other whilst the tiny Princess Royal plays unaffectedly with her father's game. Landseer in his later years steadily dissolved his personality in alcohol but the widowed Queen remained a faithful friend to the end.

second horse, to which a transfer might be made during a long day in the field; the covert hack, used to get to the meet; and boot-covers to keep the rider's shiny boots clean before the hunt. Dress, often important in the past, assumed an even greater significance, and fashion dictated the cut and colour of a coat as well as the height of a hat. Fewer and fewer men could afford to hunt a pack alone; the subscription idea grew and with it such nefarious practices as the purchasing of foxes (bagmen) for release just before a hunt to ensure a successful day.

John Constable. The prosperity of agriculture eventually and inevitably declined into a depression after the wars of the late eighteenth and early nineteenth centuries – at the very time when perhaps the greatest of all England's painters of the countryside was ploughing a lonely and determined furrow in single-minded pursuit of his idea of truth: John Constable (1776–1837). Many of his greatest pictures were

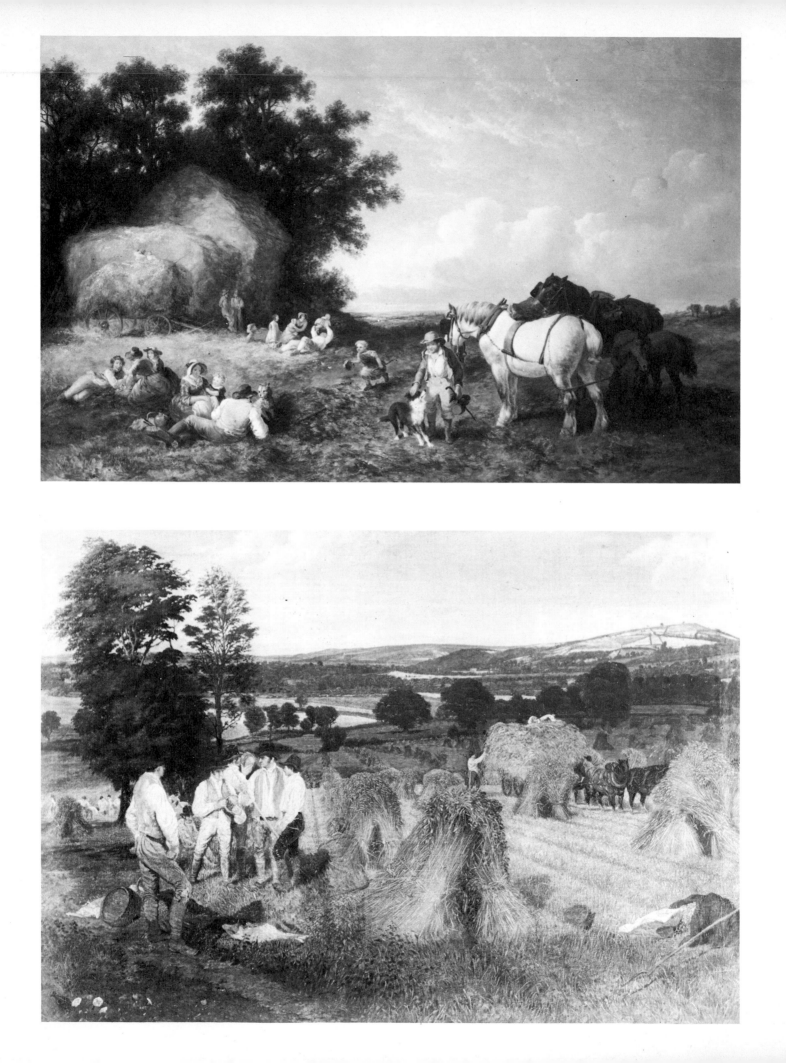

SIR EDWIN LANDSEER (1802–73): *The Monarch of the Glen.* 1851. Canvas, 63·8 × 68·9 cm. Messrs John Dewar and Sons Ltd

The amazing fame of this picture through a multiplicity of engravings and a myriad of advertisements has obscured one aspect of its meaning. The masterful, dominant pose of the stag is an entirely human sentiment: it represents the essentially urban idea that animals are in most respects subject to the same feelings and aspirations as man. In nature all is in balance and the hierarchy matter-of-fact. The paradox of this remarkable painting is that despite the wild setting, the idea stems from that time when the majority of the population had moved from the country to the town.

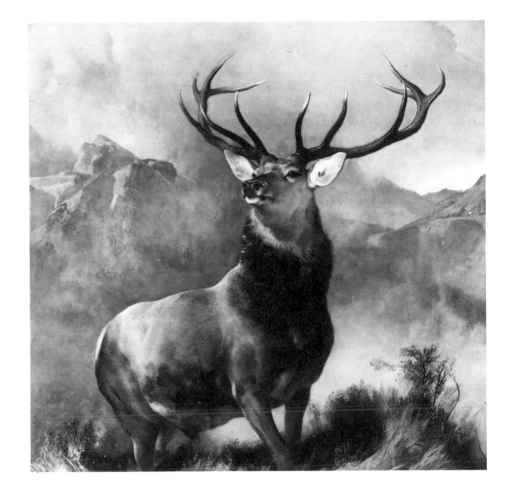

WILLIAM J. SHAYER (1811–85?): *Harvest Time.* 110·5 × 171·4 cm. Photograph by courtesy of Christie's

The very word 'yokel' has a round and smiley feel, and for most of us this pleasant scene will represent all that we imagine as true of the golden days of a once rural England. It was already doomed; most of the population now lived in the towns, and in the 1870s a huge agricultural depression swept the land, forcing many more from it. Many owners, too, were forced to seek a new kind of living from their land by adapting it to the demands of an industrial society now looking for recreation through outdoor sport.

GEORGE ROBERT LEWIS (1782–1871): *View in Herefordshire, Harvest.* About 1817. Canvas, 41·6 × 59·7 cm. London, Tate Gallery

This is the kind of harvest scene that a countryman would recognize, a great deal earthier and sweatier than Stubbs's rather more formalized version – but then, the latter artist was painting a different kind of picture. Alas, stooks of corn are no longer to be seen, nor the wagon either; fewer people are needed on the land now and many fewer remain, for most of those who live in the country no longer work there, even if they think that they appreciate it more.

painted in London: paradoxically their inspiration, the old countryside, was already, to all intents and purposes, doomed.

Agricultural depression and recovery. The agricultural depression of the early 1800s was exacerbated by the new game laws that restricted still further the freedom of countrymen to catch their own meat. It became illegal to buy game let alone offer it for sale, the assumption being that it had been poached. Pheasant, partridge and hare were the game in question; the first was particularly keenly preserved – for shooting. But it should never be forgotten that the rabbit and the woodcock, for instance, were free of the draconian restrictions. Terrifying discontent swept the land, ricks were burnt, machinery smashed and yeomanry raised as a protection. But, inevitably, there was a reaction and then prosperity returned to the land; so much so that by the middle of the nineteenth century the experimental breeding and improvement of livestock had reached new heights, and the final clearances, drainage and enclosures had contributed to the making of the landscape familiar to us today.

Urban sentiment. Eyes were turned to Scotland to new, or at any rate renewed, experiences of sport in the wild now gone from England. Two artists shared the fruits of the new clientele. The first was Richard

Ansdell (1815–85), born in Liverpool and only now being rediscovered as the painter of a series of marvellous pictures of sport in dramatic settings and with skilfully managed groups of figures that appear so informally placed. He was the one serious rival to Sir Edwin Landseer (1802–73), who was a great favourite of Queen Victoria and the Prince Consort and whose understanding of animals ranged from the sublime to the outrageously sentimental. In this he quite properly represents that popular view of the countryside as somewhere grand or noble, or maybe warm and tolerant; a place that holds out a kind of hope of peace and plenty. For the countryman, on the other hand, the countryside is a place of work, of rest, of play, of love, of life and death.

The last paradox. The paradox of it all is that not even the brittle brilliance of the Pre-Raphaelites, and those they influenced, with their obsession for 'truth to nature' were to express the countryside. They were expressing only something that they thought they saw. There were more townsmen than countrymen, and other less prejudiced painters found their inspiration in a number of more or less contrived settings, such as cottage interiors or historical charades. The animal finally lost all its natural dignity as the servant of man, for the dignity of service was no longer understood. It was the solitary and unsuccessful John Constable who saw the truth in the countryside, and whose

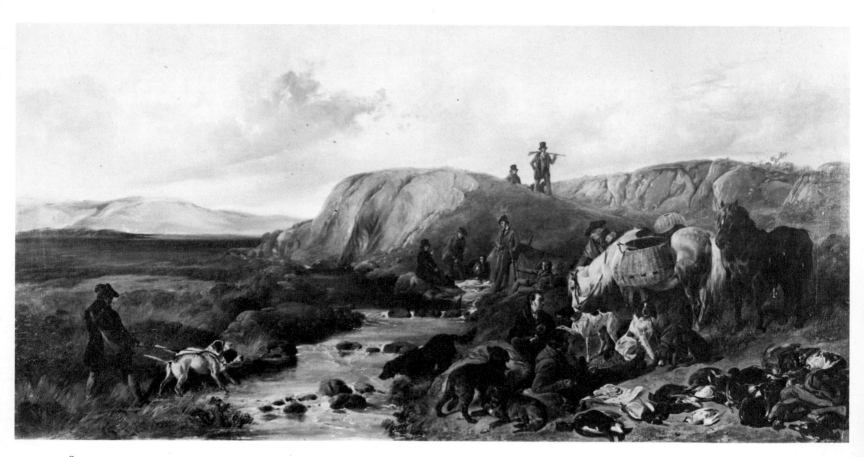

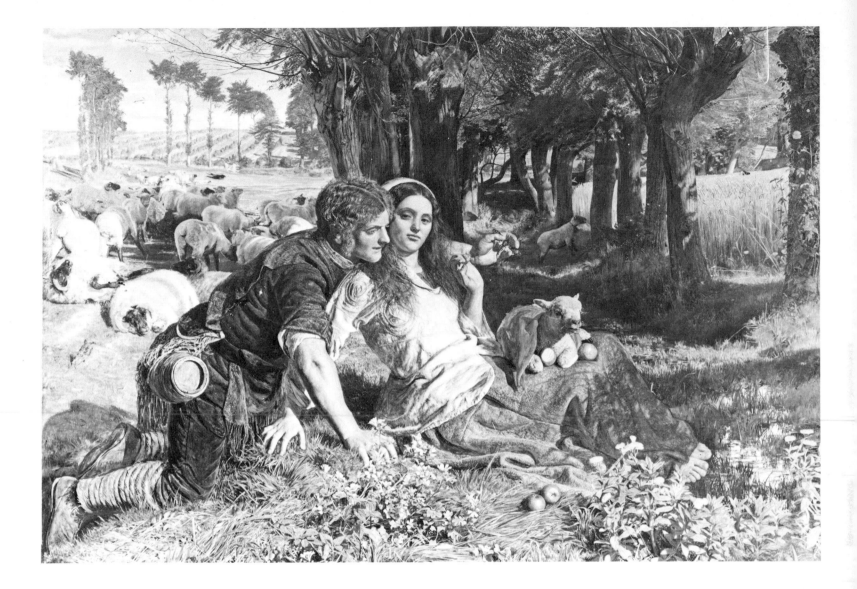

RICHARD ANSDELL (1815–85): *Shooting Party in the Highlands*. Signed and dated 1840. 97 × 161·2 cm. Liverpool, Walker Art Gallery

Ansdell was a Liverpool artist famous for his sporting scenes. This painting is a superb example of his particular mastery of portraying a number of figures apparently loosely grouped in a wide landscape. It shows Scotland in the morning of her discovery by the English shooting man, now helped by the railway towards ever greater distances and ever more discomfort in the pursuit of sport. The party here is large and obviously well organized – as befits any group which ventures unbidden into wild lands.

WILLIAM HOLMAN HUNT (1827–1910): *The Hireling Shepherd*. 1851. Canvas, 76·4 × 109·5 cm. Manchester, City Art Gallery

The Pre-Raphaelite Brotherhood was founded in 1848, and one of their aims, at least, gives them the right to be represented here: that of 'truth to nature'. The background of this picture was painted in the open air at Ewell in Surrey (now a London suburb) and the model for the girl was a local field-hand. Neither the moral overtone – of untended sheep straying into a field of ripe corn – nor the rustic dalliance can disguise the fact that, in this and similar pictures, the countryside was no longer shown as simply a place of work, but rather as somewhere to go, to dream, to relax and to forget.

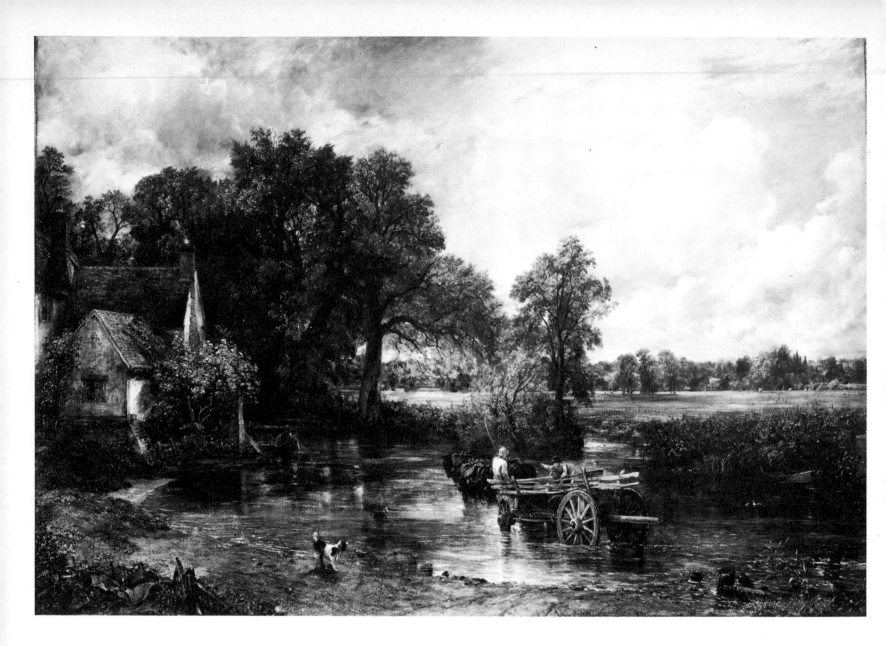

art was to influence the world – not through the support of his own countrymen, but rather through the admiration of others abroad. The glowing and special truths eventually sought by the Impressionists were to transform the nature of art, in the same way as the nature of the English countryside had been irrevocably changed by his own contemporaries, the descendants of the very people that had originally formed it two centuries before.

JOHN CONSTABLE (1776-1837): *The Haywain*. Signed and dated 1821. Canvas, 130·2 × 185·4 cm. London, National Gallery

Based upon many studies and a deep knowledge of his native countryside, this most famous of English landscape pictures was painted, paradoxically, in London. Constable was as scrupulous in his detail of plants and objects as he was in colours; he even sent to Suffolk for a friend to sketch the wagon, which is typical of the East Anglian type – relatively large and most often used for harvest work. Haymaking in the background suggests a ford crossing as the most likely subject. Exhibited at the Paris Salon in 1824 with two others of his paintings, it caused a sensation and profoundly affected the course of European art. Few of his compatriots realized Constable's importance at the time.

Select Bibliography

For the practical convenience of the reader this list is in general restricted to books recently published. Many have extensive and authoritative bibliographies.

BACHRACH, A. G. H.: *Shock of Recognition, The Landscape of English Romanticism and the Dutch Seventeenth-Century School* (Arts Council exhibition catalogue, 1971)

BIRD, ANTHONY: *Roads and Vehicles* (1969, 1973)

BLOME, RICHARD: *Hawking, or Faulconry.* Edited from *The Gentleman's Recreation*, 1686, by E. D. Cuming (1929)

BOVILL, E. W.: *The England of Nimrod and Surtees 1815-1854* (1959)

BOVILL, E. W.: *English Country Life 1780-1830* (1962)

BROWN, CHRISTOPHER: *Dutch and Flemish Painting* (1977)

BUTLIN, MARTIN with ANDREW WILTON and JOHN GAGE: *Turner* (Royal Academy exhibition catalogue, 1974)

CARDUS, NEVILLE and JOHN ARLOTT: *The Noblest Game, A Book of Fine Cricket Prints* (1969)

CARR, RAYMOND: *English Fox Hunting, A History* (1976)

DENT, ANTHONY: *Animals in Art* (1976)

EGERTON, JUDY: *George Stubbs, Anatomist and Animal Painter* (Tate Gallery exhibition catalogue, 1976)

ERNLE, LORD: *English Farming, Past and Present* (4th edition 1927)

FORD, JOHN: *Prizefighting, The Age of Regency Boximania* (1971)

GAUNT, WILLIAM: *A Concise History of English Painting* (1964)

GAUNT, WILLIAM: *The Great Century of British Painting, Hogarth to Turner* (1971)

GAUNT, WILLIAM: *Painting in Britain, The Restless Century* (1972)

GOMBRICH, E. H.: *Art and Illusion, A Study in the Psychology of Pictorial Representation* (1960)

GRIGSON, GEOFFREY: *The Englishman's Flora* (1958, 1975)

GRIGSON, GEOFFREY: *Britain Observed* (1975)

HAYES, JOHN: *Rowlandson, Watercolours and Drawings* (1972)

HAYES, JOHN: *Gainsborough, Paintings and Drawings* (1975)

HOSKINS, W. G.: *The Making of the English Landscape* (1955, 1974)

KLINGENDER, FRANCIS D.: *Art and the Industrial Revolution*, edited and revised by Arthur Elton (1968)

LEVEY, MICHAEL: *A History of Western Art* (1968, 1974)

LONGMAN, C. J. and COL. H. WALROND: *Archery* (1894)

LONGRIGG, ROGER: *The History of Horse Racing* (1972)

LONGRIGG, ROGER: *The History of Foxhunting* (1975)

LONGRIGG, ROGER: *The English Squire and his Sport* (1977)

MILLAR, OLIVER: *The Queen's Pictures* (1977)

MILLAR, OLIVER with MARY WEBSTER, LIONEL LAMBOURNE and DAVID COOMBS: *British Sporting Painting 1650-1850* (Arts Council exhibition catalogue, 1974)

ORWIN, C. S. and C. S.: *The Open Fields* (2nd edition 1954)

PARKER, CONSTANCE-ANNE: *Mr Stubbs The Horse Painter* (1971)

PARRIS, LESLIE: *Landscape in Britain c. 1750-1850* (Tate Gallery exhibition catalogue, 1973)

PARRIS, LESLIE with IAN FLEMING-WILLIAMS and CONAL SHIELDS: *Constable, Paintings, Watercolours and Drawings* (Tate Gallery exhibition catalogue, 1976)

PARTRIDGE, MICHAEL: *Farm Tools through the Ages* (1973)

PLUMB, J. H. and HUW WHELDON: *Royal Heritage, The Story of Britain's Royal Builders and Collectors* (1977)

POTTERTON, HOMAN: *Reynolds and Gainsborough* (1976)

ROBERTS, KEITH: *Rubens* (1977)

SELWAY, N. C.: *The Regency Road, The Coaching Prints of James Pollard* (1957)

SMART, ALASTAIR and ATTFIELD BROOKS: *Constable and his Country* (1976)

SMITH, D. J.: *Horse Drawn Carriages* (1974, reprinted 1976)

SPARROW, WALTER SHAW: *British Sporting Artists, from Barlow to Herring* (1922, reprinted 1965)

TAYLOR, BASIL: *Animal Painting in England, from Barlow to Landseer* (1955)

TAYLOR, BASIL: *Painting in England 1700-1850.* From the Collection of Mr and Mrs Paul Mellon (Royal Academy exhibition catalogue, 1964)

TAYLOR, BASIL: *Stubbs* (1971, 1975)

TRENCH, CHARLES CHENEVIX: *A History of Horsemanship* (1970)

TRENCH, CHARLES CHENEVIX: *A History of Marksmanship* (1972)

TREVELYAN, G. M.: *English Social History, A Survey of Six Centuries, Chaucer to Queen Victoria* (1944)

TROW-SMITH, ROBERT: *A History of British Livestock Husbandry 1700-1900* (1959)

TYLDEN, G.: *Harness and Saddlery* (1971)

VAUGHAN, WILLIAM: *Endymion Porter and William Dobson* (1970)

VINCE, JOHN: *Carts and Wagons* (1970, revised 1975)

WALKER, STELLA A.: *Sporting Art, England 1700–1900* (1972)

WILDER, F. L.: *English Sporting Prints* (1974)

UNKNOWN ARTIST: *A Rat Pit*. About 1860. Canvas, 68·6 × 88·9 cm. Private Collection

Following the prohibition of cock-fighting in 1849 there was a revival of interest in another kind of bloody sport – the killing of rats by a dog within a fixed time. There was great opportunity for betting on the combination of weight of dog against weight of dead rats. Hogarth would have made much of such a scene; as it is this painting may well have been based on a series of individually taken photographic portraits of the small carte-de-visite variety.

Index

The argument of this book ebbs and flows between text, captions and illustrations.
Individual pictures are listed below the artist's name.